Salvador DALÍ
1904-1989

VICTORIA CHARLES

Salvador Dalí
1904-1989

"In view of the tangle of riddles, Dalí has emerged to conquer the world of painting, and out of this fight
has brought us something more valuable than gold. He has opened up new horizons to spread them before
us, but above all has given us something more tangible: Salvador Dalí."

Julien Green[1]

Grange Books Plc

Front cover illustration:
The Weaning of Furniture-Nutrition, 1934
Oil on panel. 18 x 24 cm
The Salvador Dalí Museum, St Petersburg (FL)

Frontispiece:
Paranoiac Metamorphosis of Gala's Face (detail), 1932
Indian ink on Japan paper, 29 x 21 cm
The Gala-Salvador Dalí Foundation, Figueras

Back cover illustration:
Little Cinders (Cenicitas), 1927–1928
Oil on panel. 64 x 48 cm
The Reina Sofia National Museum, Madrid

Text: Victoria Charles

Cover and page layout: Stephanie Angoh

© Confidential Concepts, worldwide, USA, 1996

© Sirocco, London, 2002 (English version)
Printed and bound in Slovakia

Published in 2003 by Grange Books
an imprint of Grange Books Plc
The Grange
Kingsnorth Industrial Estate
Hoo, nr Rochester
Kent ME3 9ND

www.Grangebooks.co.uk

ISBN 1-84013-544-1

CONTENTS

The Public Secret of Salvador Dalí

At the age of 37, Salvador Dalí wrote his autobiography. Titled *The Secret Life of Salvador Dalí*, the Spanish painter portrays his childhood, his student days in Madrid, and the early years of his fame in Paris up to his leaving to go to the USA in 1940. The exactness of his descriptions are doubtful in more than one place. Dates are very often incorrect, and many childhood experiences fit too perfectly into the story of his life. As Dalí had studiously read the works of Sigmund Freud and Otto Rank, his autobiography like his painting, is imbued with applied psychoanalysis. The anecdotes, memories, and dreams that comprise Dalí's autobiography were, one suspects, deliberately chosen.

The picture that Dalí drew of himself in 1942, and further developed in the years up to his death in 1989, shows an eccentric person, most at ease when placed in posed settings. Despite this tendency, Dalí often revealed intimate details of his life in front of the cameras. This act of self-disclosure, as Dalí explains in his autobiography, is a form of vivisection, a laying bare of the living body carried out in the name of pure narcissism: "I perform it with taste – my own – and in the Jesuit manner. But something else is valid: a total section is erotically uninteresting; this leaves everything just as unfathomable and coiffeured as it was before the removal of the skin and flesh. The same applies for the bared skeleton. In order to conceal and at the same reveal, my method is to gently intimate the possible presence of certain internal wounds, while at the same time, and in a totally different place, plucking the naked sinews of the human guitar while never forgetting that it is more desirable to let the physiological resonance of the prelude ring out, than experience the melancholy closing of the full circle."[2] The more Dalí showed himself in public, the more he concealed himself. His masks became ever larger and ever more magnificent: he referred to himself "genius" and "god-like". Whoever the person behind Dalí really was, it remains a mystery. "I never know when I start to simulate, or when I am telling the truth", he professed in an interview with Alain Bosquet in 1966, "In any case the audience should never be allowed to guess if I am joking or being serious; and I am certainly not allowed to know either."[3]

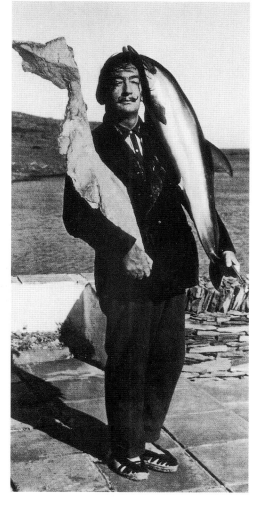

1. Julien Green: *Dalí, the Conquistador*; in: *Salvador Dalí – Retrospective 1920-1980*. Catalogue for the exhibition at the Georges Pompidou Centre, Paris 1979, p. 9
2. Salvador Dalí: *The secret life of Salvador Dalí*, Munich 1974, p. 298 f.
3. Alain Bosquet: *Conversations with Dalí*, in: *Hommage to Dalí*, Munich 1974, p. 57

Opposite page: *The Soft Watch*, 1950
Pen and ink on cardboard. 13.7 x 18.6 cm
Private collection

Above: Dalí illustrating his theory of hard and soft, 1958

Above: Dalí in the Grévin Museum with
his wax figure, Paris, 1968

Opposite page: Dalí in his studio
of Port Lligat with portraits he valued:
Stalin, Hitler, *The Mona Lisa*, Gala

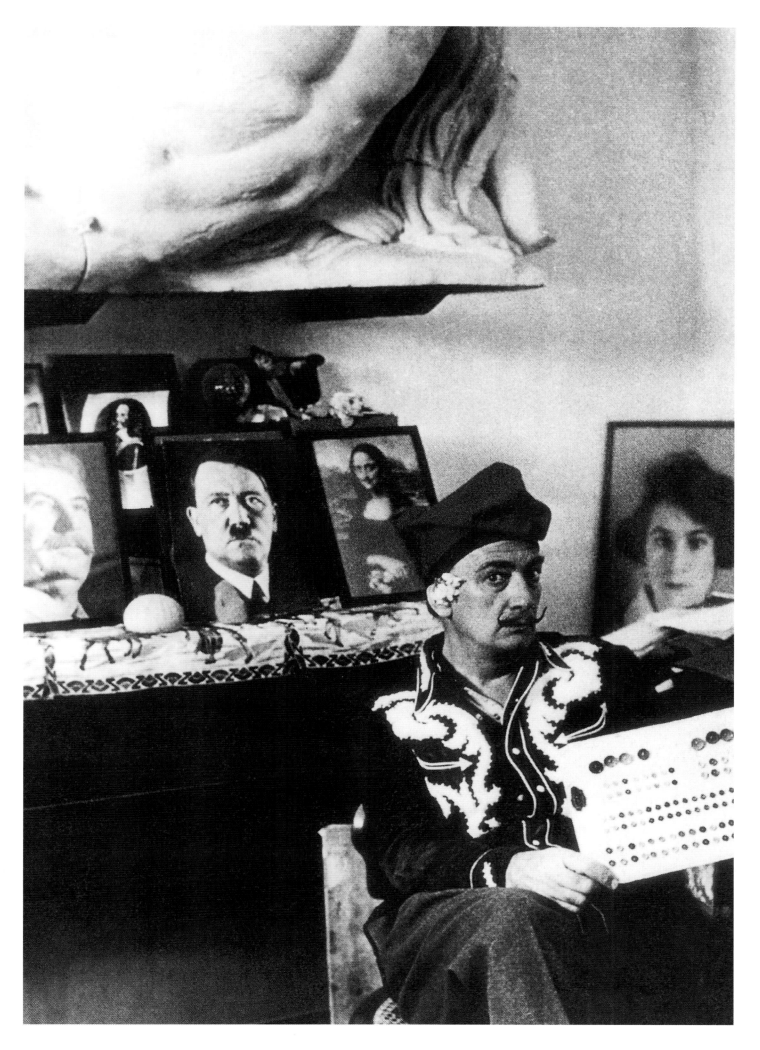

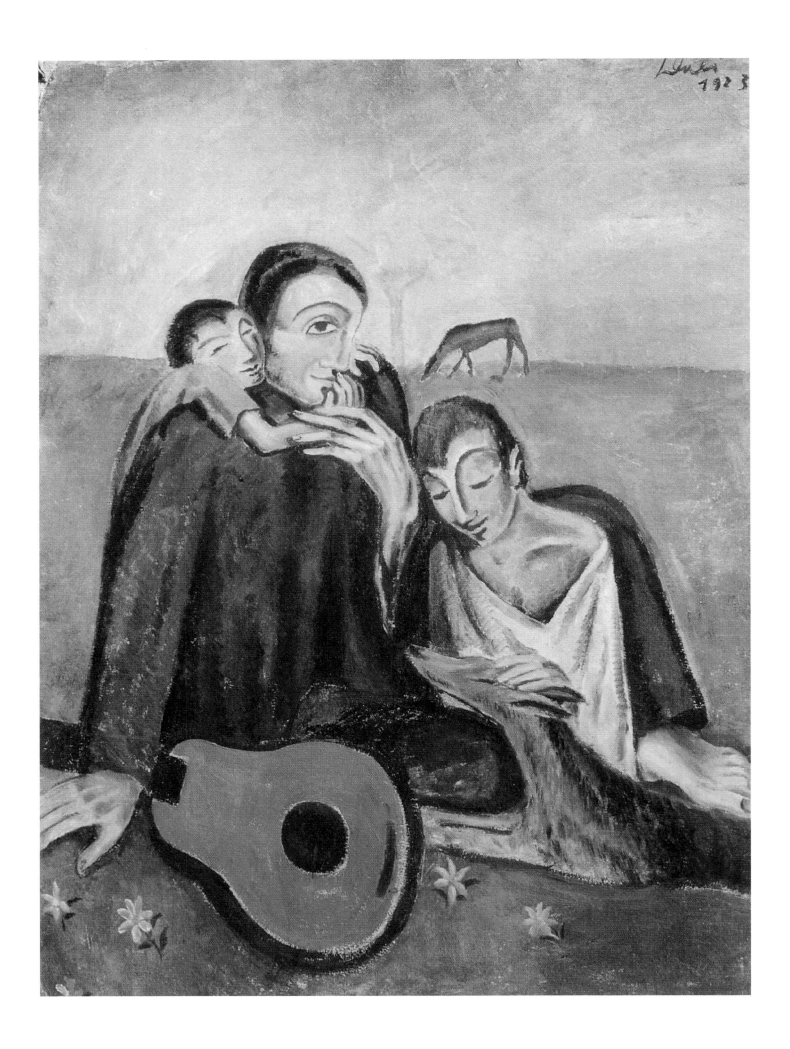

10

The Years of the King

Childhood and Adolescence in Figueras and Cadaqués

Dalí's memories appear to begin – or so Dalí informs us in his autobiography – two months before his birth on May 11th, 1904. Recalling this period, he describes the "intra-uterine paradise" defined by "colours of Hell, that are red, orange, yellow and bluish, the colour of flames, of fire; above all it was warm, still, soft, symmetrical, doubled and sticky."[4] His most striking memory of birth, of his expulsion from paradise into the bright, cold world, consists of two eggs in the form of mirrors floating in mid-air, the whites of which are phosphorising: "These eggs of fire finally merged together with a very soft amorphous white paste; it appeared to be drawn out in all directions, its extreme elasticity which molded itself to all forms appeared to grow along with my growing desire to see it ground down, folded, rolled-up and pressed out in the most different directions. This appeared to me to be the pinnacle of all delight, and I would have gladly had it so always! Technical objects were to become my biggest enemy later on, and as for watches, they had to be soft or not at all."[5]

Dalí's life is overshadowed by the death of his brother. On August 1st, 1903, the first-born child of the family, scarcely two years old, died from gastroenteritis. Dalí himself claimed that his brother had already reached the age of seven and became ill with meningitis. In preparation for an exhibition on Dalí's formative years, in London in 1994, Ian Gibson examined the dead brother's birth and death certificates and determined that the painter's statement was incorrect. Gibson also pointed out that Dalí's accusation – that his parents had given him the name of his dead brother – was only partly true. In addition to being given the first forename of the father, both were also given two second names. The first-born was baptised Salvador Galo Anselmo, and the second, Salvador Felipe Jacinto.[6]

Regardless, the child Salvador sees himself as nothing more than a substitute for the dead brother: "Throughout the whole of my childhood and youth I lived with the perception that I was a part of my dead brother. That is, in my body and my soul, I carried the clinging carcass of this dead brother because my parents were constantly speaking about the other Salvador."[7]

Out of fear that the second-born child could also sicken and die, Salvador was particularly coseted and spoiled. He was surrounded by a cocoon of female attention, not just spun by his mother Felipa Doménech Ferrés, but also later by his grandmother Maria Ana Ferrés and his aunt Catalina, who moved into Dalí's

4. Dalí: *The secret Life…*, p. 42
5. Dalí: *The secret Life…*, p. 47
6. Cf.: Ian Gibson: *Salvador Dalí: The Catalan background*, in: *Salvador Dalí – The early years*. Catalogue for the exhibition of the same name at the Hayword Gallery, London 1994, p. 51
7. Salvador Dalí in a television interview with Pierre Cardinal for French television in 1975

Opposite page: *Family Scene*, 1923
Oil and gouache on cardboard
105 x 75 cm
The Gala-Salvador Dalí Foundation, Figueras

8. Dalí: *The secret Life…*, p. 89
9. Cf.: Meryle Secrest: *Salvador Dalí. His eccentric Life – his works of Genius – his fantastic World*, Bern, Munich, Vienna 1987, p. 47
10. Dalí: *The secret Life…*, p. 92

Above: *Dutch Interior (Copy after Manuel Benedito)*, 1914
Oil on canvas. 16 x 20 cm
Joaquin Vila Moner collection, Figueras

Opposite page: *Portrait of Lucia*, 1918
Oil on canvas. 43 x 33 cm
Private collection

family home in 1910. Dalí reported that his mother continually admonished him to wear a scarf when he went outdoors. If he got sick, he enjoyed being allowed to remain in bed: "How I loved it, having angina! I impatiently awaited the next relapse – what a paradise these convalescences! Llucia, my old nanny, came and kept me company every afternoon, and my grandmother came and sat close to the window to do her knitting."[8]

Dalí's sister Ana Maria, four years younger, writes in her book, *Salvador Dalí visto por su hermana* (*Salvador Dalí, seen through the eyes of his sister*), that their mother only rarely let Salvador out of her sight and frequently kept watch at his bedside at night, for when he suddenly awoke, startled out of sleep, to find himself alone, he would start a terrible fuss.[9]

Salvador enjoyed the company of the women and especially that of the eldest, his grandmother and Lucia. He had very little contact with children of his own age. He often played alone. He would disguise himself as a king and observed himself in the mirror: "With my crown, a cape thrown over my shoulders, and otherwise completely naked. Then I pressed my genitals back between my thighs, in order to look as much like a girl as possible. Even then I admired three things: weakness, age and luxury."[10]

Dalí's mother loved him unreservedly, even lionized him. With his father, Dalí enjoyed a different type of relationship.

13

11. Cf.: *Catalogue 1994*, p. 49

Above: *The Sick Child (Self-Portrait in Cadaqués)*, c. 1923
Oil and gouache on cardboard
57 x 51 cm
The Salvador Dalí Museum,
St Petersburg (FL)

Salvador Dalí y Cusi was a notary in the Catalan market-town of Figueras, near the Spanish-French border. His ancestors were farmers who moved to the Figueras area in the middle of the 16th century. Dalí himself claimed that his forefathers were Moslems converted to Christianity. The family name, unusual in Spain, stems from the Catalan word "adalil", which in turn has its roots in the Arabic and means "leader".[11]

Dalí's grandfather, Galo Dalí Viñas, committed suicide at the age of thirty-six after losing all his money speculating on the stock-exchange. Dalí's father grew up in the home of his sister and her

husband, a Catalan nationalist and atheist. His influence over his young brother-in-law was considerable: vocationally, Dalí's father followed in his footsteps, choosing to study law, and matured into an anti-Catholic free thinker. Because of this, he decided not to send his son Salvador to a church school, as would have befitted his social status, but to a state school. Only when Salvador failed to reach the required standard in the first year did his father allow him to transfer to a Catholic private-school of the French "La Salle" order.

There, among other things, the eight-year-old learned French, which was later to become his second mother tongue, and received his first lessons in painting and drawing. In 1927, in the magazine *L'Amic de les Arts*, Dalí wrote about the brothers of the order, saying they had taught him the most important laws of painting: "We painted some simple geometrical forms with watercolours, sketched out beforehand in black right-angled lines. The teacher told us that good painting technique in this case, and in general, good painting consists of the ability to not paint over the lines. This art teacher [...] knew nothing about aesthetics. However, the healthy common sense of a simple teacher can be more useful to an eager student than the divine intuition of a Leonardo."[12]

At about the same time as Salvador was receiving his first lessons from the brothers of the "La Salle" Order, he set-up his first

12. Salvador Dalí: *Reflections*, in: *L'Amic de les Arts* of 31st August, 1927. Quote from: *Catalogue 1979*, p. 44.

Above: *Portrait of Ana María*, c. 1924
Oil on cardboard. 55 x 75 cm
The Gala-Salvador Dalí Foundation, Figueras

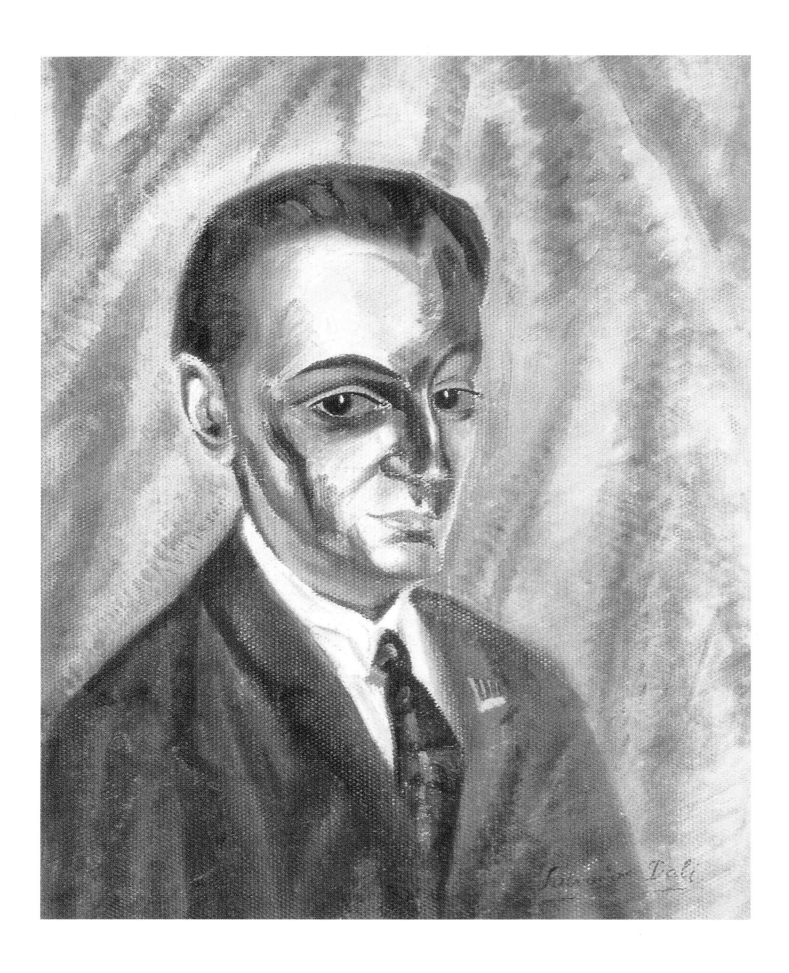

Above: *Portrait of José Torres*, c. 1920
Oil on canvas. 49.5 x 39.5 cm
Museum of Modern Art, Barcelona

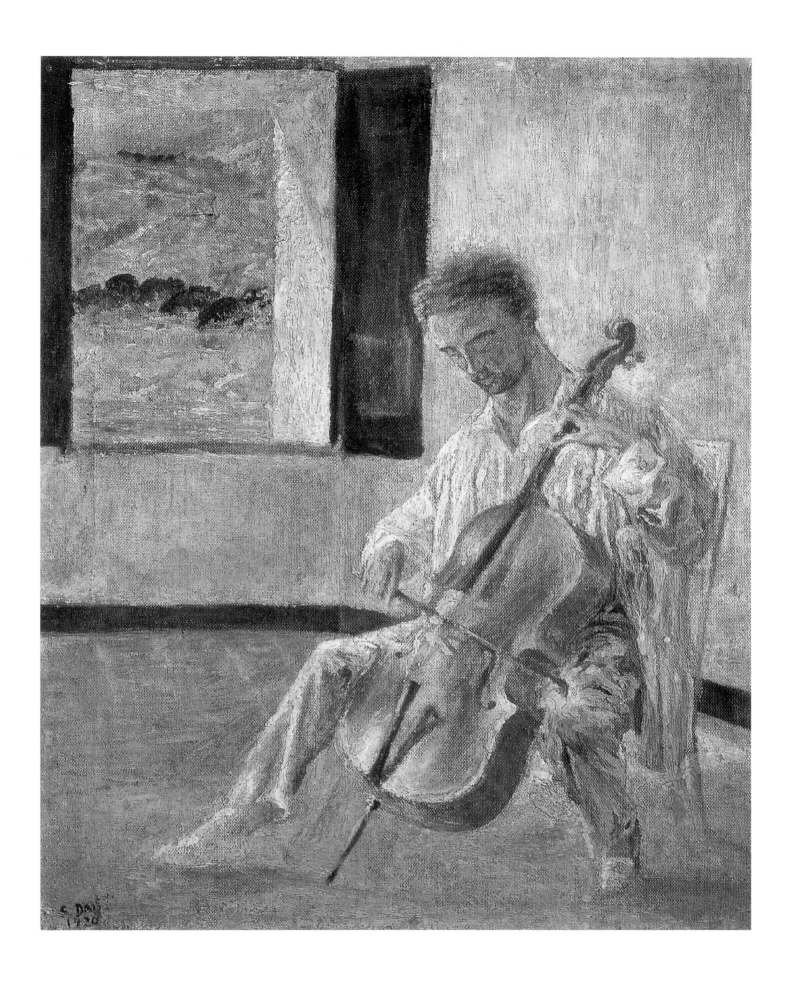

Above: *Portrait of the Cellist Ricardo Pichot*, 1920
Oil on canvas. 61.5 x 49 cm
Private collection, Cadaqués

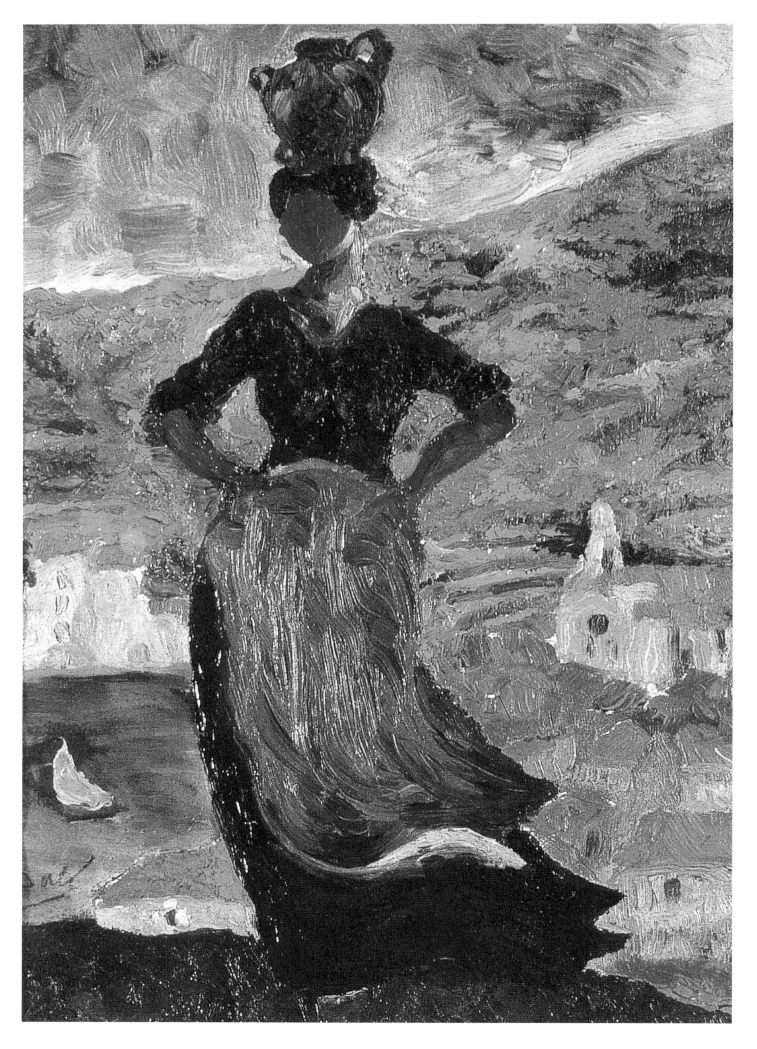

18

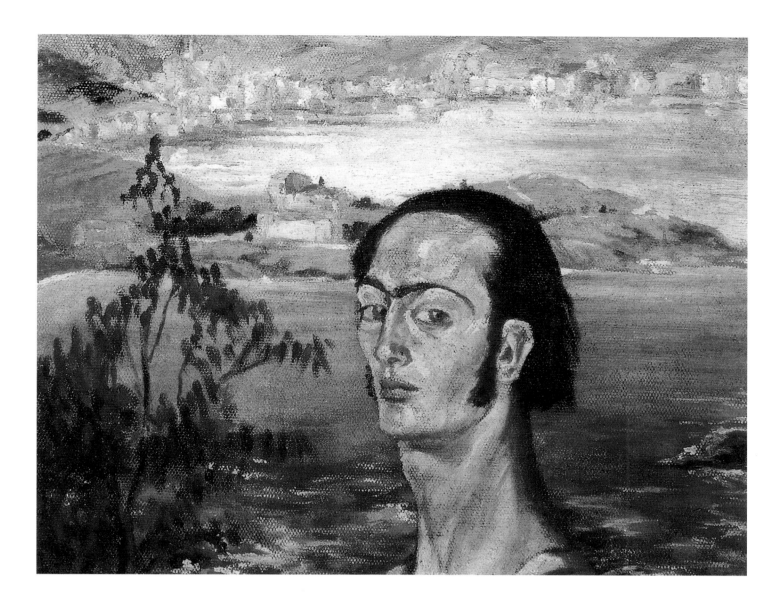

atelier in the old, disused wash-room in the attic of his family home: "I placed my chair in the concrete basin and arranged the high-standing wooden board (that protects washerwomen's clothing from the water) horizontally across it so that the basin was half covered. This was my workbench! On hot days I sometimes took off my clothes. I only needed then to turn on the tap, and the water that filled the basin rose up my body to the height of my belt."[13]

Apparently Dalí painted his first oil painting in this wash-basin. The oldest existing works, however, date from the year 1914. They are small-format watercolours, landscape studies of the area around Figueras. Oil paintings by the eleven-year-old also exist, mostly as copies of masterpieces which he found in his father's well-stocked collection of art books, and in particular the *Gowan's Art Books*. Salvador spent many hours studying the reproductions and was particularly enthusiastic about the nudes of Rubens and Ingres.[14]

For Salvador, the atelier became the "sanctuary" of his lone-liness: "When I reached the roof I noticed that I became inimitable again; the panorama of the city of Figueras, which lay at my feet, served most advantageously for the stimulation of my boundless pride and the ambitions of my lordly imagination."[15]

13. Dalí: *The Secret Life...*, p. 92 f
14. Cf.: Gibson: *Salvador...*, p. 54
15. Dalí: *The Secret Life...*, p. 96

Opposite page: *Portrait of Hortensia, Peasant Woman from Cadaqués*, 1920
Oil on canvas. 35 x 26 cm
Private collection

Above: *Self-Portrait with the Neck of Raphaël*, 1920-1921
Oil on canvas. 41.5 x 53 cm
The Gala-Salavdor Dalí Foundation, Figueras

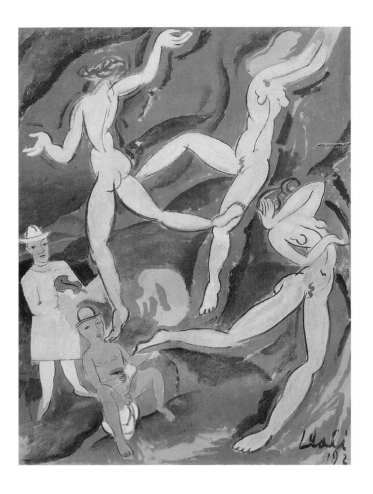

16. Dalí: *The Secret Life...*, p. 95
17. Television interview from 1975

Above on the left: *Satirical Composition ("The Dance" by Matisse),* 1923
Gouache on cardboard. 138 x 105 cm
The Gala-Salvador Dalí Foundation, Figueras

Above on the right: *Self-Portrait,* 1923
Indian ink and pencil on paper
31.5 x 25 cm
Collection of the Estalella Brothers, Madrid

His parent's home was one of the largest in the city. In the laundry room-atelier the little king tried out a new costume: "I started to test myself and to observe; as I performed hilarious eye-winking antics accompanied by a subliminal spiteful smile, at the edge of my mind, I knew, vague as it was, that I was in the process of playing the role of a genius. Ah Salvador Dalí! You know it now: if you play the role of a genius, you will also become one!"[16]

Later Dalí analysed his behavior: "In order to wrest myself from my dead brother, I had to play the genius so as to ensure that at every moment I was not in fact him, that I was not dead; as such, I was forced to put on all sorts of eccentric poses."[17]

His parents supported this eccentric behavior by showering him with extra attention. They told their friends proudly that their son was alone "up there" for hours painting. For Dalí, the expression "up there" became the symbol of his extraordinary standing.

Salvador's attempts to distance himself from his dead brother went so far that he believed himself immortal. Descending the stairs one day at school, it suddenly occured to him that he should let himself fall. But at the very last moment fear held him back. However, he worked out a plan of action for the next day: "At the very moment I was descending the stairs with all my classmates, I did a fantastic leap into the void, and landing on the steps below bowled over and over until I finally reached the bottom. I was thoroughly shaken and my whole body was crushed, but an intense and inexplicable joy made the pain seem incidental. The effect on the other boys and the teachers who ran over to help me

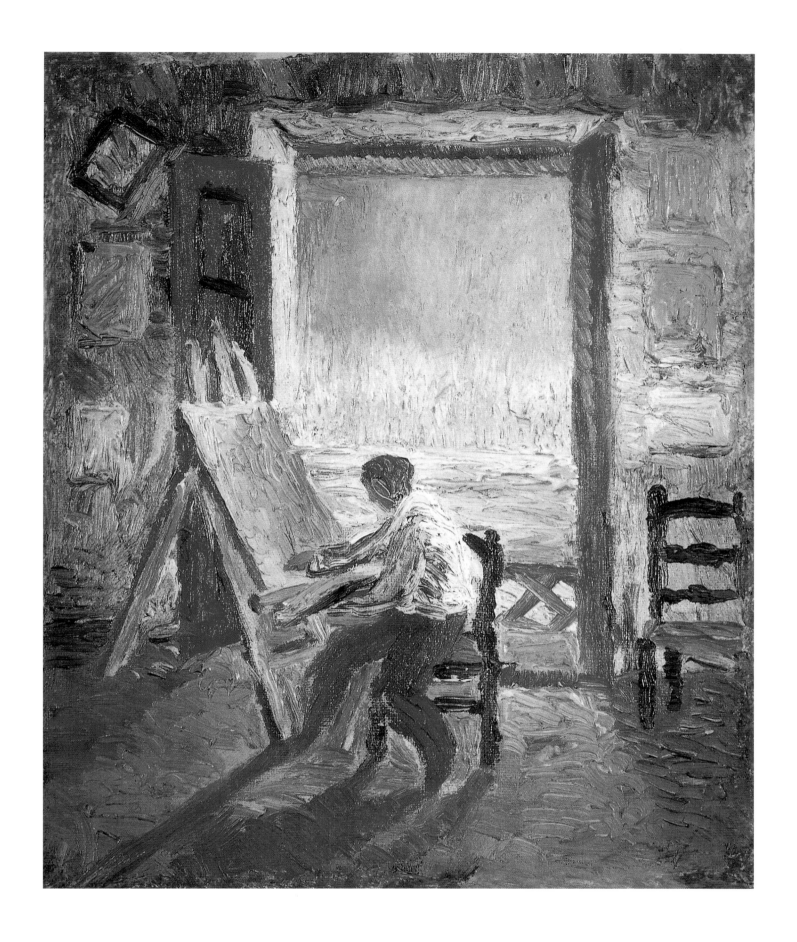

Above: *Self-Portrait in the Studio,*
c. 1919
Oil on canvas. 27 x 21 cm
The Salvador Dalí Museum,
St Petersburg (FL)

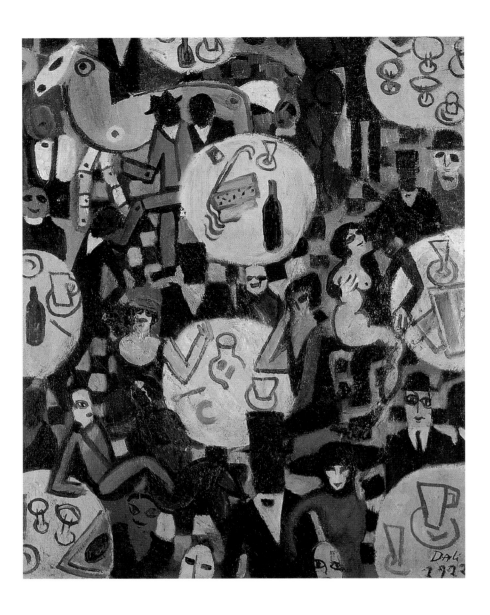

was enormous. [...] Four days later I repeated the action again but this time I launched myself from the top during the long break, just as the school-playground was at its most animated. [...] The effect of my plunge was even better than the first time: before I let myself go, I let out a piercing scream, making everybody turn and look. My joy was indescribable, and the pain caused by my fall was, in comparison, a mere trifle. This spurred me on to continue my ventures and from time to time I repeated the stunt. Each time, just as I was descending the stairs a huge tension prevailed. Will he jump or won't he? What fun it was to walk down quietly and normally and to know that at that moment a hundred pairs of eyes were fixed on me in greedy anticipation."[18]

The ability to attract the attention of the others, and to be subsequently admired by them afforded the little king Salvador untold enjoyment. However, he did prefer it when his "entourage" kept their distance. From his window in the laundry room-atelier he spied on the other children, particularly the schoolgirls from the neighbouring school. Once, on the way home, three girls were walking in front of him. The one in the middle, nicknamed "Dullita" by her friends, walked straight ahead without turning around, while the others looked around at the boy giggling. For Salvador, Dullita became the proud one; striding ahead, she was his

18. Dalí: *The Secret Life...*, p. 29.

Above: *Scene in a cabaret*, 1922
Oil on canvas. 52 x 41 cm
Bénédicte Petit Collection, Paris

Opposite page: *Cubist Self-Portrait*, 1923
Gouache and collage on cardboard
104.9 x 74.2 cm
Reina Sofia Art Centre, Madrid

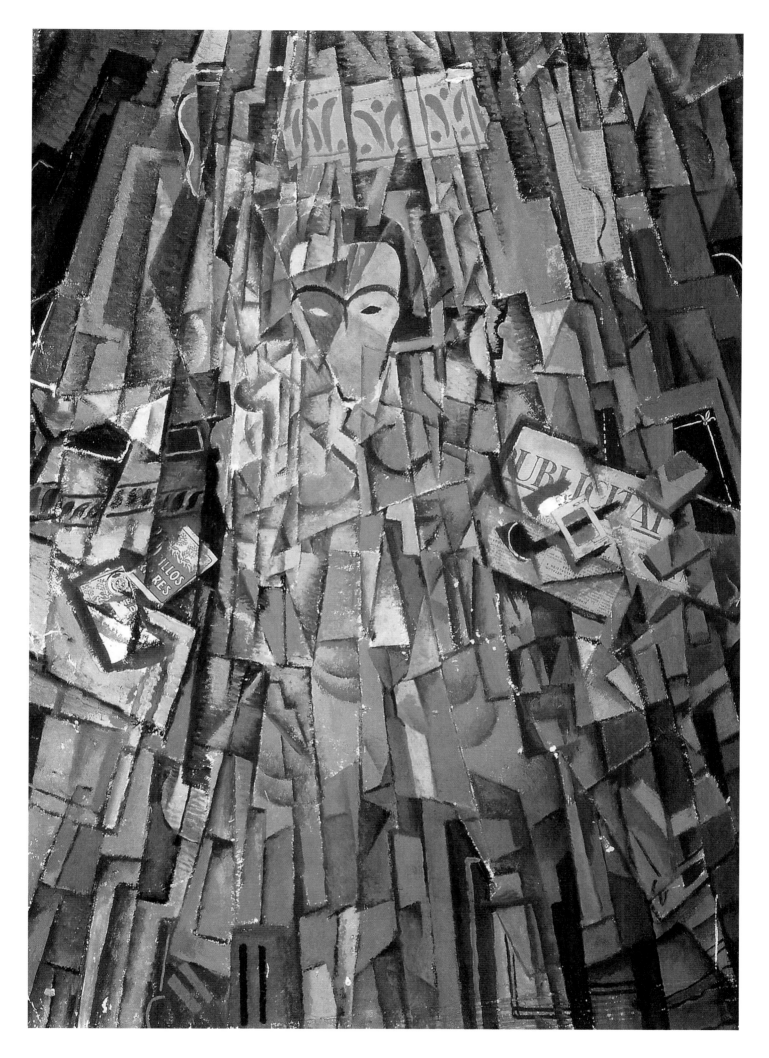

23

queen. From the attic window he watched out for her in vain. But he never saw her again, and in his memories she appears as simply a narrow back with such a small waistline that both body-halves appear detached from one another. In his fantasies this view of her back becomes transformed into an expression of erotic longing that cannot be fulfilled, since Dullita did not turn around. In order to avenge her, he dreamt of crushing her like an eggshell.

In the summer of 1916, the twelve-year-old was sent on holiday to the estate of some family friends, the Pitchots. The "Mulí de la Torre" estate, named after its tower-mill, and just a few kilometers from Figueras, was to become a place of magic for Salvador. For weeks he gave himself up to his day-dreams undisturbed, a reverie for which he only had the odd single hour in Figueras in his laundry room-atelier. Most of his fantasies at this time were of an erotic nature.

One day he found an old crutch in the store-room at the mill and took it with him as a plaything. Finding a dead hedgehog a little while later, he used the crutch to inspect the carcass. Worms had already devoured the animal's body and Salvador was overcome by a sickening feeling of disgust, that transfered itself from the hedgehog onto the crutch. He thought of a way to try and "clean" it. Observing some women on the estate who are picking lime-blossoms, he set himself the task of touching the breast of one of the women with the sullied crutch. All afternoon he worked out a complicated plan, finally managing to carry out this "erotic act" successfully on one of the countrywomen.

Salvador decided to turn this countywoman's daughter into his new Dullita. With the help of a toy, a diabolo, Salvador lured her into the mill tower. And there, while leaning over the balustrade, he was reminded of the back of the first Dullita and of his wish to destroy: "There sat Dullita, with her back to me again, her legs hanging into nothing, her palms resting on the balustrade [...] With great caution, I pushed the fork of my crutch in the direction of the narrowest part of Dullita's waist [...]. As if sensing the touch of my crutch in advance, Dullita turned towards me, not surprised or startled in any way, and pushed herself against it of her own free will."[19] At this point Salvador hurled the diabolo into the depths instead of the girl, in an attempt to try and hurt Dullita just a little. He had given the toy to her as a present shortly before.

From this day onwards, the crutch became the "symbol of death" for Dalí, as well as the "symbol of resurrection."[20] Eroticism and death become unified very early in Dalí's life. In his imagination, the adolescent killed his lovers but in reality this wish manifested itself in other forms of cruelty. The thirteen-year-old tormented his first girlfriend in Figueras with the premonition that he would leave her in exactly five years.

Salvador terrorised other children just for fun. Once he kicked one of his classmate's violin to pieces. His enjoyment of these attacks on his classmates, as he later analysed it in his autobiography, originated from the sensation of fear experienced during the execution of his sadistic plans.

But he was also made the victim of a similar type of cruelty: "Once my cousin deliberately squashed a big locust on my neck. I

19. Dalí: *The secret Life...*, p. 142
20. Dalí: *The secret Life...*, p. 142

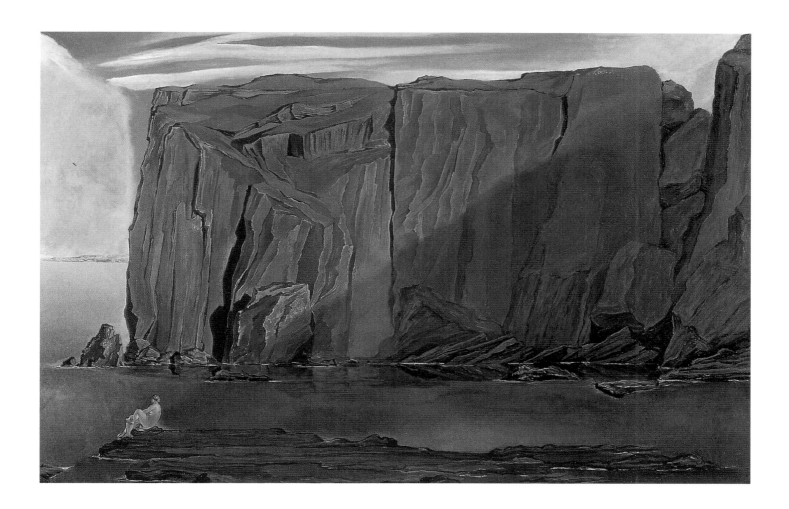

sensed the same untold sliminess that I had felt with the fish; and although squashed and covered with a disgusting sticky liquid, half crushed, I could still feel it moving between my shirt-collar and my skin, and its serrated legs clawed with such power at the nape of my neck, that I sensed they would rather tear off than loosen their death-grip."[21] On discovering his horror of locusts, his classmates continually put squashed specimens between the pages of his reader. Salvador saved himself a trick: he fools them into believing that he found folded paper cocks more disgusting. His classmates believed him and now ribbed him with something that in reality left him totally unmoved.

From a net of fantasies centered around eroticism, death, and disgust, Dalí only managed to save himself by his own mental agility. During puberty, and wholly without any system, he began to read through his father's extensive library. He occupied himself especially with the philosophers Voltaire, Nietzsche, Descartes, and Spinoza; but without doubt his favourite was Kant: "I understood almost nothing of what I read, but this in itself was enough to fill me with pride and gratification. I loved very much to lose myself in the labyrinth of his avenues of thought, in which the ever expanding crystals of my youthful intelligence found true heavenly music reflected."[22]

At the same time he wrote his own philosophical work, to which he lent the title *The Tower of Babylon*: "I had already written five-hundred pages and still had not finished the prologue! At the time, my sexual appetite vanished almost completely, and

21. Dalí: *The secret Life...*, p. 160
22. Dalí: *The secret Life...*, p. 173

Above: *Penya-Segats (Woman on the Rocks)*, 1926
Oil on olive panel. 26 x 40 cm
Private collection

the philosophical theories of the book occupied the whole span of my psychic activity."[23]

Despite this monopolisation by philosophy, Dalí also occupied himself with art history and continued his attempts at painting. His father supported him by buying him canvas, brushes, paints and magazines. However, a more important role as sponsor was taken over by Pepito Pitchot, who recognized the talent of the twelve-year-old during the summer at the mill tower. At the Pitchots, Dalí saw impressionistic paintings for the first time. They were painted by Ramon, Pepito's brother, who lived in Paris: "The pictures that amazed me most of all were the newest, where on some canvases the flowing impressionism simply took on a unified pointillist pattern in the end. The methodical parallel of orange and violet engendered a kind of illusion and joy in me."[24] In an atelier that Pepito set up for him in a barn, Dalí painted in the impressionist style landscapes of the type he had seen on Ramon Pitchot's paintings. However, he also developed his own ideas. One day, for example, he attached real cherry-stems to his paintings of cherries. Pepito Pitchot was impressed by this idea; so much so that he promised to talk Señor Dalí into allowing Salvador to receive lessons in painting.

In the coming school year Dalí changed to the private Marist high-school, a Catholic missionary order. In addition, he visited Juan Nuñez's painting-class at the city art-school. As Dalí later stated, he owed much to this teacher: "I remember the precious hours that he devoted to me, describing the subtlety of light and dark in an original Rembrandt embroidery that he owned. With

23. Dalí: *The secret Life...*, p. 186
24. Dalí: *The secret Life...*, p. 107

Above: *Figure on the Rocks (Sleeping Woman)*, 1926
Oil on plywood. 27 x 41 cm
The Salvador Dalí Museum,
St Petersburg (FL)

Above: *The Girl of Ampurdán*, 1926
Oil on plywood. 51 x 40 cm
The Salvador Dalí Museum,
St Petersburg (FL)

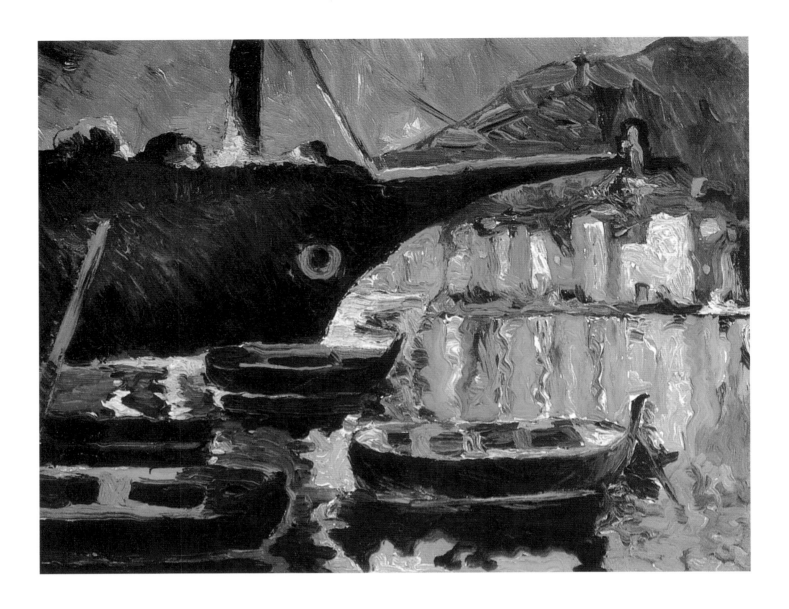

25. *Salvador Dalí: Becoming the Man.*
Compiled and presented by André
Parinaud, Munich among others, 1976,
p. 48
26. *Catalogue 1994*, p. 20

Above: *Port of Cadaqués (Night)*, 1919
Oil on canvas. 18.7 x 24.2 cm
The Salvador Dalí Museum,
St Petersburg (FL)

his mystic belief in art, he understood how to convince me of the
importance of the painter's work and how to strengthen my own
belief in my brilliant aptitude."[25]

By this time the boy was convinced that he wanted to become
a painter. Fundamentally, his father had nothing against this; how-
ever he insisted on a formal training: first the high school diploma,
then study at the vocational school of art, sculpture and graphics
in Madrid.

In the winter of 1918/1919, Dalí took part in a group exhibi-
tion of artists from Figueras. In the local newspaper, the fourteen-
year-old was celebrated as an up-and-coming "master painter".[26]

Dalí spent the following summer in Cadaqués, his father's
birthplace on the Costa Brava. The family had a little holiday
house there. Cadaqués was a place which Dalí loved "with fanati-
cal loyalty" the whole of his life: "without exaggerating in the
least, I can say without doubt, that I know each contour of the
rocks and beaches at Cadaqués. I have learned each geological
anomaly of its singular landscape and light by heart. [...] Each hill,
each contour of rock could have been drawn by Leonardo himself!
Besides structure there is practically nothing. Almost no
vegetation. Only the extremely tiny olive-trees, whose silver-yellow
colours crown the hill like greying, venerable hair on the philo-

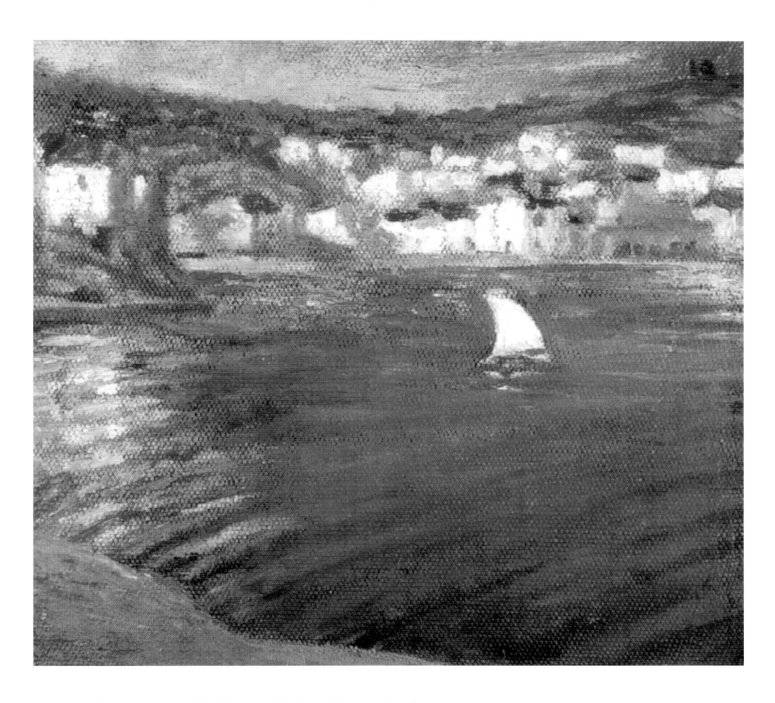

sophical forehead, wrinkled by parched rivulets and rudimentary paths half masked by thistles."[27]

On February 6th, 1921, Felipa Doménech died. The father promptly married his deceased wife's sister, Catalin, who had already been living in his household for the last eleven years. For Dalí, the death of his mother was "the worst blow of my whole life. I worshipped her; for me she was unique. [...] Weeping and with clenched teeth I swore that with all the power of the holy light which one day would circle my glorious name I would rescue my mother from death and from fate."[28]

The sixteen-year-old planned his fame in detail: first he wanted to go to the vocational school of art, sculpture, and graphics in Madrid for three years, win a prize, and then continue his studies in Italy. Before departing for Madrid after having successfully completed his high school diploma, Dalí presented eight paintings at a group-exhibition held by the Catalan student-union in Barcelona's Dalmau gallery. In the local press the young painter was confirmed as having extraordinary talent: "Dalí is on the road to great success."[29]

27. Dalí: *The Secret Life...*, p. 156 ff
28. Dalí: *The Secret Life...*, p. 187
29. *Catalogue 1994*, p. 23

Above: *Landscape near Cadaqués,* 1920-1921
Oil on canvas. 31 x 34 cm
The Gala-Salvador Dalí Foundation, Figueras

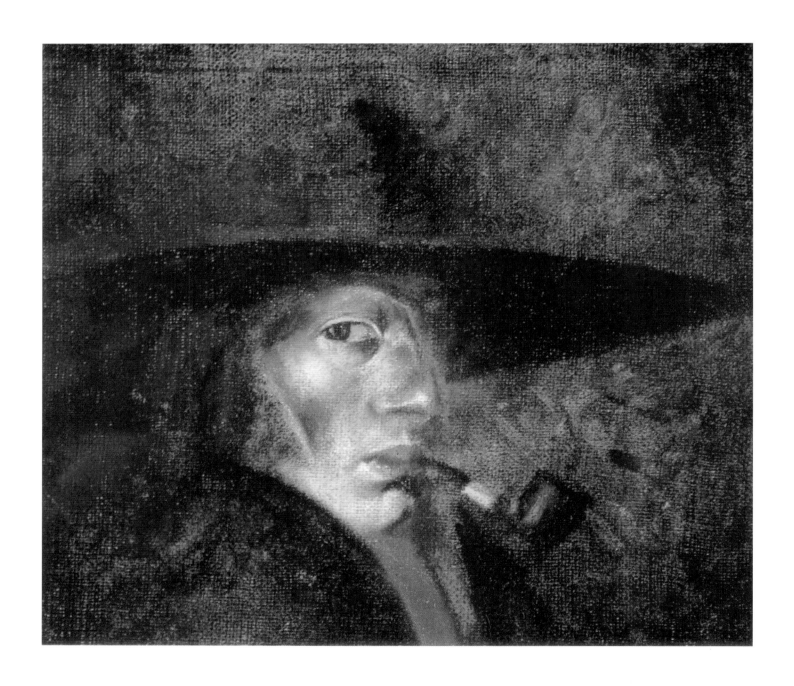

Above: *Self-Portrait*, c. 1921
Oil on canvas. 36.8 x 41.8 cm
The Salvador Dalí Museum,
St Petersburg (FL)

From Outsider to Dandy

The Student Years in Madrid

In the autumn of 1922, accompanied by his father and his sister Ana Maria, the eighteen-year-old traveled to the entrance examination at the art school in Madrid. For over six days, the applicants had to prepare a drawing of a classical sculpture. Dalí's model was a cast of *Bacchus* after Jacopo Sansovino. In his autobiography Dalí reported that each day in this week his father waited for him in the school courtyard full of impatience and worry. Often he chatted with the caretaker, who on the third day told him that Salvador would not pass the examination because he had failed to pay heed to the regulations: his drawing was too small. Thereupon the notary persuaded his son to start afresh. Dalí rubbed out his drawing and started to retrace his marks, this time larger. However, he could not get the proportions right and wasted a further two days rubbing out his efforts. On the last day he began again and finished his drawing in just one hour. However, his drawing was now even smaller than before. Nevertheless, the examination commission decided to accept him: his work was perfect.

Dalí moved into a room at the "Residencia de Estudiantes", a student residential and cultural centre based on the Oxford and Cambridge model. At the beginning of the twenties a group of Spain's literary and artistic offspring lived there; amongst others, Luis Buñuel, Federico Garcia Lorca, Pedro Garfias, Eugenio Montes, and Pepin Bello.

Dalí kept to himself and cultivated his role as a loner: he let his hair grow long, and dressed himself in short trousers, a long cape and a big, black felt hat. In the morning he attended his courses at the academy, and in the afternoon and evening he worked in his room: "My life was limited to my studies. [...] I shunned the groups that met in the hostel, and always went directly to my room, where I locked myself in and continued with my studies. [...] My relatives, who had been informed of my lifestyle by the director [...], were worried about my ascetic behavior, something that everybody found unnatural."[30]

The young student did not hold many of his teachers at the academy in very high esteem; for him they were too modern. "I understood immediately that these old professors, even with their rows of honours and awards, could not teach me anything. This did not lie in their academic nature or philistine manner, but on the contrary in their revolutionary thinking, in their ability to receive and accept everything new. I had expected barriers, sternness, and

30. Dalí: *The Secret Life...*, p. 195

31

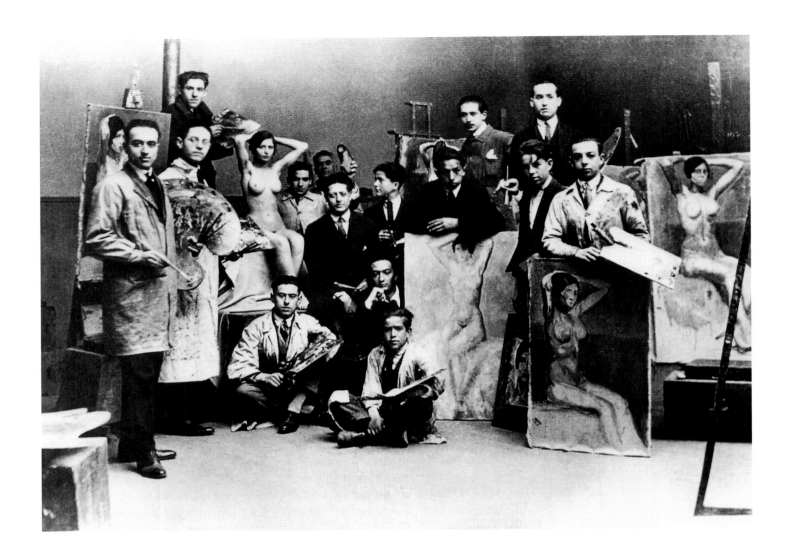

science. Instead I was offered freedom, laziness, new approaches!"[31] In order to illustrate the inefficiency of his teachers, Dalí reports that even on a question of craftsmanship, or in the case relating to the ratio of mix for oil colours, the professors would state that no rules existed; that the interpretation and temperament of the artist alone was crucial. At the same time Dalí criticized the professors for their inability to let go of French impressionism and their lack of attention to the newer developments in art, such as cubism.

In his private studies, Dalí read the writings of Georges Braque and bought reproductions of his pictures. He attempted to apply the new teachings on form to canvas. One day, one of his fellow students, Pepin Bello, discovered two cubistic paintings in his room. Bello belonged to a literary-artistic circle, and he informed them of his findings immediately. Dalí explained: "they all came to look at my pictures at once. And with the snobbery that they so openly carried, they clasped their hands to their breasts, their admiration greatly exaggerated – their amazement knowing no bounds."[32]

Up to this point Dalí had been considered a reactionary eccentric. Of all people, nobody had suspected that he could be so well-informed of the newest events in Paris, the great art-metropolis. The two paintings that caused so much astonishment no longer exist today. Dalí had applied a distemper a little too thickly, so that the ground later split.

31. Dalí: *The Secret Life...*, p. 196
32. Dalí: *The Secret Life...*, p. 214

Above: Dalí at the school of Fine Arts in San Fernando in Madrid, during the 1922-1923 school year

Dalí's life changed following this discovery. The interest the others showed in him suddenly transformed him: the lone wolf metamorphosed and a dandy was born. He cut his hair and bought the most expensive suit he could find, including an azure silk-shirt and cuff-links inlaid with sapphires, at the most elegant men's outfitters in Madrid. After four months of ascetic studies Dalí began the life of a Bohemian. Instead of attending painting-classes he now went to restaurants and bars. In the literary-artistic circles at the Café de Pombo he met Luis Buñuel, later to become film-director, and the poet Federico Garcia Lorca.

The round of conversations at the café reinforced Dalí's interest in philosophy and literature. There he encountered a new area of interest: psychoanalysis. In 1923, Sigmund Freud's *The Interpretation of Dreams* appeared in Spanish. Dalí began reading it immediately and used it to analyse his own dreams.[33]

At the beginning of his second year of studies, Dalí was gated from the academy for twelve months. During an official event, when the new post for the Chair of Painting was to be announced, a fracas broke out because the candidate favoured by the students had not been chosen. Although he had left the hall during the director's speech, Dalí was held responsible for the protest. From a moral point of view, Dalí did consider himself responsible, even though he wanted to have nothing to do with the actual attack.

Exclusion from classes did not trouble him. He firmly believed that the professors were incapable of teaching him anything. He first remained in Madrid and began to study sketching nudes at the "Free Academy", which had been founded previously by the painter Julio Moisés. At the beginning of 1924 he returned to Figueras. Elections were taking place and Dalí's father had stood against the dictator Miguel Primo de Rivera. Well known for his anarchistic activities his son was arrested on arrival and thrown into gaol for a month: "This period of detention amused me enormously. Naturally, I was placed with all the political captives, while their friends, their comrades and their relatives showered us with gifts. Each evening we drank very poor, local sparkling wine."[34]

Following his release due to lack of evidence, Dalí remained at his parents' home until the autumn. His sister, Ana Maria, became his preferred model. He painted rear views of her either standing or sitting at the open window.

In October 1924, he returned to the academy and continued his bohemian life; in a vain attempt at control, his father tried to discipline him by shortening his allowance.

The following months were to become a milestone in Dalí's rise to fame. In May 1925, he took part in the "First Iberian Artists' Art-Salon" with ten paintings, amongst them a portrait of his friend Luis Buñuel that he had painted in 1924. In November, the Dalmau gallery in Barcelona presented the first single-showing of Dalí's paintings. A critic already recognized the "systematic repression of the emotions" in these works but at the same time found it unsuccessful – the "objective coldness" was broken by a "sensitive, soft shimmer". In his *Portrait of my Father*, he saw a

33. Cf.: Dalí: *The Secret Life…*, p. 206 ff
34. Dalí: *The Secret Life…*, p. 244

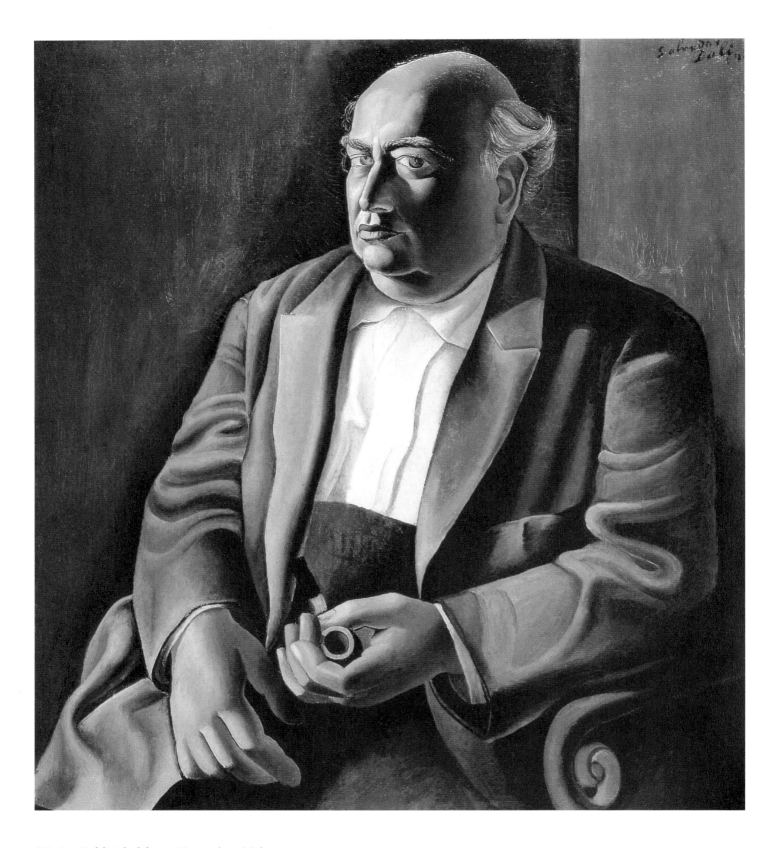

35. *La Publicidad* from November 20th, 1925. Quote from: *Catalogue 1979*, p. 42 f

Above: *Portrait of My Father*, 1925
Oil on canvas. 100 x 100 cm
Museum of Modern Art, Barcelona

Opposite page: *Seated Girl from the Back*, 1925
Oil on canvas. 103 x 73.5 cm
Reina Sofia National Museum, Madrid

"sensitive sweetness [...] the same as in the landscapes of Cézanne."[35]

Regardless of whether this characterization of his works at the time is justifiable or not, the critic is mistaken in his identification of the direction that Dalí's work will take: it is not the restrained sensitivity that pushes through in the following years, but the repression of the emotions. Dalí rejected all emotion in his painting: "In my opinion, exalted things can only be exalted when one frees them from every emotion. Emotion is one of the most banal, perhaps even one of the lowest components of everyday

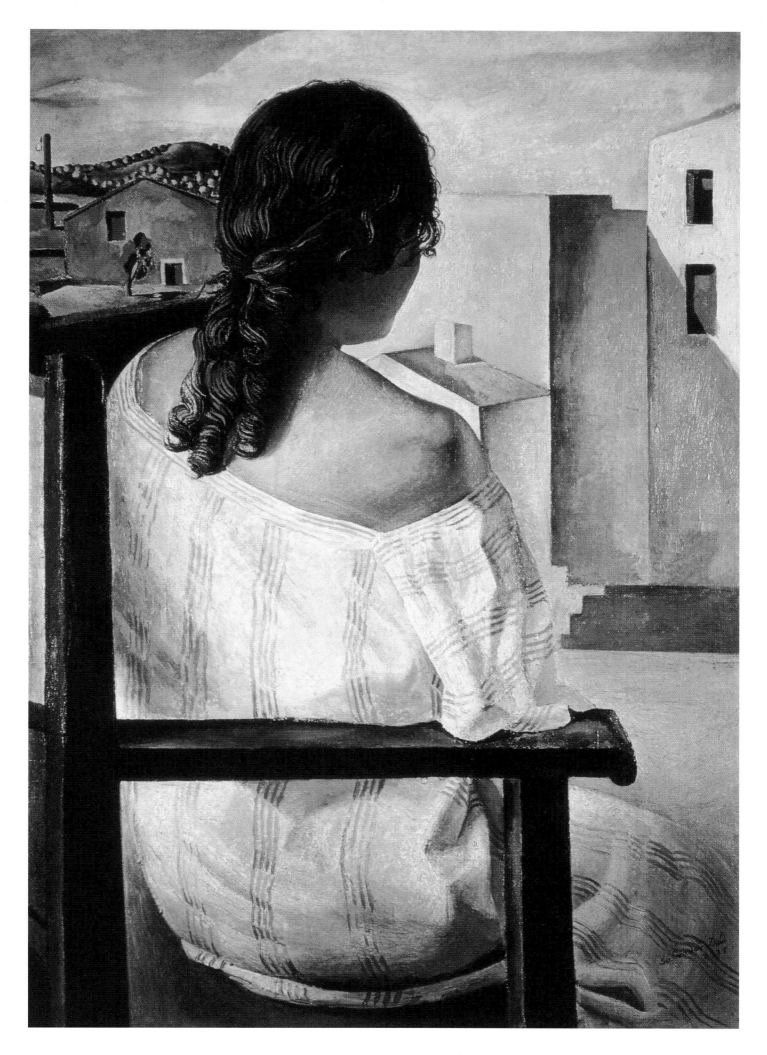

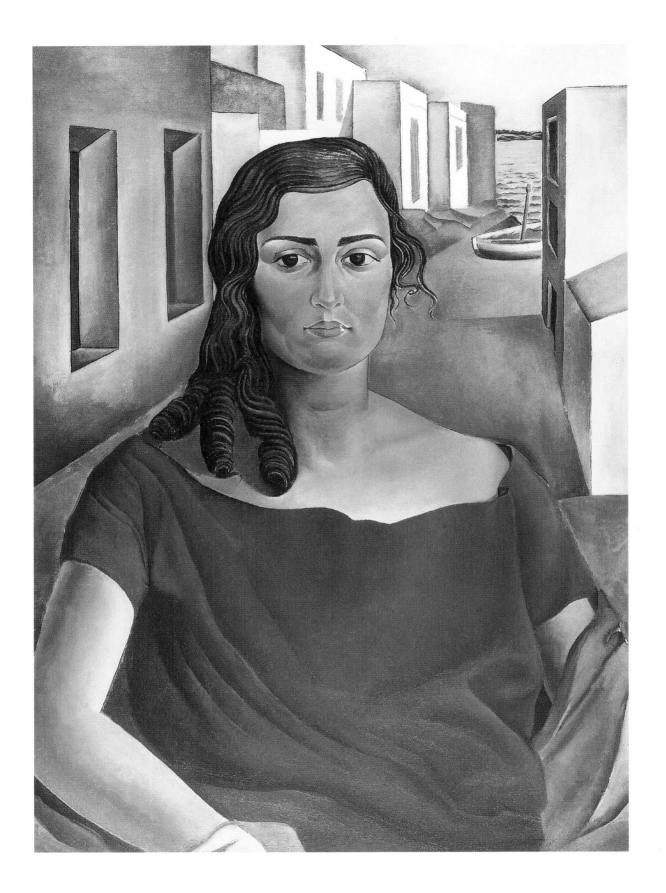

Above: *Portrait of a Girl in a Landscape*,
1924-1926
Oil on canvas. 92 x 65 cm
The Gala-Salvador Dalí Foundation,
Figueras

Opposite page: *Figure at a Window*,
1925
Oil on canvas. 103 x 75 cm
Reina Sofia National Museum, Madrid

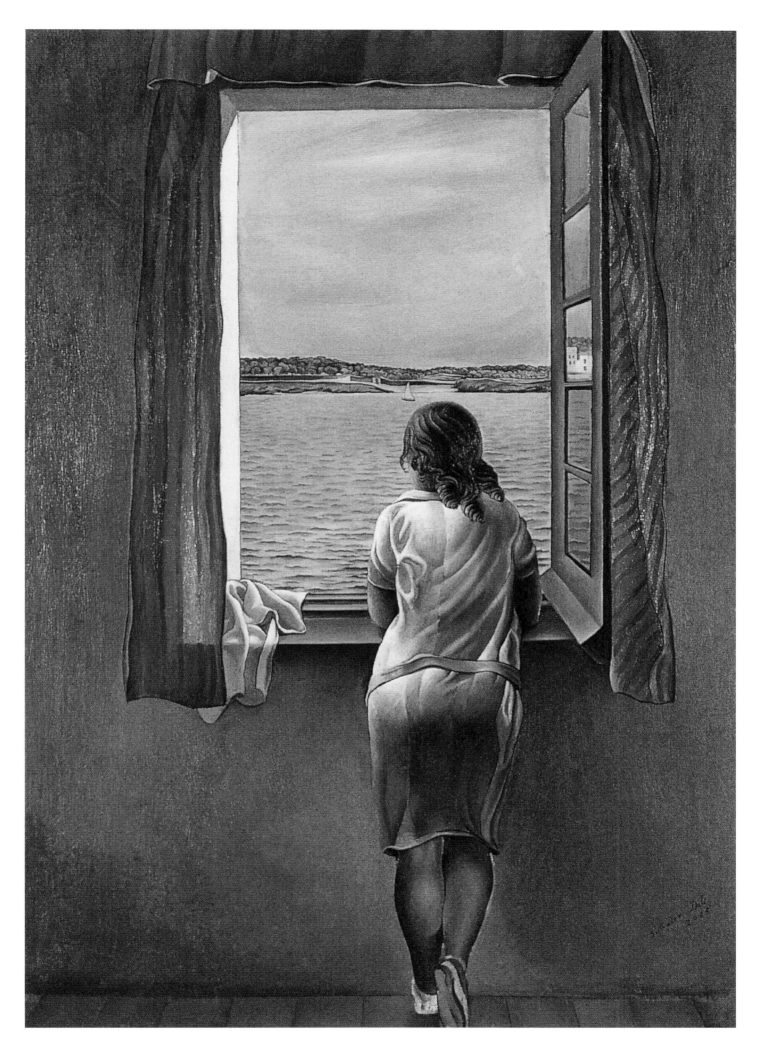

38

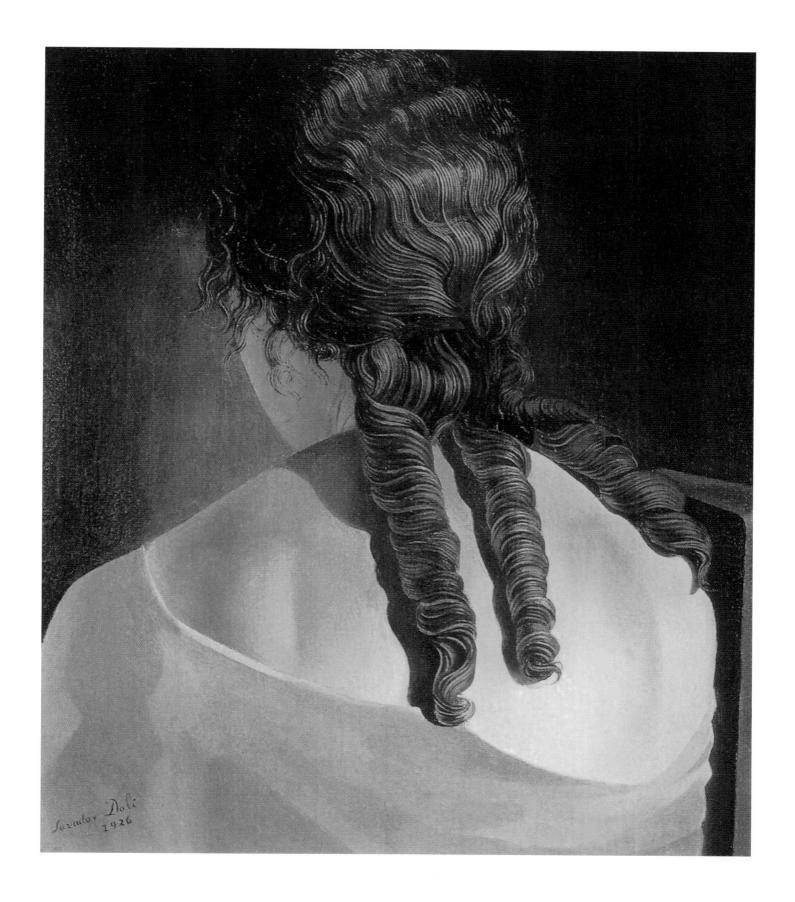

Opposite page: *Girl Sewing (Study for "Ana Maria")*, 1926
Pencil on paper. 53 x 32.5 cm
The Gala-Salvador Dalí Foundation,
Figueras

Above: *Girl from the Back*, 1926
Oil on panel. 32 x 27 cm
The Salvador Dalí Museum,
St Petersburg (FL)

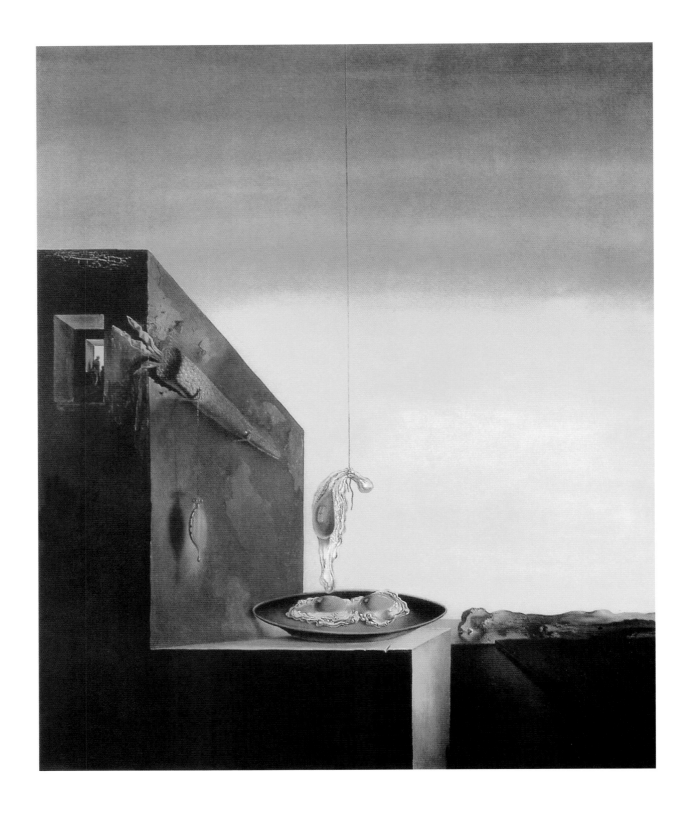

36. Bosquet: *Discussions...*, p. 30
37. Cf.: Television interview in 1975

Above: *Fried Eggs on the Plate without the Plate*, 1932
Oil on canvas. 60 x 42 cm
The Salvador Dalí Museum,
St Petersburg (FL)

life."[36] Also the comparison with Cézanne could hardly have flattered Dalí; he held the father of the modern to be a highly overrated painter, who could not even draw an apple properly.[37]

Among the most renowned visitors at the exhibition was Pablo Picasso. The forty-one-year-old was especially taken by the painting *Young Girl Standing at a Window*. Six months later, Dalí travelled to Paris and visited his famous countryman: "As I entered Picasso's apartment in the rue de la Boétie, I was so deeply moved and full of respect, it was as if I was at an audience with the Pope. [...] I had brought a small, carefully wrapped painting with me, *The Girl from Figueras*. He looked at it for at least fifteen minutes without making any comment. Then we went up one floor, where

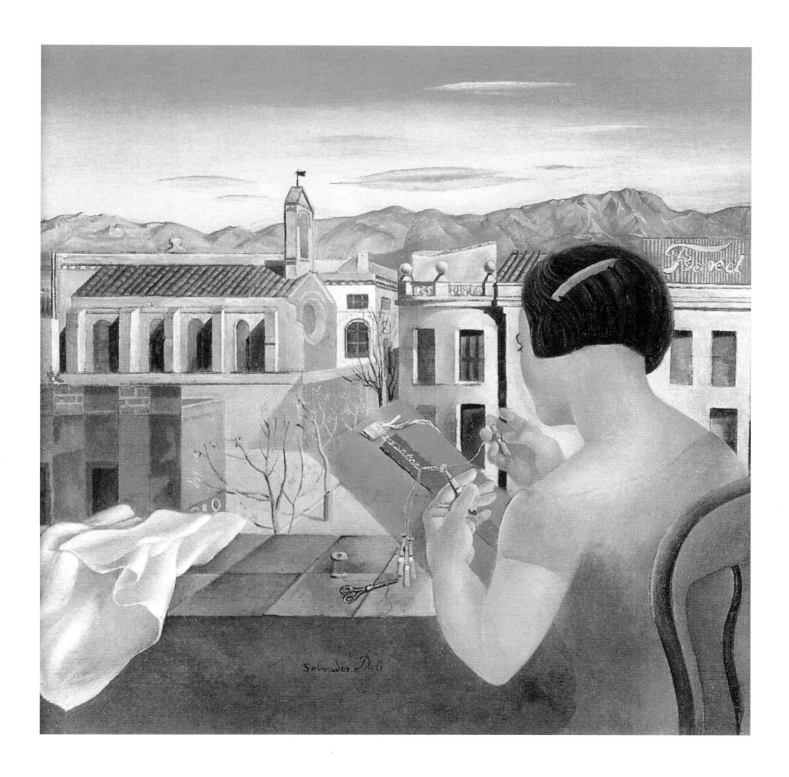

Picasso showed me numerous pictures of his own for two hours. [...] Before showing me each new canvas he threw me a look of such vivaciousness and intelligence that I began to tremble."[38]

Dalí's high regard for Picasso did not last long. Later he was to claim that just one of his own paintings was a thousand times better than the whole of Picasso's work together.[39]

Shortly after his return from Paris, the final examinations took place at the art school. Dalí denounced the examination commission as not being qualified to assess him. He was, once more, banished from the academy and returned to Figueras.

38. Dalí: *The secret Life...*, p. 254
39. Cf.: Bosquet: *Discussions...*, p. 7

Above: *Woman at the Window at Figueras*, 1926
Oil on canvas. 24 x 25 cm
Collection of Juan Casanelles, Barcelona

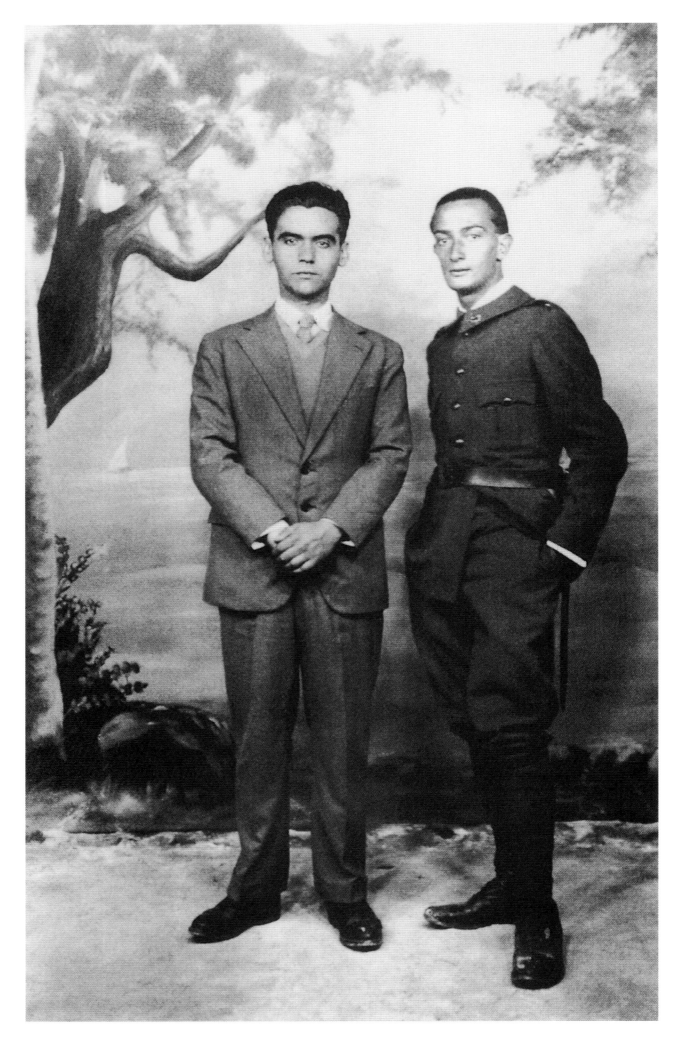

A Friendship in Verse and Still-Life

Dalí and Garcia Lorca

"It was an erotic and tragic love," Dalí wrote of his friendship with the poet Federico Garcia Lorca in a January of 1987 letter to the Spanish newspaper *El Pais*. "Tragic because it could not be divided."[40]

Both men had met in 1923 in Madrid but their close friendship only developed in 1925 during the Easter holidays when they travelled to Figueras and Cadaqués together. They took many hiking trips and, on these, were often accompanied by Dalí's sister, Ana Maria. Lorca was particularly taken by the countryside around Cadaqués: "The olive groves of Cadaqués. What a miracle! / Baroque bodies and gray souls."[41] At Dalí's home Garcia Lorca organised two readings from his first drama, *Mariana Pineda*.

After his departure, a lively correspondence developed between Garcia Lorca and Dalí but also with Ana Maria. Garcia Lorca wrote to her using tender words. Later, Dalí claimed more than once that the poet's love had been directed at him alone: "He was a known homosexual and madly in love with me. He tried to have me twice. It was very embarrassing for me because I was not homosexual and had no desire to give in. [...] However, from the point of view of prestige I felt very flattered. Deep down inside me I said to myself, he is a great poet and at the very least, I owe him just a little of the divine Dalí's arse-hole! But in the end he took a girl, and she stepped into my place in the role of victim."[42]

Dalí's letters to Garcia Lorca take on another tone; they are still free of all the cynicism that will later become the trade mark of the painter: "Dear Federico, I am writing to you in a mood of huge contentment and boundless peace. [...] Next to me at the window my sister is sewing laundry, in the kitchen jam is being made, and the people are talking of hanging out grapes to dry. I have been painting all afternoon. [...] You would not be able to imagine the way in which I have given myself up to my pictures, the tenderness with which I paint my open window, facing out to sea, with its rocks, my bread-baskets, my young girls sewing, my fish, and my sky, all like sculptures."[43]

From the correspondence between Dalí and Garcia Lorca, only the letters of the painter remain almost completely preserved, while most of the others were lost in the civil war.

In 1926, Garcia Lorca wrote the *Ode to Salvador Dalí*: "But above all I sing of our mutual ideas / that unite us in the dark and golden hours. / Art is not the light that blinds our eyes. / First it is love, or friendship or even the conflict."[44] In the same year, the

40. Rafael Santos Torroella: *Early Friendship at the Madrid Student Residency: Lorca – Dalí – Buñuel*, in: *Salvador Dalí. 1904-1989*. Catalogue for the exhibition of the same name at the city gallery Stuttgart, 1989, p. 1
41. Antonia Rodrigo: *The poet Garcia Lorca, the painter Dalí*, quote from: *Catalogue 1979*, p. 25
42. Bosquet: *Discussions...*, p. 26
43. Private archive of Garcia Lorca's family in Madrid, quote from: *Catalogue 1979*, p. 29 f
44. Federico Garcia Lorca: *Ode to Salvador Dalí*, quote from: *Catalogue 1979*, p. 36

Opposite page: Photography of Luis Buñuel and Salvador Dalí

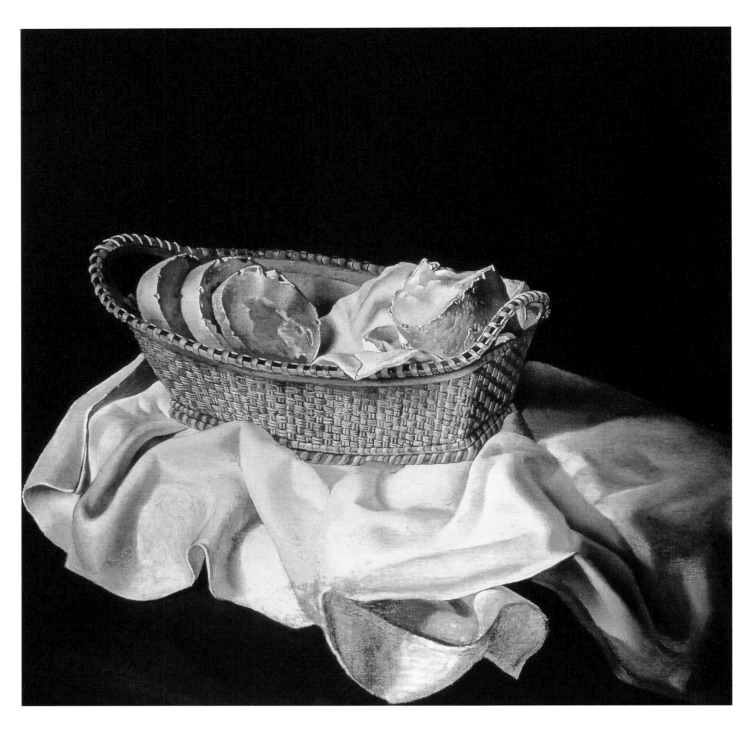

Above: *Basket of Bread*, 1926
Oil on panel. 31.5 x 31.5 cm
The Salvador Dalí Museum,
St Petersburg (FL)

Opposite: *Festival at San Sebastián*
Gouache on cardboard. 52 x 75 cm
The Gala-Salvador Dalí Foundation,
Figueras

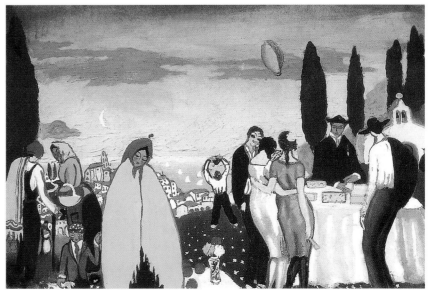

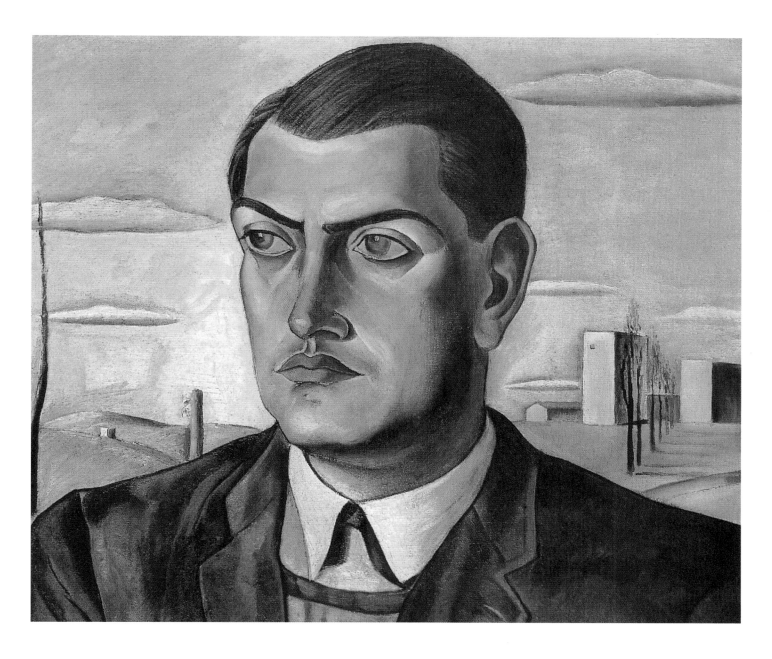

portrait *Still Life (Invitation to Sleep)* is painted. From a photo Ana Maria had taken of the sleeping poet in 1925, Dalí painted Garcia Lorca's head in the style of a Roman bust, where the plastic qualities in relief and outline are broken down into shadows and the portrayal of features. Above it hovers a transluscent lilac-coloured oval, that the Spanish art historian Rafael Santos Torroella interprets as being a halo. Torroella sees in the poet's depiction an allusion to the sainthood of Sebastian.[45]

In the summer of 1927, Dalí published a drawing titled *Holy Sebastian* in the magazine *L'Amic de les Arts*, dedicated to Garcia Lorca. In a letter to the poet he writes: "And just imagine, the holy Sebastian as the patron saint of Cadaqués, do you remember the hermitage of the holy Sebastian on Mount Poní? Now, there is a story there [...] that proves the way in which he was bound to the columns, and that his back was certainly left unharmed. Would that have occured to you, that the buttocks of the holy Sebastian could have been left without injury?"[46]

Dalí called the portrait Garcia Lorca's *Nature Morte*. Here he is making reference to the goings-on that Garcia Lorca organized in the student residency: "Lorca [...] sometimes acted

45. Torroella: *Early Friendship...*, p 5
46. Private archive of Garcia Lorca's family, Madrid, quote from: *Catalogue 1979*, p. 29 f

Above: *Portrait of Luis Buñuel*, 1924
Oil on canvas. 70 x 60 cm
Reina Sofia National Museum, Madrid

Above: *Sun, Four Fisherwomen of Cadaqués*, 1928
Oil on canvas. 147 x 196 cm
The Reina Sofia Art Ccentre, Madrid

Above: *Bather*, 1928
Oil, sand and gravel collage on panel
52 x 71.7 cm
The Salvador Dalí Museum,
St Petersburg (FL)

out his own death. I can still see his dark, dreadful face, how he stretches himself out on the bed attempting to act out the different stages of his slow decline. This game of putrefaction lasted for five days. He described his coffin, his lying in state, the scene where the coffin is finally closed, and the journey with the hearse through the bumpy streets of Granada. And at the moment of our deepest uneasiness, just as he sensed it, he would suddenly jump up, break out into wild laughter and bear his white teeth in a grin. Then he would push us to the door and jump back into bed again, to sleep the sleep of the free and untroubled."[47]

The poet and the painter do not only, in their respective work, make reference to one another. In 1926, they also began to work on a piece together: Dalí created the scenery and the costumes for the premiere of Garcia Lorca's *Mariana Pineda* in Barcelona. However, the date for the beginning of rehearsals at the Goya-theater was continually postponed. In the spring of 1927, Dalí impatiently wrote to Garcia Lorca "I await you every day."[48] He described his ideas to his friend: "all the acts [...] in white frames, in the style of lithographs [...] The colour must be in the costumes and in order to present these in the best possible light; the scenery, as a consequence, will be almost monotone; the shadows only light as if bleached out, all pieces of furniture, ornamental mirror, consoles, etc, simply painted onto the scenery."[49]

In May of 1927, Garcia Lorca finally arrived in Figueras to finish the scenery with Dalí. The premiere took place on 24th June. Immediately afterwards, Garcia Lorca accompanied the Dalí family back to Cadaqués This was the last summer that the friends spent together.

In the spring of 1928, Dalí drew the title-picture for *Gallo*, the magazine that Garcia Lorca published in Granada. However the painter and the poet were both approaching a point in their lives where they would choose to take different directions. Dalí engaged himself in anti-art activities and joined the Surrealists; Garcia Lorca developed an ever-growing interest in folk-art. In April of 1928, Garcia Lorca published his *Gipsy-Romance*. Dalí responded to it in a letter: "Your poetry is bound to the old poetry by hand and foot. Your choice of particular metaphors may be correct [...] but I would say to you that your poetry itself has joined with the inner confines of the illustrious framework of hackneyed and conformist commonplace."[50]

The last written evidence of this, and one of the few letters from Garcia Lorca which has survived, is from the year 1930. In it, he asked Dalí to accompany him to New York: "I have missed your friendship for too long."[51] Dalí did not choose to follow-up on the invitation, but did however make contact again. In 1934, the friends met for the last time in Barcelona. Two years later, shortly after the beginning of the Spanish civil war, Garcia Lorca was murdered by Franco's soldiers. In 1966, Dalí described his reaction to the death of his young friend: "As I learnt of his death, I reacted like a bandit. Someone had brought me the newspaper, and realising that he had been executed by firing squad, I cried out: 'Olé'.[...] for Federico Garcia Lorca, I considered this to be the most beautiful death: to be mown down by the civil war."[52]

47. Dalí: *Becoming the Man*, p. 13 f
48. Private archive of Garcia Lorca's family in Madrid, quote from: *Catalogue1979*, p. 26
49. Private archive of Garcia Lorca's family in Madrid, quote from: *Catalogue1979*, p. 26
50. Private archive of Garcia Lorca's family in Madrid, quote from: *Catalogue1979*, p. 32
51. *Catalogue1994*, p. 38
52. Bosquet: *Discussions...*, p. 25

Opposite page: *Portrait of Maria Carbona*, 1925
Oil on panel. 52.6 x 39.2 cm
Museum of Fine Arts, Montréal

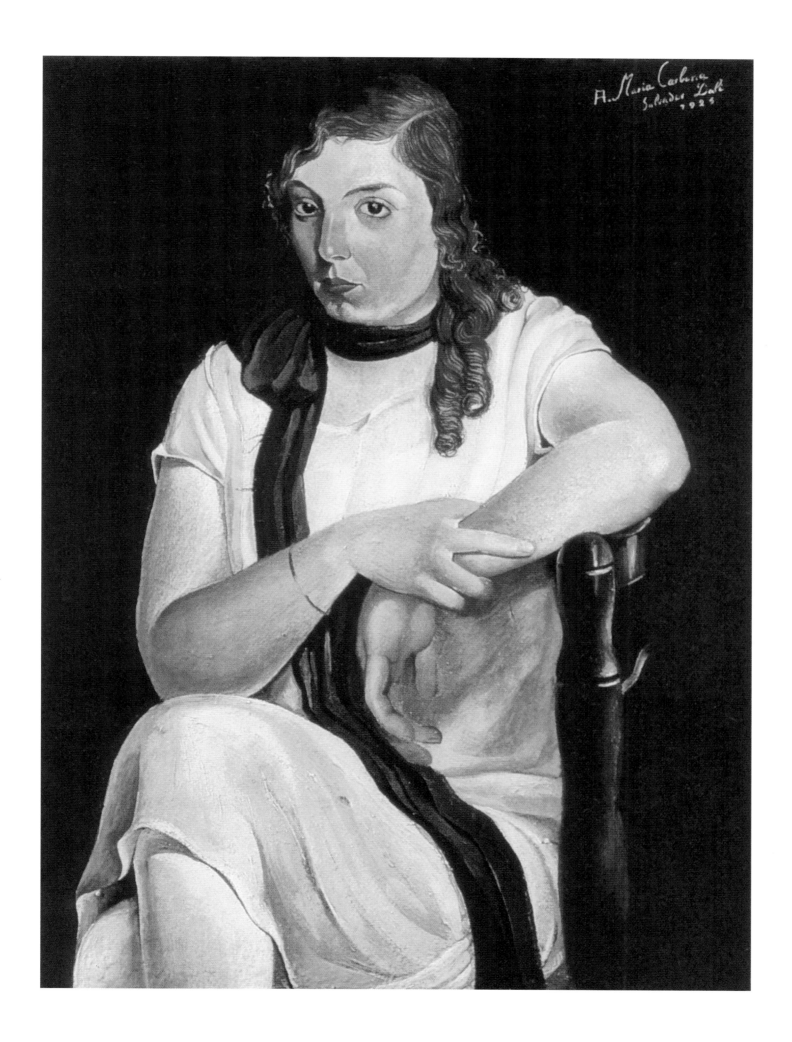

49

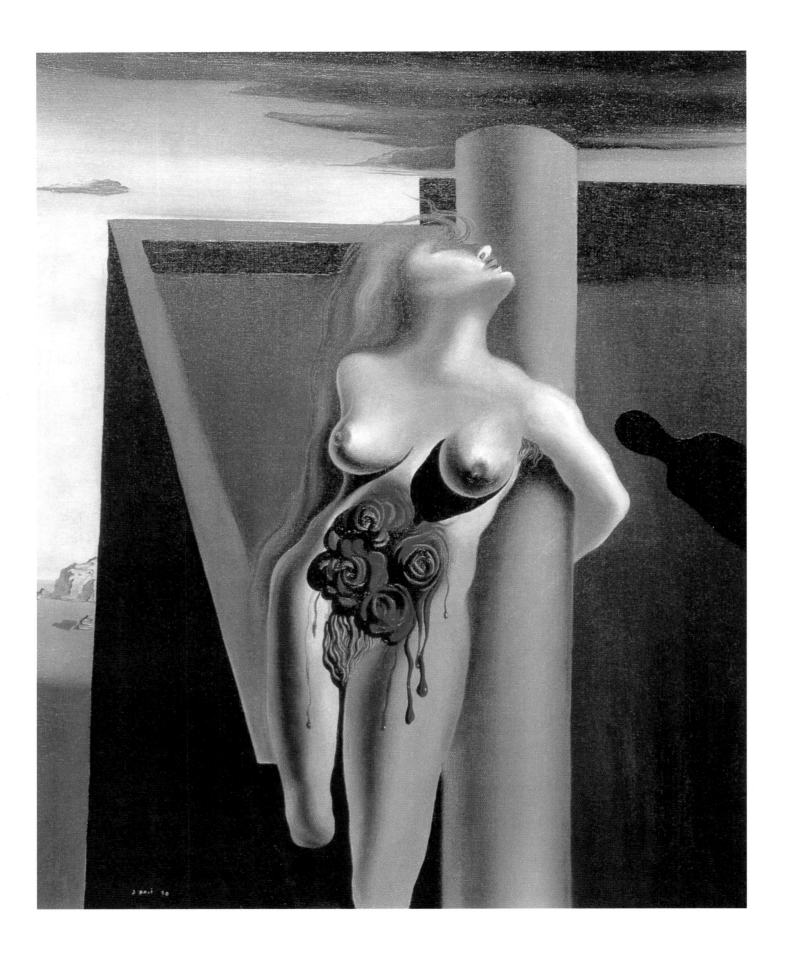

The Cut Eye

Dalí and Buñuel

Indeed, Dalí's friendship with Buñuel preceeded that with Garcia Lorca; it was only after Buñuel moved to Paris in 1925 that Dalí drew close to Lorca.[53]

In Paris, the 25 year-old Buñuel got to know the circle of Surrealists around André Breton. Breton had published the *First Surrealist Manifesto* in 1924, a work in which he introduced the idea of psychic automatism – that is, free association not affected by thought – as an artistic principle. The aesthetics of Garcia Lorca stood in direct opposition to the irrationality of the surrealist movement. During that time, Dalí co-operated on the production of *Mariana Pineda*. Buñuel wrote to their common friend, Pepin Bello, saying that Garcia Lorca would be to blame if Dalí got left behind by new evolutions in art.[54]

Already in Madrid, Dalí and Buñuel forged plans for a joint film project. However, this only took on real shape in the summer of 1928 as Buñuel visited Dalí in Figueras. Six months later they met once more to finish the script, which they give the title *Un chien andalou – An Andalusian Dog*.

Later, both authors claimed the central ideas in this joint project as their own. Dalí even claimed to be singularly responsible for the whole scenario: "His [Buñuel's] film idea appeared to me to be extremely average, it was of an unbelievable naive avantgarde nature. The script described the production of a newspaper edition, which was brought to life via the imagery of its news, comic strips and various other tricks. At the end, one saw how this newspaper gets thrown onto the pavement and how a waiter sweeps it into the gutter. I found this utterly cheap and sentimental and undignified, and I told Buñuel that his film-story did not excite the least interest. However, I in comparison, had just written a very short script which incorporated a touch of the brilliant and which was the exact counterpart of the present film."[55] Dalí then merely revised the existing script together with Buñuel.

Some motifs in the film could already be found in the earlier paintings and writings of Dalí. At the end of 1926, he began working on the painting *Honey is Sweeter than Blood*: the body of a naked woman can be seen on a beach with hands, feet and head lying severed: the head of Garcia Lorca lying beside it with a decomposing donkey carcass. In the magazine *L'Amic de les Arts*, Dalí wrote about the picture in 1927: "Now the newspaper's little capital letters devour the stiff donkey on the beach, putrid and clean like mica. We approach the place where the poor

53. Bosquet: *Discussions...*, p.193
54. Cf.: *Catalogue 1994*, p.193
55. Dalí: *The Secret Life...*, p. 253

Opposite page: *The Bleeding Roses*, 1930
Oil on canvas. 75 x 64 cm
Private collection, Geneva

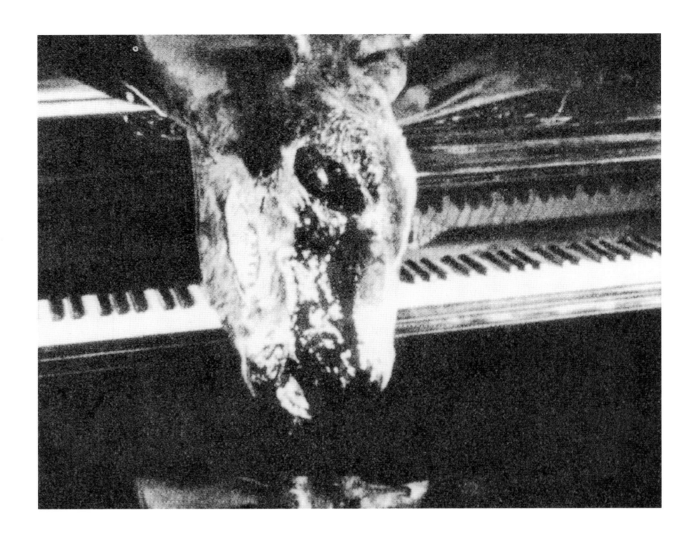

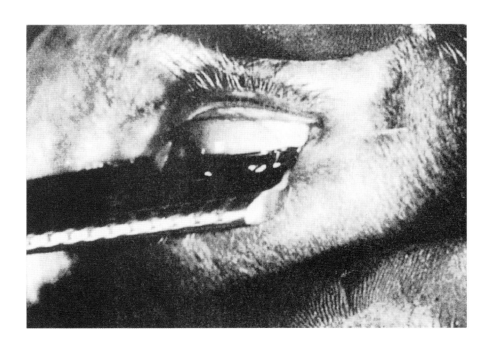

Above and opposite: Scene from the first film by Bunuel and Dalí, *An Andalusian dog*

downtrodden animals flounder, their veins burst in pounding flight, with little drops of serum sweated-out. There we shatter snail shells until we find the ones which do not contain any small nickel working, sweet like honey, showing the transparent

perfection of their limbs. [...] My lover lies prostrate, her limbs tenderly severed [...] The drowsy tenderness of the wash-basin and the gentleness of the hair-breadth incisions of the razor in the circumflex of the pupil please my lovers."[56]

The donkey-cadaver serves as a central theme in *An Andalusian Dog* and the scene where the woman's pupil is cut with a razor is regarded as the most well known sequence. The cut eye became a central image for the Surrealists.

The film was financed by Buñuel's mother without them even knowing it: she had lent her son 25,000 pesetas for a film about the painter Goya, a project that Buñuel gave up.

In the spring of 1929, Dalí travelled to Paris to see the film being shot. The painter also used his stay in the French capital to look after his business affairs. There he signed a contract with the gallerist Camille Goemans: Dalí was to spend the summer painting pictures to be shown at an exhibition in the wintertime. During this period, Goemans wanted to support him with some 3,000 francs.

Joan Miró, who Dalí had met by way of a family friend, introduced his fellow countryman to the various Parisian circles. Dalí encountered the painter René Magritte, the sculptor Hans Arp, and the poet Paul Éluard.

In a private screening on June 6th, 1929, *An Andalusian Dog* is shown for the first time at the Studio des Ursulines. The audience responded to it in the way that Dalí had expected and hoped: "I wanted it [the film] to shock and disrupt the normal attitudes of thought as well as the viewing attitudes and the taste that the intellectuals and snobs of the capital had for petit-bougeois entertainment; a film which was designed to return each viewer to the secret realm of their childhood, to the very source of their dreams, to the source of their fate, and to the secrets of life and death; a work which discarded all preconceived opinions and which was to be the proof of my genius and Buñuel's talent."[57]

This seventeen-minute long silent-film contains no action in the conventional sense; the various scenes combine with one another by way of motifs. A man stares at his hand. Ants crawl from the centre of the palm as if out of a wound. A woman looks at the man. They both look at each another. Then the image of the hand and the ants blends with an image of the woman's armpit. In a different scene, a man looks out of a window and sees how a woman gets knocked down in the street; he subsequently turns to another woman in the room and caresses her breasts.

A procedure such as this, employing the over-blending of two images, the pan of the camera or cutting techniques being used to form an association between disgust and sexuality, between death and eroticism, is also applied by Dalí in his paintings. The difference being that on his canvases, both images are seen simultaneously.

Following *An Andalusian Dog*, Buñuel and Dalí became firmly placed in the spotlight of Parisian cultural life. The Viscount Charles de Noailles and his wife Marie-Laure, who as patrons supported such avant-garde artists as Man Ray or René Crevel, suggested to the two Spaniards that they make another film, this

56. *L'Amic de les Arts* of Novenber 30th, 1927, quote from *Catalogue 1979*, p.48
57. Dalí: *Becoming the man*, p. 85

time in feature-length and with sound. The noble couple were prepared to cover the production costs. At the end of November, Buñuel and Dalí met in Figueras to make a start on the first ideas. At the beginning of January 1930, Buñuel drove down to the Noailles' summerhouse in Saint-Bernard-en-Hyères in order to work on the script. The title of the project changed several times but the name, *L'âge d'or – The Golden Age*, was finally agreed upon.

For Dalí, the period between both films is characterised by several events and changes of a decisive and radical nature. In the summer of 1929, he met Gala Éluard in Cadaqués and they both fell in love with one another. At the end of November, shortly before Buñuel was due to visit Figueras, a dispute broke out between Dalí and his father. Dalí traveled to Cadaqués. A few days later, his father told him the family wished to have nothing more to do with him. They did not meet again until 1940. In his autobiography published two years later, Dalí remains silent about

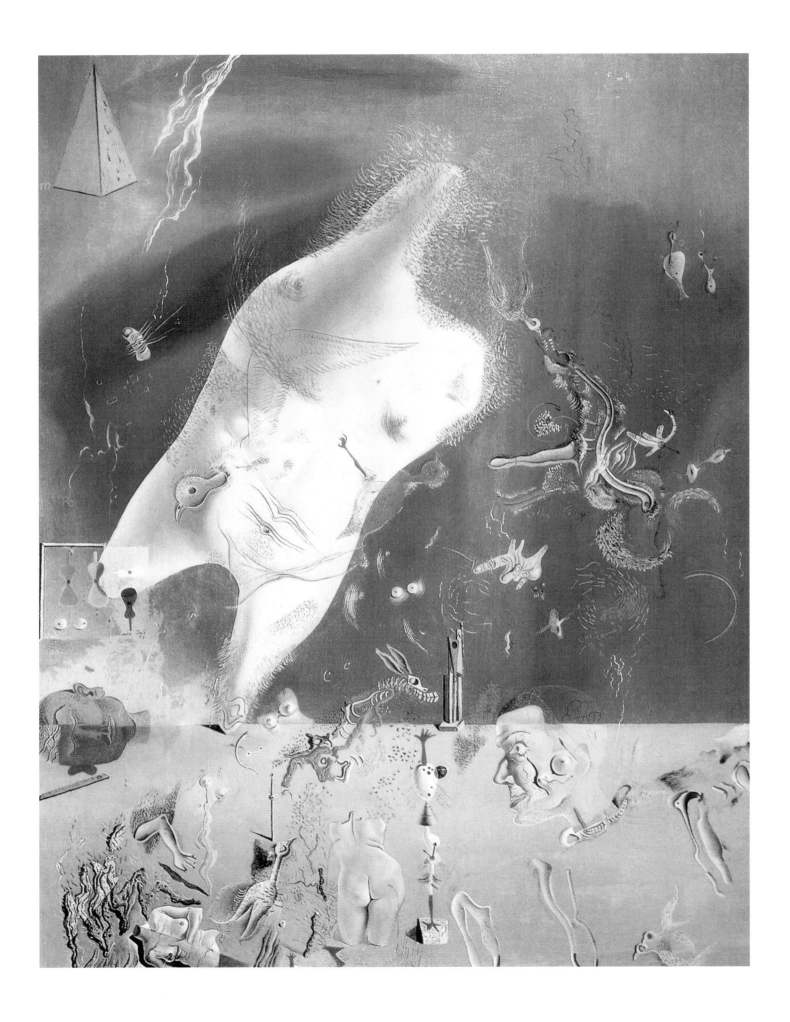

56

Opposite page: *Little Cinders
(Cenicitas)*, 1927-1928
Oil on panel. 64 x 48 cm
The Reina Sofia National Museum,
Madrid

Above: *The wounded bird*, 1928
Oil and sand on cardboard
55 x 65.5 cm
The Mizne-Blumental Collection,
Monte Carlo

Opposite: *Anthropomorphic Beach*,
1928
Oil, cork, stone, red sponge and
polychrome finger carved of wood
on canvas. 47.5 x 27.5 cm
The Salvador Dalí Museum,
St Petersburg (FL)

58. Cf.: Dalí: *The Secret Life...*, p. 308

Above: *The Enigma of Desire – My Mother, my Mother, my Mother*, 1929
Oil on canvas. 110 x 150.7 cm
Gallery of Modern Art, Munich

the background for this rift: "I do not wish to reveal here the deep lying reason for this decision because this secret is between my father and myself."[58]

One reason for his father's anger may have been Dalí's relationship with Gala who at this time was still married to Paul Éluard. A further cause may have been Dalís ink-drawing *The Sacred Heart*. On it, Dalí had written: "Sometimes, I spit on the portrait of my mother for fun".

In addition to this split with his family, a troubling message arrived from Paris: Dalí's gallerist was bankrupt and could not pay the promised retainer for the exhibition in winter. Dalí was made penniless in one blow. Through Buñuel, Viscount Noailles learned of his plight and sent Dalí money. In return, and in consideration of his generosity, the painter gave him the recently finished painting *The Old Man William Tell*, which reflected his conflict with his father.

Using the Viscount's money, Dalí and Gala travelled to Spain in March and purchased a cottage in Port Lligat, a fishing-village near Cadaqués. At the same time in Paris, Buñuel began filming *The Golden Age*. Dalí was not present during the production of the film and did not make an appearance, but instead, dedicated himself to the project in thought and reported his ideas to Buñuel by letter.

Not all his suggestions were taken up by his partner and when so, they were significantly changed. In his autobiography, Dalí wrote: "Even in those days I was moved and intoxicated, yes

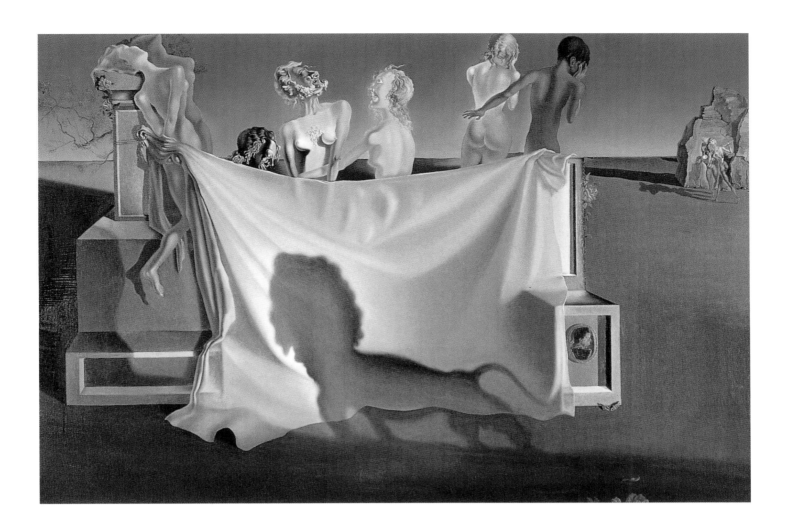

even possessed by the magnificence and splendor of Catholicism. I said to Buñuel: "For this film I want plenty of archbishops, mortal remains and monstrances. I especially want archbishops, bathing between the fallen rocks at Cape Creus with their embroidered mitres. In his naïvety, and with his stubborn Aragonic manner, Buñuel managed to change all this into an example of simple anticlericalism."[59]

In the scene that Buñuel filmed at Cape Creus near Cadaqués, the location proposed by Dalí, some bishops can be seen sitting on the rocks. In the preceding shot, the director had placed scorpions in the same position, letting them crawl over the rocks in order to draw attention to the virulence of Catholicism by way of association. This mocking of the church can be seen thoughout the film and reaches its zenith at the very end as the Marquis de Blangis – an allusion to the Marquis de Sade, an author well known for his pornographic books – makes his appearance. In the film, Blangis claims to have caused the death of eight girls and eight boys in 120 days of continuous orgy. The marquis had similar hair and was dressed in the same style as Christ in traditional depictions.

At a private screening, *The Golden Age* was presented to a discerning audience on October 22nd, 1930. Among others, Gertrude Stein, Pablo Picasso, Marcel Duchamp, André Malraux and Man Ray were invited. The reaction to the film was extremely cool; most guests left the cinema directly after the end of the showing.

59 Dalí: *The Secret Life...*, p. 307

Above: *The Old Age of William Tell*, 1931
Oil on canvas. 98 x 140 cm
Private collection

Unsatisfied Desires, 1928
Oil, sea-shells and sand on cardboard
76 x 62 cm
Private collection

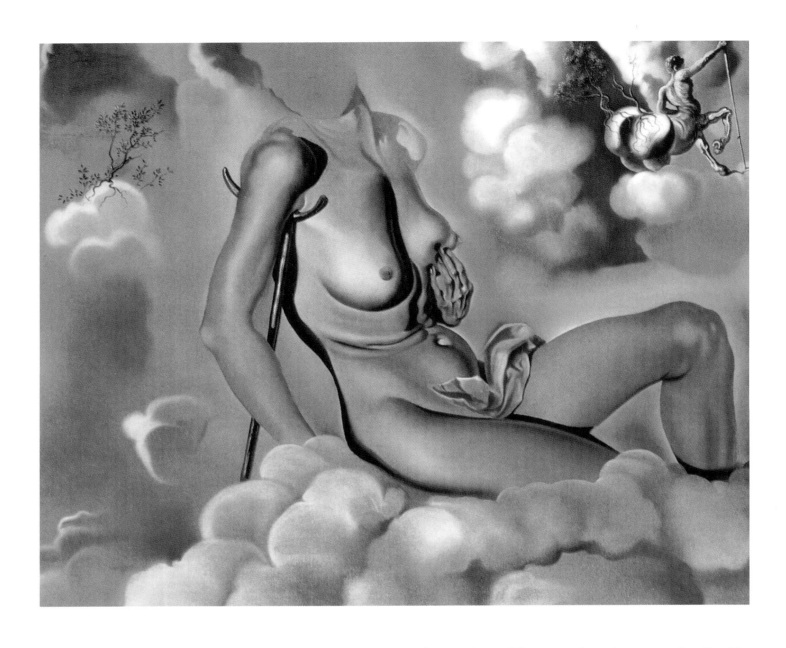

60. Dalí: *The Secret Life...*, p. 348

Above: *Honey is Sweeter than Blood,*
1941
Oil on canvas. 49.5 x 60 cm
The Santa Barbara Museum of Art,
Santa Barbara

On November 28th, public screenings began at Studio 28.
The Parisian Surrealists took part in the event: André Breton pub-
lished a manifesto for which Louis Aragon, René Char, Paul Éluard
and Dalí had made written contributions. In the foyer of the cine-
ma, an exhibition of works from Dalí, Joan Miró, Max Ernst,
Hans Arp, Man Ray and Yves Tanguy also took place. On
December 3rd, the cinema was attacked by members of the Action
Française, a right-wing and antisemitic association. Apparently,
the attack was not only directed against the film but also against
its Jewish producer, Marie-Laure de Noailles. A week after the raid
– during which most of the exhibited paintings had been damaged
– *The Golden Age* was prohibited in France. The film could not be
shown for fifty years. Out of solidarity to Buñuel but not out of
conviction, Dalí defended the film: "I accepted responsibility for
the sacrilegious scandal, although I did not have any ambition in
that direction."[60]

The friendship had however hit rocky ground. The final
break came in 1934. Dalí had seen a new version of *An Andalu-
sian Dog* and had noticed that his name was no longer mentioned.
In Barcelona at the same time, *The Golden Age* was being
announced as a "Film from Buñuel, in cooperation with Dalí" and

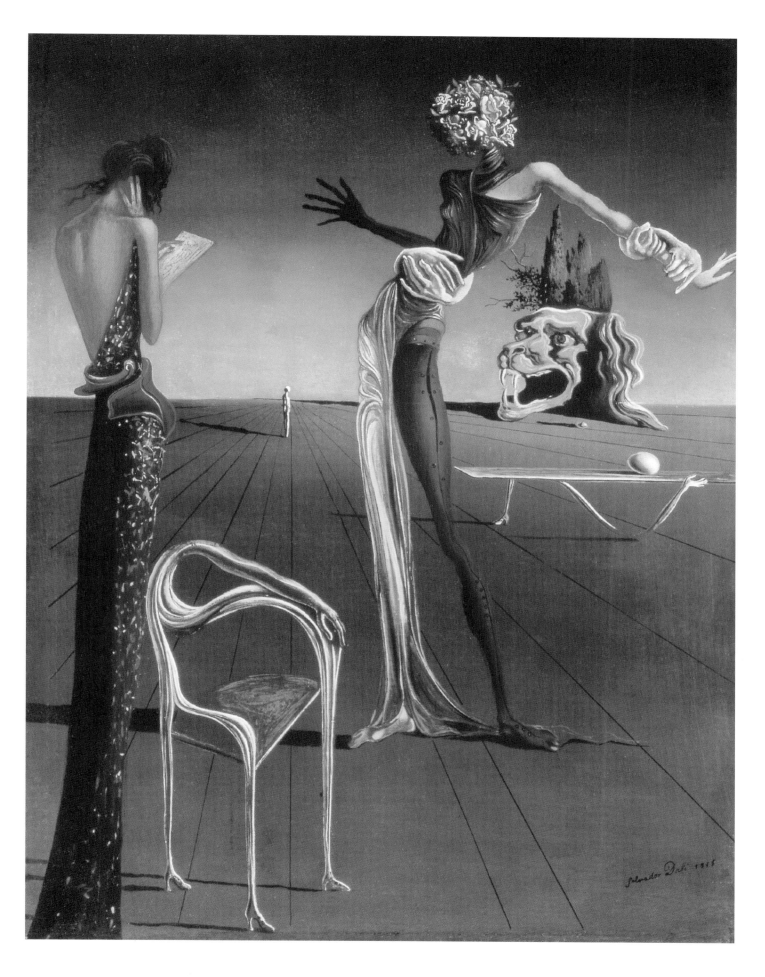

Above: *Woman with a Head of Roses*,
1935
Oil on panel. 35 x 27 cm
Kunsthaus Zürich, Zurich

61

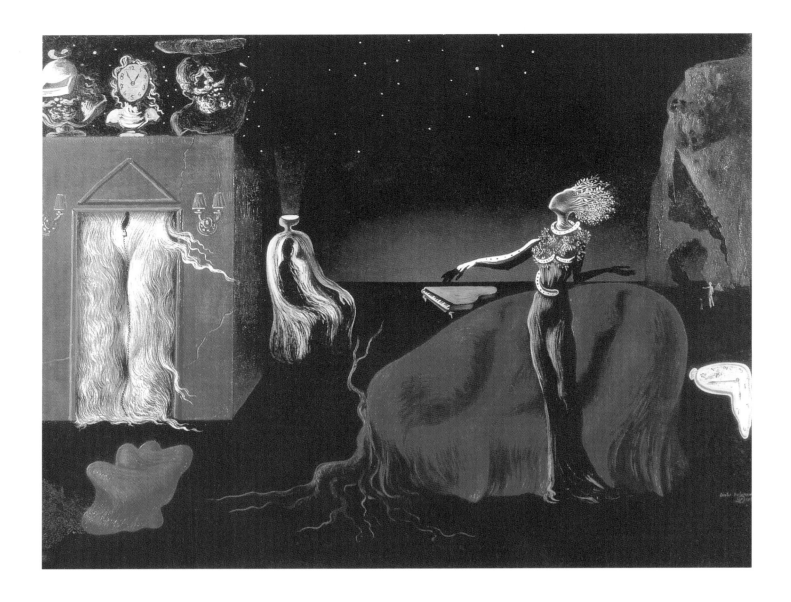

not as a work of equal parts between Buñuel and Dalí. The director rejected his friend's claim. Over the course of the following years, in various interviews, they both never tired of making repeated reference to the role that each played in the authorship of the piece.

In the sixties, Dalí attempted to renew contact with Buñuel without success. Finally in November 1982 he sent him a video: "Dear Buñuel, every ten years I send you a letter, and I will continue to do so even when you do not want it. Last night I dreamed of a film that we could make in just ten days but not one about the philosophical demon, one about our own lovely devil. If you are interested, come to me at Chateau Pubol."[61] Even this attempt remained unanswered. Eight months later, Buñuel died.

61. Quote from *Catalogue 1994*, p.205, author's translation

Above: *Singularities*, 1935/1937
Oil on canvas. 165 x 195 cm
The Estrada Museum, Barcelona

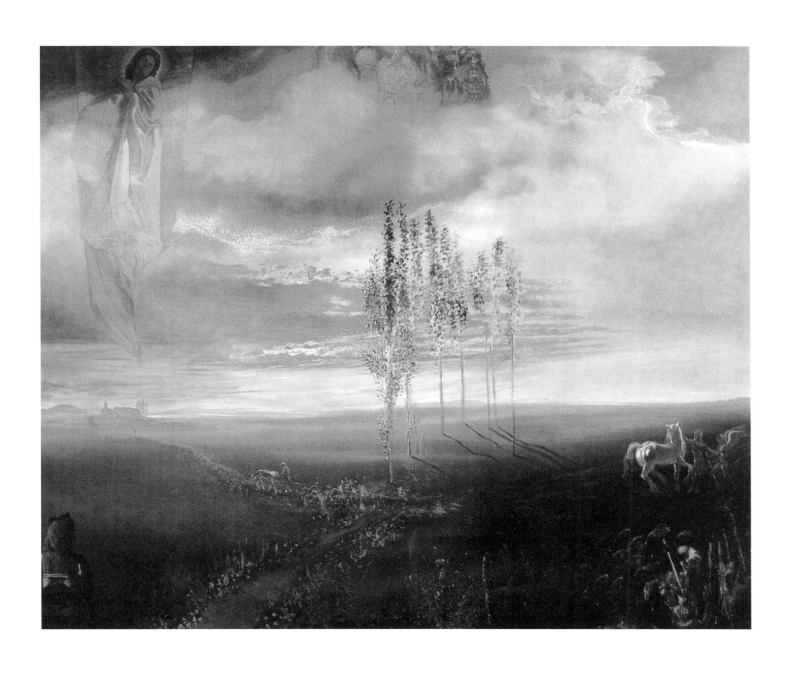

Above: *Gala's Castle at Púbol*, 1973
Oil on canvas. 160 x 189.7 cm
Gift of Dalí to the Spanish State

63

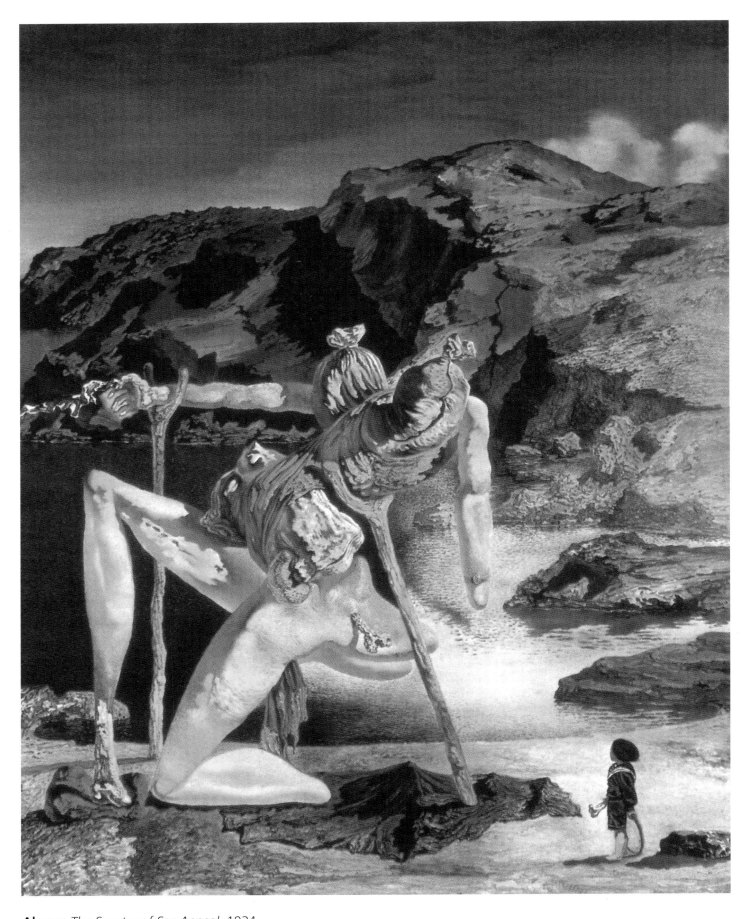

Above: *The Spectre of Sex Appeal*, 1934
Oil on panel. 18 x 14 cm
The Gala-Salvador Dalí Foundation,
Figueras

Opposite page: *Geological Destiny*, 1933
Oil on panel. 21 x 16 cm
Private collection

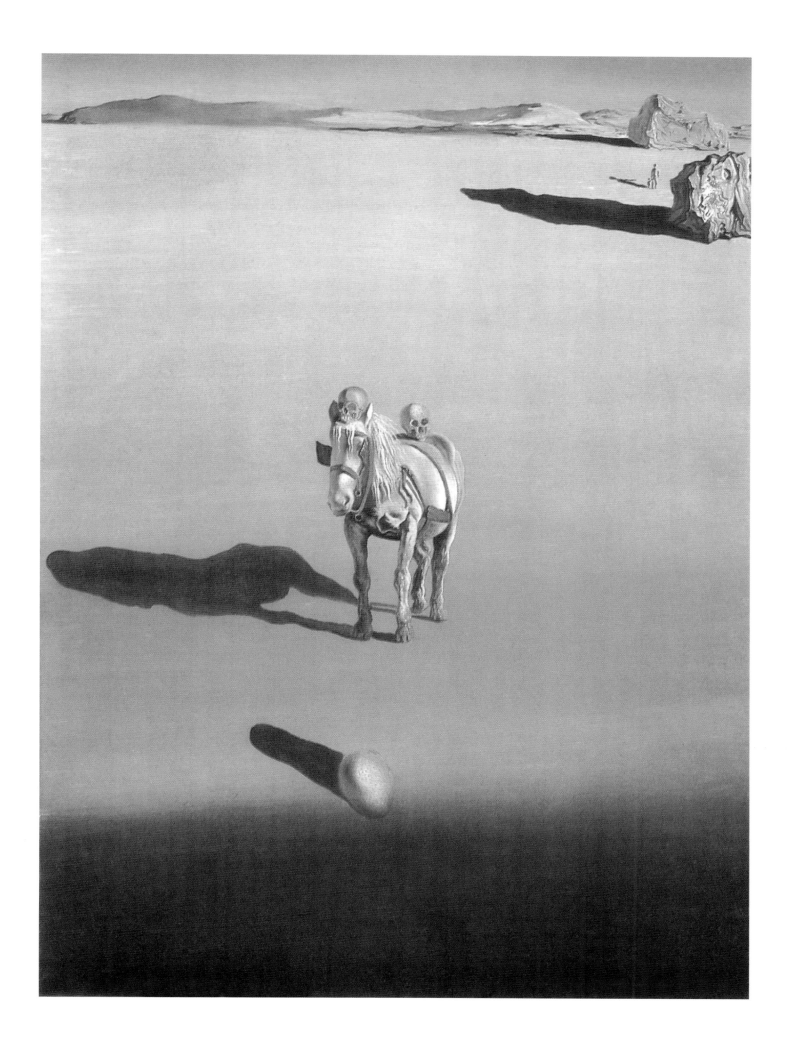

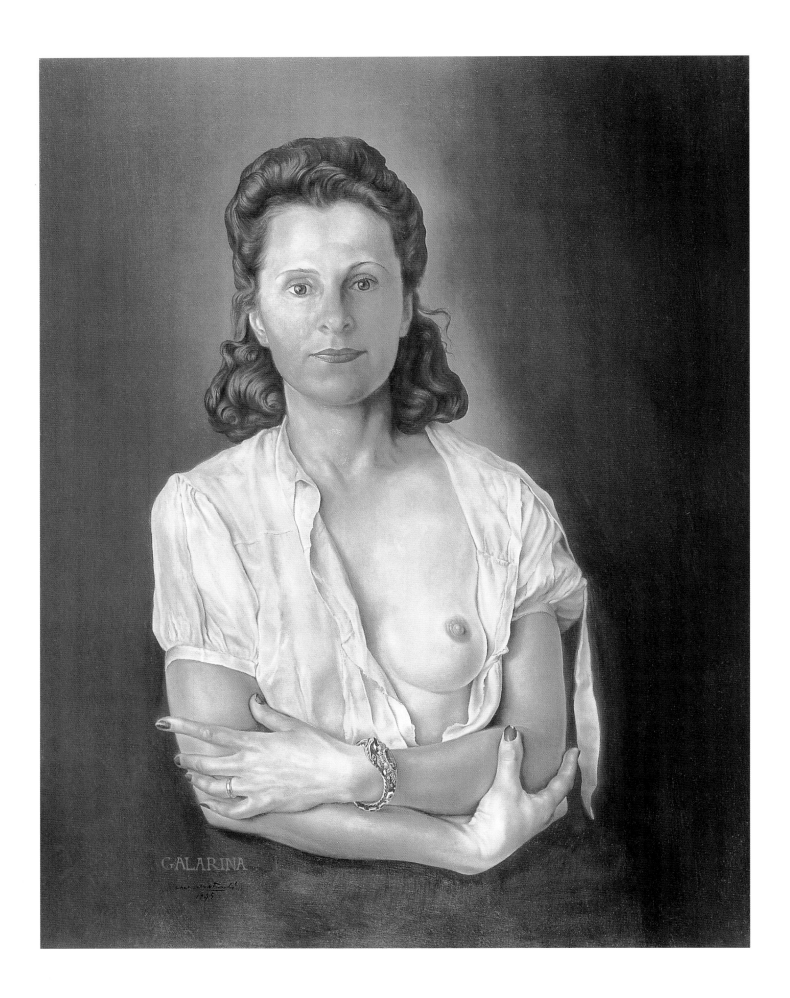

GALARINA

Gala: or The Healing Gradiva

The Surrealist Years in Paris

Dalí's work as a scriptwriter affected his general life in other ways. He became acquainted with the Noailles through it – or rather the rich art-friends became acquainted with the painter and started to collect his paintings. Furthermore, he formed ties with the Parisian circle of Surrealists.

In the summer of 1929, the gallerist Camille Goemans visited Dalí in Cadaqués with René Magritte, Luis Buñuel and Paul Éluard. Éluard was accompanied by his wife Gala and Dalí instantly fell in love: "On the second morning after my friends' arrival, and drunk with the desire to make her look at me, I shaved my armpits for her and painted them blue, cut my shirt and smeared myself with fish glue and goat dung, hanging a string of pearls around my neck and placing a jasmine blossom behind my ear. But when I saw her, I was gripped by a kind of crazy laughter, by paralysis and fanaticism, by a fear of the abyss and by such horror that I was incapable of saying a word to her. The following day she grabbed me by the hand and calmed my laughter, saying seriously: 'My little one, we will never part from one another.' She became Gradiva, the healer of fear, the conqueror of my frenzy, the loving lover of my powers."[62] Gala kept her promise: as the others travelled back to Paris in September, she remained in Cadaqués.

Little is known of the Russian-born woman. Her date of birth is quoted by different biographers as being between 1890 and 1895.[63] Jelena Deluwina Diakonoff came to Paris from Moscow in 1916. Four years earlier, the affluent lawyer's daughter had met the French poet Paul Éluard at the Clavadel lung sanatorium in Davos where both were recovering from a bout of tuberculosis. Éluard fell in love with the beautiful young woman; he gave her the pet name Gala. After her return to Moscow, Jelena considered herself engaged. As she arrived back in Paris, she learned that her future husband had been sent to the front as a soldier. She lived with his mother, drew and learned French, almost never going out and writing letters full of longing for her fiancé. Brought up in the Greek-orthodox faith, she converted to the Roman Catholic faith in order to marry Éluard in February of 1917. A year later, the pair were granted a daughter. Gala was just as unable to come to terms with her role as mother as she was with the life of a housewife. In a letter to her husband, she talks of her hate for housework, describing it as unproductive, something that saps the strength of a woman. Nevertheless, she says to be ready to make this sacrifice for him.[64]

62. *Salvador Dalí: My Passions*, recorded by Louis Pauwels, 1969, p.31 [*Les passions selon Dalí*, Paris, 1968]
63. Secrest: *Salvador...*, p.116
64. Cf.: Secrest: *Salvador...*, p. 123

Opposite page: *Galarina*, 1944-1945 Oil on canvas. 64.1 x 50.2 cm The Gala-Salvador Dalí Foundation, Figueras

65. Cf.: Secrest: *Salvador…*, p. 116

Above: *Gradiva (Study for The Invisible Man)*, 1930
Pen, ink, and pencil on paper
35 x 25 cm
The Salvador Dalí Museum,
St Petersburg (FL)

Opposite page: *Gradiva*, 1933
Pen and Indian ink on smoothed-down
sandpaper. 63 x 45.5 cm
Staatliche Graphische Sammlung,
Munich

The blissful home Gala wanted to create, contrary to her own convictions, did not fulfill the poet's wishes. Éluard had affairs with other women and also wished that his own wife would live out her passions with other men. Between 1921 and 1924, the painter Max Ernst lived with the couple, and was at this time also Gala's lover.

Many Surrealists paid court to the beautiful Mrs Éluard. André Breton called her "the eternal woman".[65] As Gala fell in love with Dalí in 1929, Éluard considered it just a brief love affair.

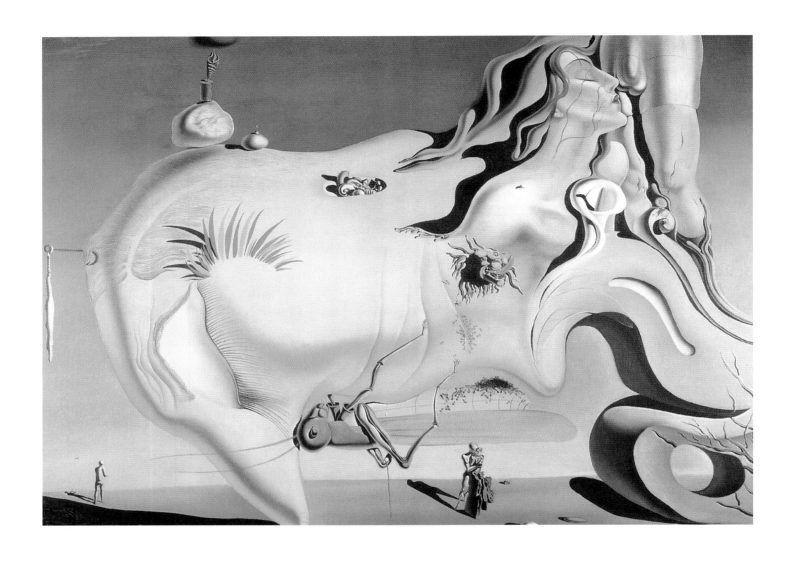

66. Ramón Gómez de la Serna: *Dalí, Eltville am Rhein* 1981, p. 224

Above: *The Great Masturbator*, 1929
Oil on canvas. 110 x 150 cm
The Reina Sofía National Museum, Madrid

Opposite page: *The Invisible Man*, 1929
Oil on canvas. 140 x 80 cm
The Reina Sofía National Museum, Madrid

He was deceived: Gala separated from him. She remained at Dalí's side until her death in 1982, marrying him at a church wedding in 1956, four years after Éluard's death.

Dalí continually stressed that he would never have become the Dalí that he was without this woman at his side. For him she was muse, model, and manager all in one. She organized Dalí's business affairs because, as he confessed, he let everybody cheat him while Gala always saw through their plans.[66] He honoured her importance for his artistic work by signing many of his paintings with "Gala Salvador Dalí".

Dalí called Gala his "Gradiva" an allusion to the heroine in W. Jensen's novella of the same name, of which he had learned through his readings of Sigmund Freud. According to Freud, Gradiva heals the male hero of his hallucinations. Gala in turn saved Dalí from his death-fantasies by asking him to kill her. Together they planned out the act. These conversations, Dalí was later to claim in his autobiography, replaced the actual act.

Furthermore, Gala freed him of his impotence complex, something that had paralysed him since his early youth. On the one hand, Dalí traces his fear of sexuality back to his father, who had often elaborated on the dangers of venereal disease to him as a child, and, on the other, to his reading of books that portrayed sadomasochistic games, which he wrongly understood to be depictions of the real act of love: "At that time my libido degenerated

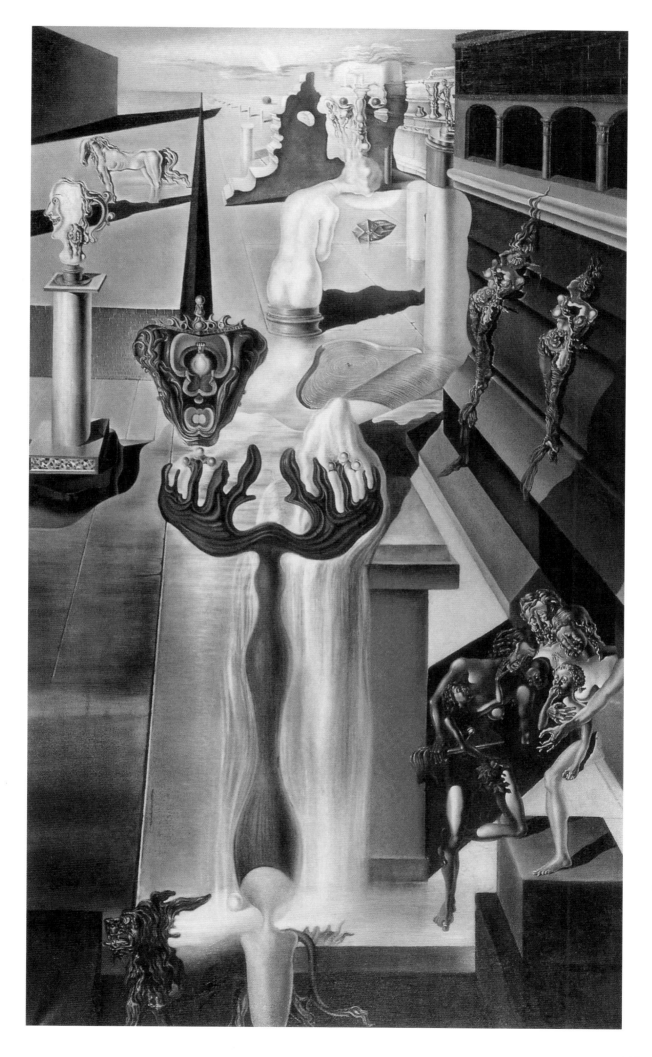

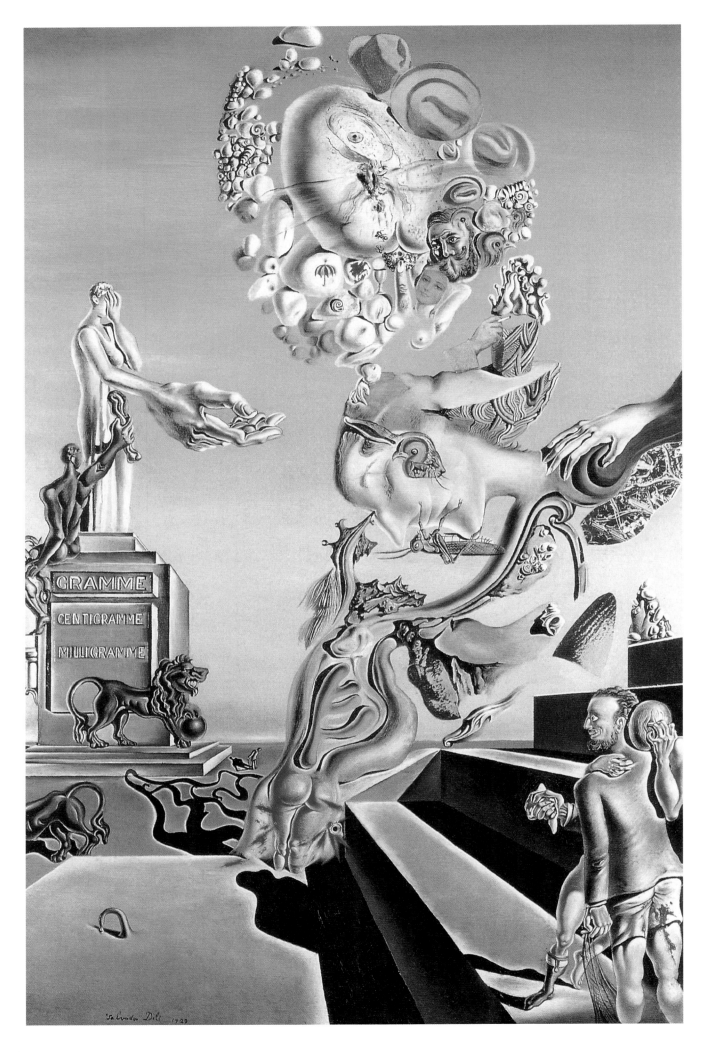

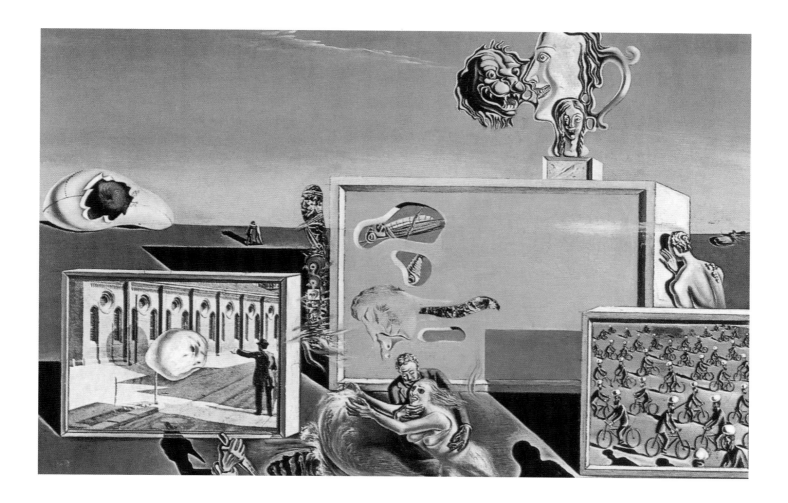

into such a state of downright erotic idiocy as a result of this impotence-complex [...] I dressed myself as a king and masturbated and had I not found Gala, who helped me discover, so to speak, normal love, then it would have taken no more than two years for all my hallucinations to over-step the measure of paranoia to such an extent that they would have become psychopathological. Instead of that she brought me a divine element of balance and classicism, and from then on, instead of just being an obvious mad-man, I was able to become a classical one."[67]

A painting that Dalí began in the autumn of 1929 carries the title *The Great Masturbator*. He described it as follows: "A large head was depicted on it, sallow like wax, with very rosy cheeks, long eyelashes, and an imposing nose pushing down towards the earth. This face didn't have any mouth, and in its place hung a gigantic locust. The decomposed belly of the locust was full of ants. Several of these ants were scurrying around, where the mouth of this fear-inciting face should have been; the head finishes in buildings and ornaments in the style of the 'Jahrhundertwende'."[68]

Several other works painted in this year also concern themselves with the head of the "Masturbator". In *Puzzle of Desire*, a honeycomb structure grows out of it and in its various chambers "ma mère" – "my mother" – is written. It also forms the central focus in *The Dark Game* and *Inspired Pleasures*. The four paintings were shown at Dalí's first single exhibition in Paris, at the Goemans gallery at the end of November of 1929. *The Dark Game* was bought by the Viscount de Noailles and of all the paintings of this period, won the greatest admiration.

67. Television interview from 1975
68. Dalí: *The secret Life...*, p. 302

Opposite page: *The Lugubrious Game*, 1929
Oil and collage on cardboard
44.4 x 30.3 cm
Private collection

Above: *Illuminated Pleasures*, 1929
Oil and collage on hardboard
24 x 35 cm
Museum of Modern Art, New York

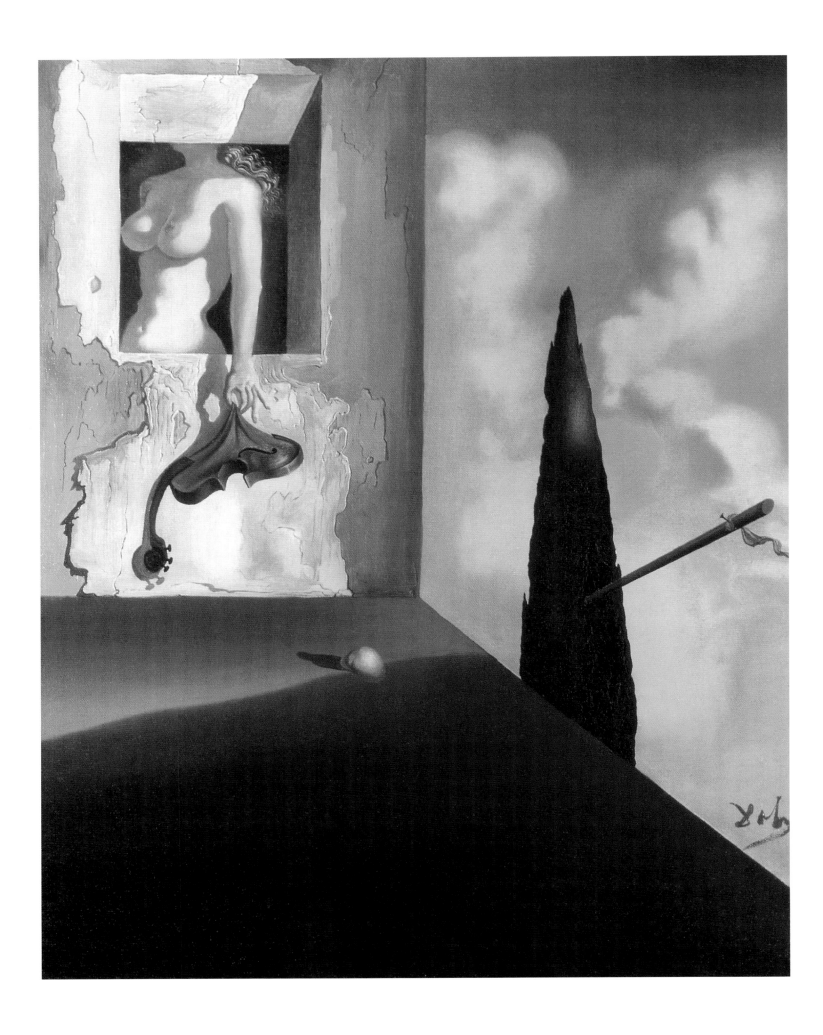

74

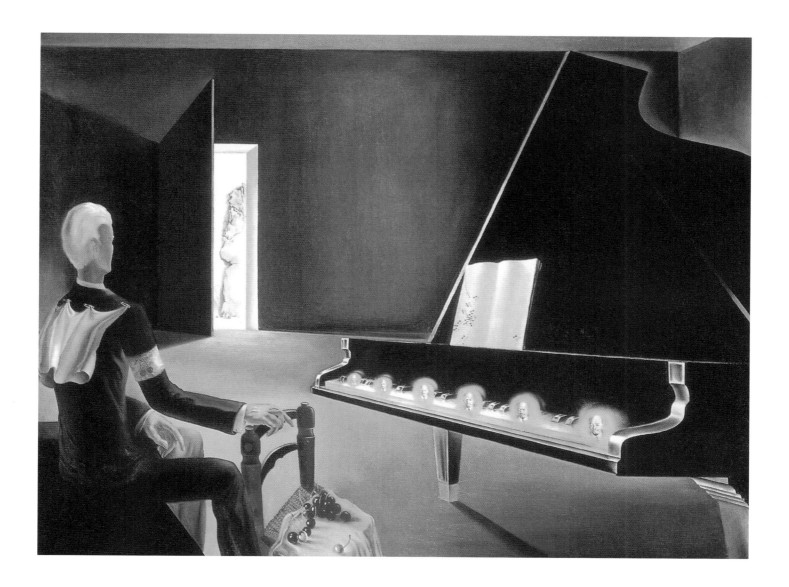

Dalí was celebrated by the Surrealists as being one of their own but not without reservations. In the song of praise André Breton sung about Dalí, soft tones of misgiving can be heard. In the exhibition catalogue, Breton wrote: "On the one hand there are the moths who make a nest of their apparel and who do not even want to discard it on the street; the said moths are of the opinion that Spain and even Catalonia are in order; they find it entrancing when a man can paint such little things so well (and it would be even better, when he grew), a man with shit on his shirt like on his pictures. *The Dark Game* is worth ten of these men and how much more than one hundred naked men and then it is time for the vermin to rule the streets in our dear country and uncultivated capital."[69]

This question regarding faeces became Dalí's point of test for the Surrealists: "They explained everything to me very eloquently that I should transcribe everything which went through my head through pure automatism without reason or aesthetics or morals practicing any form of control. I possessed the ideal method of and potential for communication. Very soon however, Breton became shocked by the evidence of so many obscene elements. He wanted neither excrement nor Madonna images. It defeats the very reason for having pure automatism if a system of control is introduced, for these images of excrement came to me in a direct, biological way."[70]

69. André Breton, quote from: *Catalogue 1979*, p. 12
70. Dalí: *Becoming the Man*, p. 142

Opposite page: *Masochist Instrument*, 1933-1934
Oil on canvas. 62 x 47 cm
Private collection

Above: *Partial Hallucination. Six apparitions of Lenin on a Grand Piano*, 1931
Oil on canvas. 114 x 146 cm
The National Museum of Modern Art, Georges Pompidou Centre, Paris

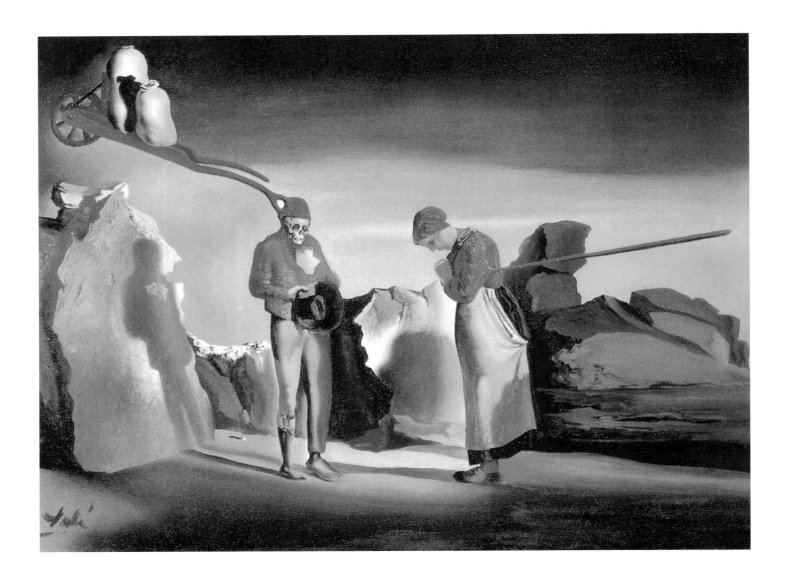

71. Cf.: *Catalogue 1979*, p. 132
72. Dalí: *The Secret Life...*, p. 384

Above: *Atavism at Twilight*, 1933-1934
Oil on panel. 14 x 18 cm
Kunstmuseum, Bern

Opposite page: *The Angelus of Gala*,
1935
Oil on panel. 32 x 26 cm
Museum of Modern Art, New York

From the very beginning, Dalí took on the position of out-sider in the Parisian surrealist scene. He did not just laugh about Breton's censored automatism, he also remained distant with regard to the political commitment of the group. Nevertheless, for several years, the surrealists celebrated him as their most important representative. Dalí had, in the judgment of Breton, elevated the surrealist mind to the point of radiance like no other before him.[71]

Dalí catered for emotional furor at the beginning of the thirties, above all with his surrealist objects, which he created as an anti-programme against Breton's style of automatism: "From a practical and rational viewpoint, the surrealist object is devoid of absolutely every useful characteristic, simply being created for the purpose of materializing some crazy idea or fantasy of a fetishistic type with the maximum of tangible reality."[72]

Most of these objects have not survived – for example, an apparatus that dunked a cube of sugar in a glass of milk. The glass stood in a woman's shoe, and the sugar-cube had a shoe painted on it. The apparatus was decorated with pubic hair, which had another piece of sugar taped to it, and an erotic photo.

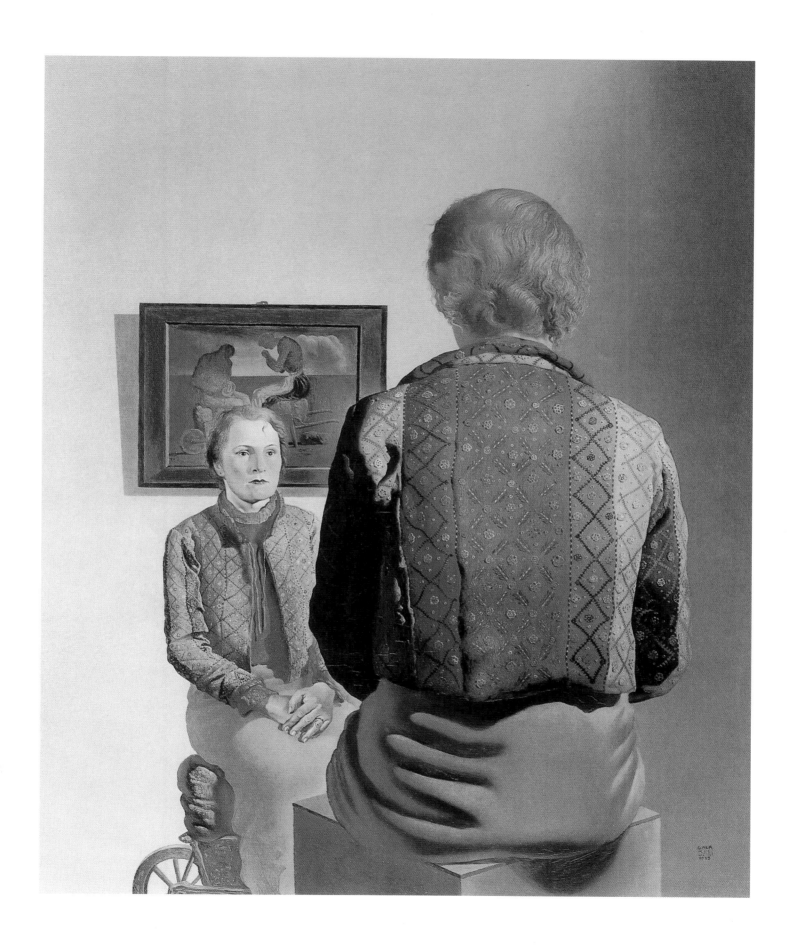

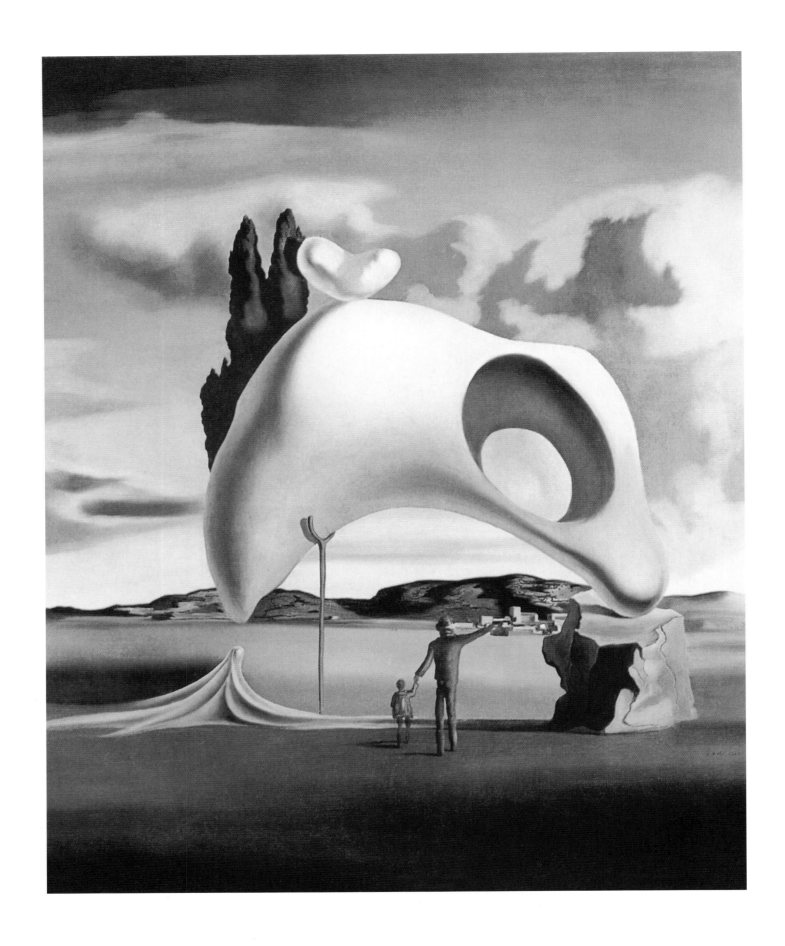

Above: Vertigo atavism after the rain,
1934
Oil on canvas. 65 x 54 cm
Perls Galleries, New York

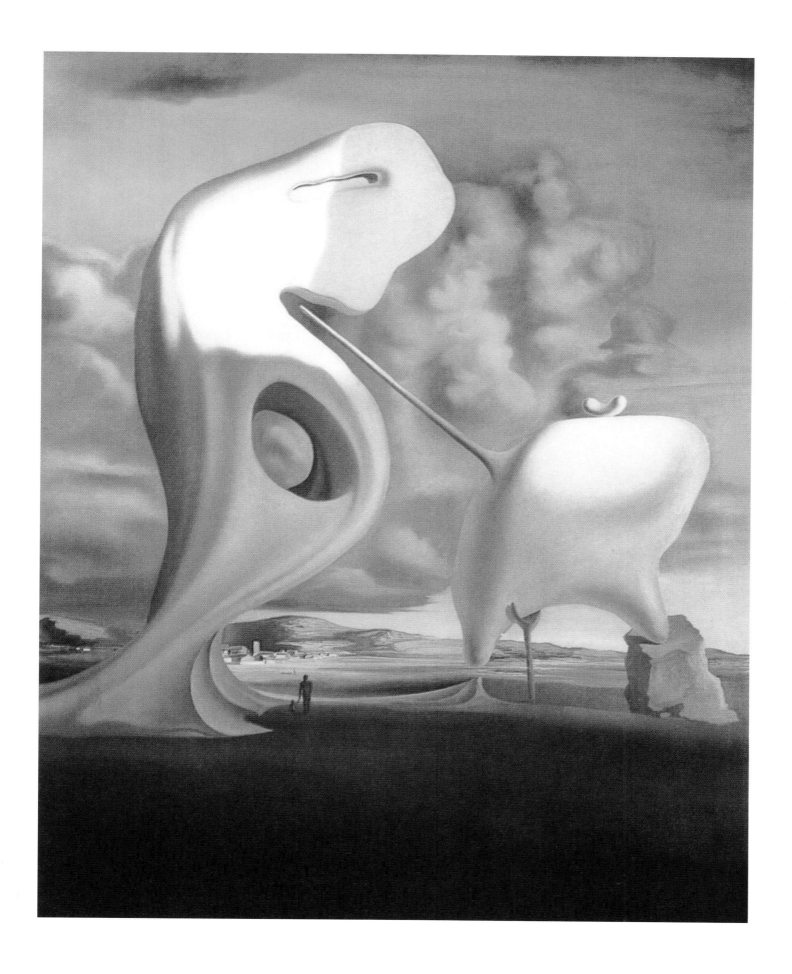

Above: *The Architectonic Angelus of Millet*, 1933
Oil on canvas. 73 x 61 cm
The Reina Sofía National Museum, Madrid

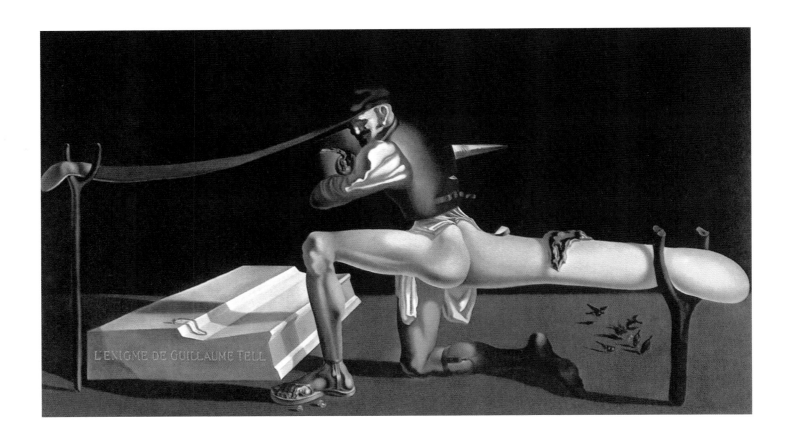

In addition to these apparently useless surrealist objects, Dalí also invented a series of "practical" objects such as furniture made out of Bakelite, which was supposed to adapt itself to the shape of the buyer's body, or even water-trousers as a substitute for the bathtub. Dalí hoped to be able to earn money with his original ideas, for at this time his pictures were selling badly. However, it was just as difficult to convince anybody to manufacture his inventions.

While Dalí spent the afternoons working on a "non-contemporary, anti-modern picture", Gala travelled around Paris on the bus going from one company to the next. Every evening she returned home tired and without success: "It was always the same story. First they would say the idea is crazy and without any commercial value. Then if Gala, in the course of several stubborn visits and with all her rhetorical brilliance and tricks, succeeded in convincing the people of the practical benefit of my inventions, they would invariably say to her that the thing is certainly interesting in theory but could certainly never be realised or, if the execution of such a product were feasible, it would be so expensive that it would be madness to bring it out onto the market. The word 'madness' always cropped up in one form or another."[73]

Despite their permanent money troubles, Dalí always ensured that he and Gala did not have to live the life of Bohemians with their dirty sheets and continual fear that the electricity would be cut off. While living very economically within their four walls, outside the home they demonstrated that all was well by continually giving good tips.

Dalí's financial situation first improved in 1933 as a group of collectors guaranteed him the frequent purchase of his pictures. Among others, the author Julien Green belonged to this group known as the "Zodiaque".

73. Dalí: *The Secret Life...*, p. 358

Above: *The Enigma of William Tell,* 1933
Oil on canvas. 201.5 x 346 cm
Museum of Modern Art, Stockholm

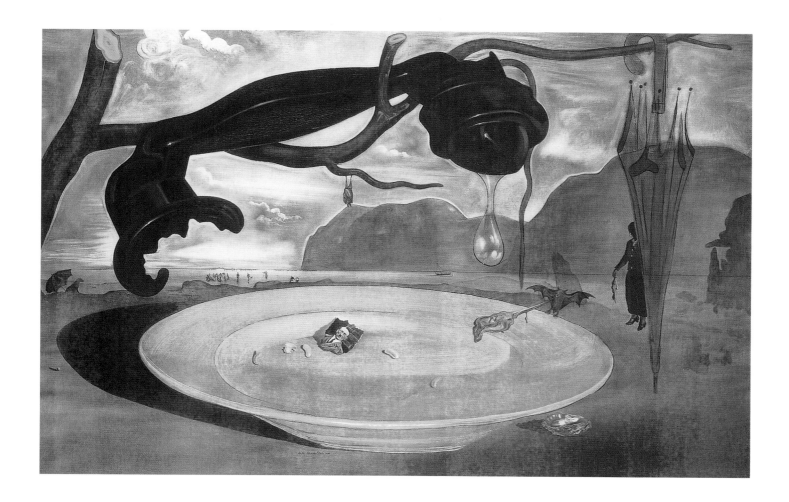

Due to his eccentric ideas, Dalí acquired a growing reputation in Paris, subsequently opening the doors to many social events: "I became indispensable at all these ultrasnobish receptions where my cane kept the beat at many successful evenings. [...] I invented artificial finger-nails made out of little mirrors, which reflected the highlights of the eyes; [...] one day I appeared with a transparent dressmakers-doll, in which red fish swam around. Every appearance was an event filled with tension."[74]

At one party, he founded a secret society with some other guests: the "Order of Bread". He planned to order the baking of a fifteen-meter long loaf of bread and to place it in the middle of the park in front of the Royal Palace. As Louis Aragon learned of the idea, he denounced Dalí "in the name of the children of the jobless, out of whose mouths I steal the food."[75]

More than once disputes broke out amongst the far-reaching, left-oriented surrealist group due to Dalí's political opinions. In 1933, he criticized the foreign policies of the Soviet Union and professed to be fascinated by Hitler: "I painted a wet nurse resembling Hitler, sitting knitting in a puddle. One tried to force me to remove the swastika from her armband. And at the same time I did not cease to claim that Hitler for me personified the undivided image of the most extreme masochist."[76]

When Dalí exhibited his painting *The Riddle of William Tell* in the Salon of the Indépendants at the beginning of 1934, it came to a confrontation: the picture was understood as ridiculing Lenin. Breton called the surrealists together for a meeting in order to expel Dalí "who has demonstrated his guilt several times via

74. Dalí: *Becoming the Man*, p. 194
75. Dalí: *Becoming the Man*, p. 135
76. Dalí: *Becoming the Man*, p. 140

Above: *The Enigma of Hitler*, c. 1939
Oil on canvas. 51.2 x 79.3 cm
The Reina Sofía National Museum, Madrid

81

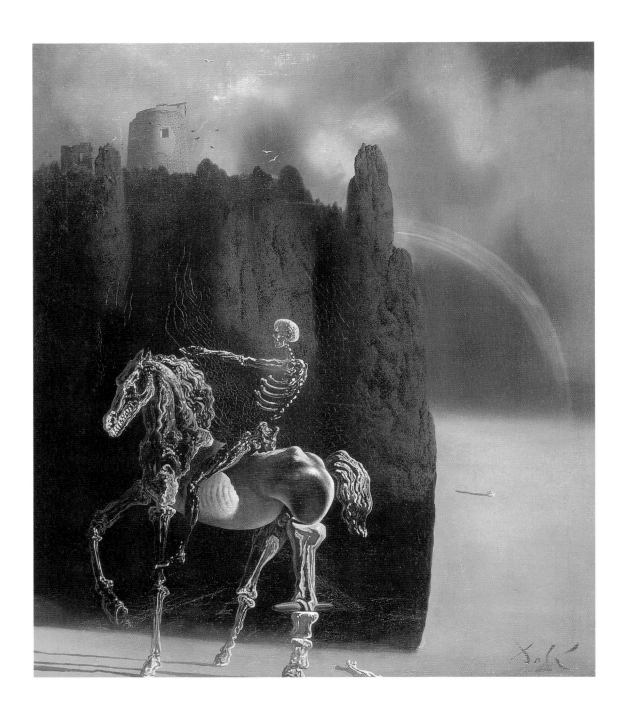

77. *Catalogue 1979*, p.135
78. Dalí: *Becoming the Man*, p. 140

Above: *The Horseman of Death*, 1935
Oil on canvas. 54 x 64 cm
The André-François Petit Collection, Paris

Opposite page: *Profanation of the Host*, 1929
Oil on canvas. 100 x 73 cm
The Salvador Dalí Museum,
St Petersburg (FL)

counter-revolutionary actions designed to glorify the fascism of Hitler".[77]

Dalí describes the incident from memory: "Together with Benjamin Péret, Tanguy, Rosey, Marcel and Hugnet, Breton had wanted to damage my *Lenin* in the Salon before this inquisitorial gathering, but their short arms were incapable of reaching the picture because it had been hung so high. This just made them all the more furious. On the same morning, 'pope' Breton had received a letter signed by Crevel, Tzara, and Éluard in which all three stated that they did not [...] want me to be excluded."[78] Dalí appeared at this session on February 5th, 1934, with a thermometer stuck in his mouth, claiming that he had influenza. While he spoke, he kept the thermometer between his lips, and from time to time, read off the temperature. He defended himself against Breton's accusations by stating that the dream of the great language of surrealism could not be censored by or through logic, morals, or fear. "I closed with the words: 'Therefore, André Breton, if I dream tonight that we

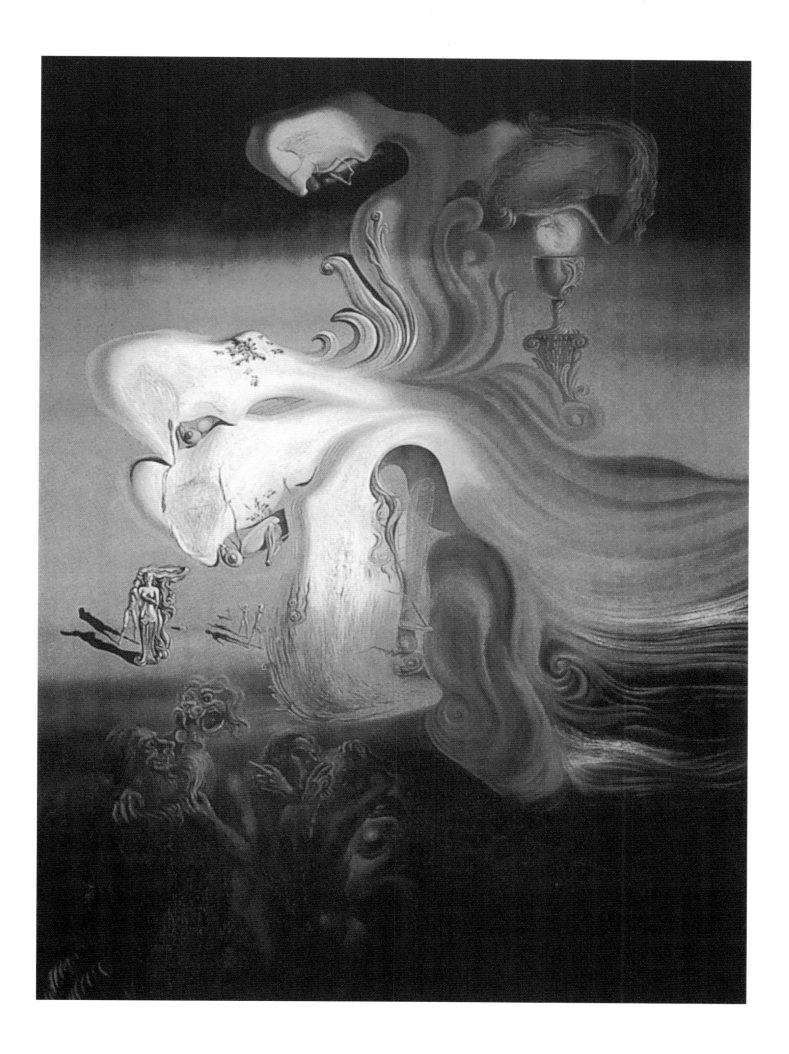

make love to one another, tomorrow morning I will paint our most beautiful positions in intercourse with the greatest wealth of detail.' Breton, mortified, his pipe clamped between his teeth, growled: 'I wouldn't like to recommend you do that my friend.' He was checkmated."[79]

Dalí ended this grotesque interview by exposing his upper body, kneeling on the floor, and solemnly swearing that he was not an enemy of the proletariat.

Even after the Paris group had expelled him Dalí still saw himself as a surrealist, in fact, as the only surrealist: "The difference between the surrealists and myself exists in the fact that I am a surrealist."[80] Gala, who had inspired so many Parisian surrealists during the twenties and thirties, remained muse and model for Dalí alone. The beautiful Russian apparently broke her marriage vows more than once, but, up until her death in 1982, never once left her husband.

79. Dalí: *Becoming the Man*, p. 141
80. *Catalogue 1979*, p. 131

Above: *Remorse or Sunken Sphynx*, 1931
Oil on canvas. 19.1 x 26.9 cm
The Kresge Museum of Art, East Lansing (MI)

Above: *Portrait of Paul Éluard,* 1929
Oil on cardboard. 33 x 25 cm
Formerly The Gala-Salvador Dalí
Collection

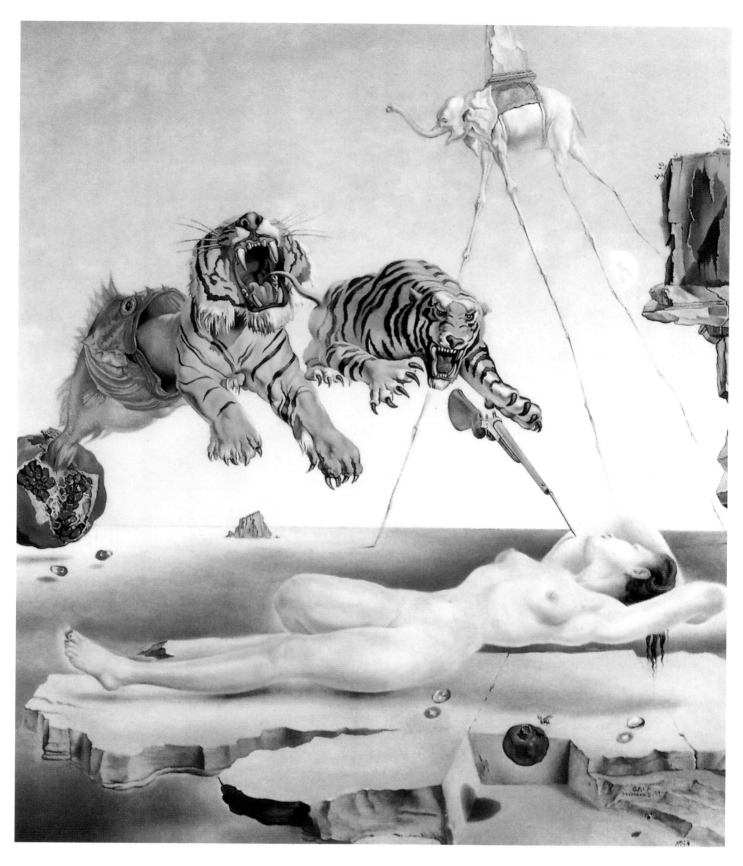

Opposite page: *Surrealist Horse –
Woman-Horse*, 1933
Pencil and pen. 52.6 x 25 cm
The Salvador Dalí Museum,
St Petersburg (FL)

Above: *Dream Caused by the Flight
of a Bee around a Pomegranate,
One Second before Awakening*, 1944
Oil on canvas. 51 x 40.5 cm
The Thyssen Museum, Madrid

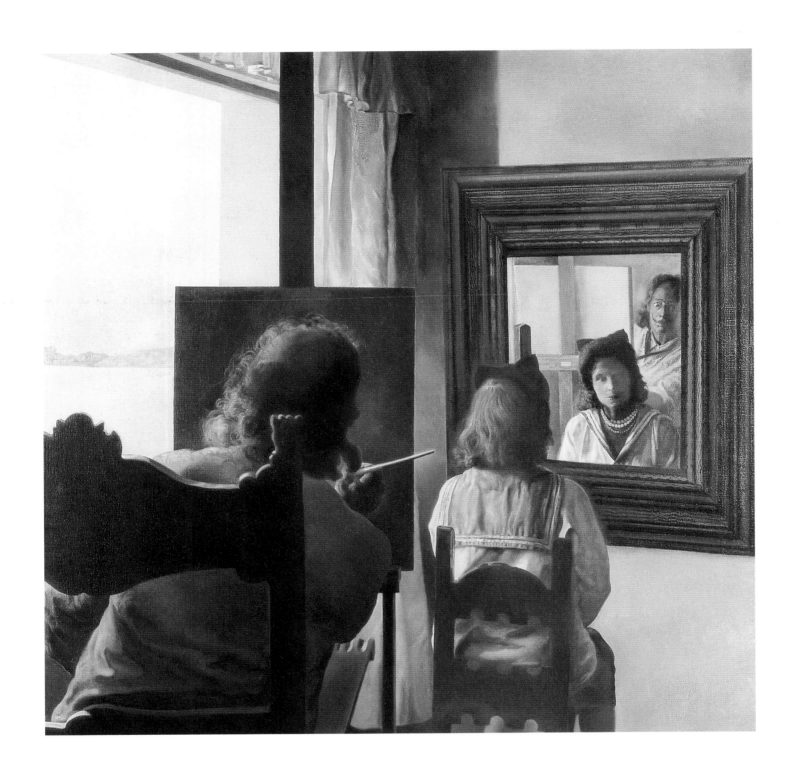

Above: *Dali from the Back Painting Gala from the Back Eternalised by six Virtual Corneas Provisionally Reflected in Six Real Mirrors (unfinished)*, c. 1972-1973
Oil on canvas (stereoscopic work on two components). 60 x 60 cm
The Gala-Salvador Dalí Foundation, Figueras

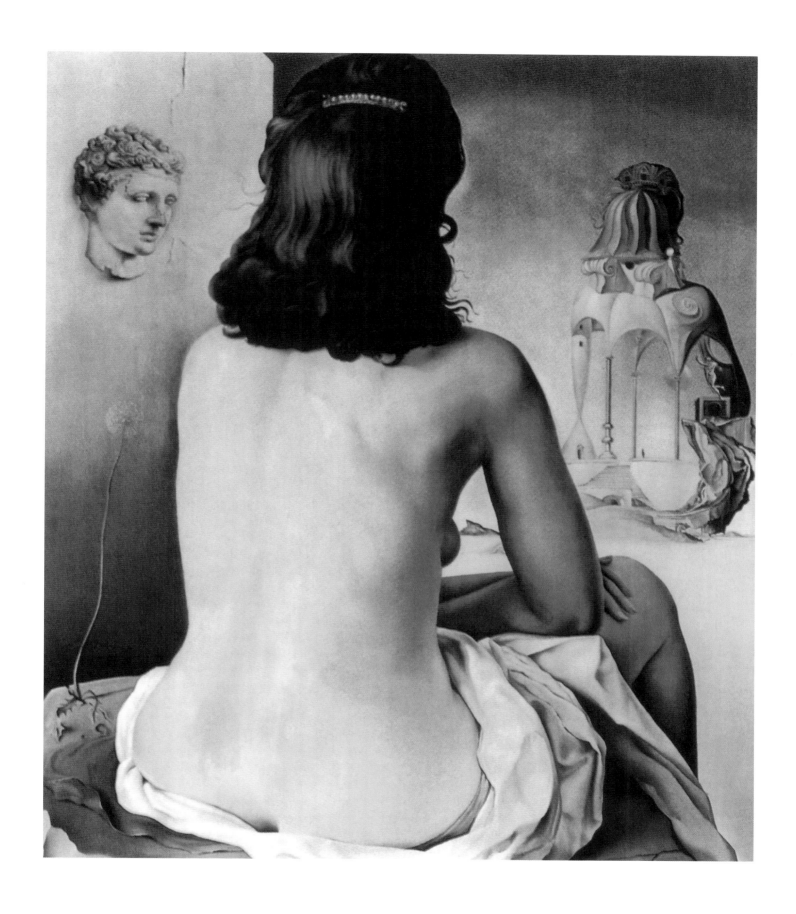

Above: *My Wife, Nude, Contemplating her own Flesh Becoming Stairs, Three Vertebrae of a Column, Sky and Architecture*, 1945
Oil on panel. 61 x 52 cm
The José Mugrabi Collection, New York

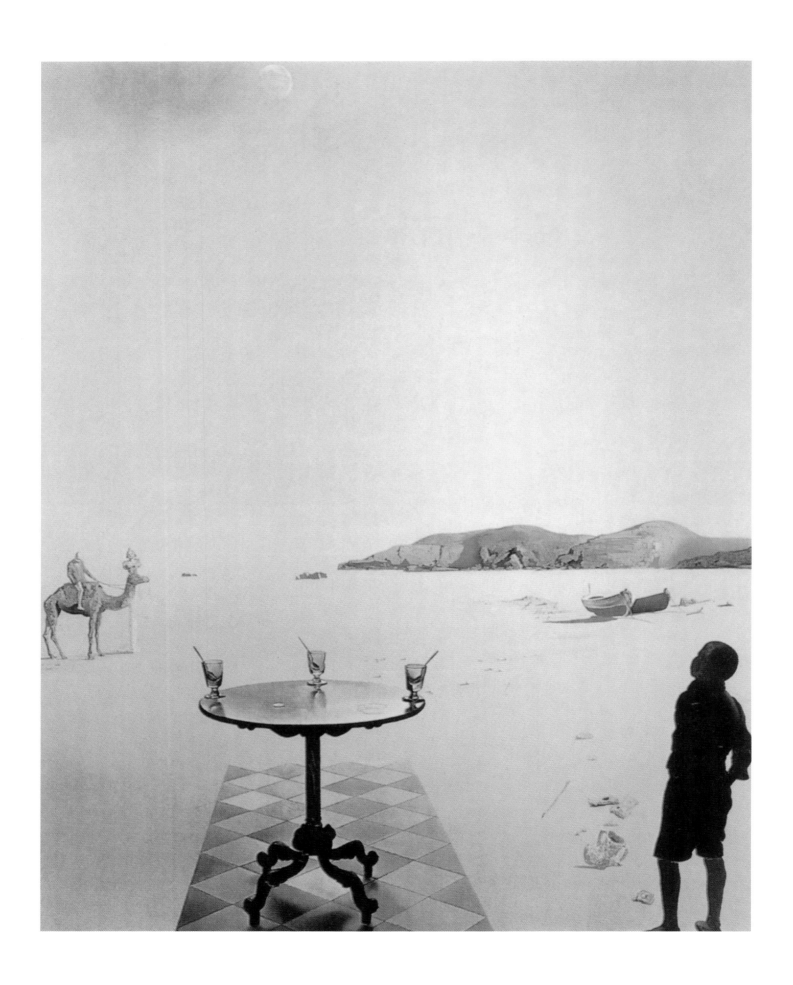

The Pictures behind the Pictures

Paranoia as Method

Dalí developed a counterpoint to Breton's artistic procedure of automatism. He did not orient himself towards the dream or towards insanity but found his model in the person who is paranoid because, in contrast to the maniac, this person possesses the "imperialistic power of conviction"[81] to create other visions. In addition, the person who suffers from paranoia is capable, by means of his "systematic delusion of interpretation,"[82] of registering subtle differences and emotions. A person who lives in fear of somebody poisoning him is capable of sensing all the hostile feelings within his family as a result of this "critical perceptiveness."[83]

Dalí mentions in his autobiography that even as a child he had already developed the ability to recognize different pictures behind optical appearances. As a result of his boredom at school, he spent many long hours observing the moisture stains on the ceiling: "In the course of my endless, exhausting flights of fancy, my eyes untiringly followed the vague outlines of the moldy silhouettes, and out of this chaos as shapeless as clouds, I saw, little by little, tangible pictures forming, which gradually increased in clarity to create elaborate and realistic single forms. [...] The amazing thing about this phenomenon (which was to become the keystone of my future aesthetics) was that, once I had seen one of these pictures, I was quite capable of repeatedly calling up its image through sheer will alone."[84]

In 1929, Dalí noted various ideas on his concept of the double picture. Gala organized his "confusion of unintelligible scribbles" and published it in 1930 under the title *La femme visible – The Visible Woman*.[85] In the first essay of the collection titled *The Donkey's Carcass*, Dalí exclaims that paranoiac activity, in contrast to hallucination, is always linked to controllable, continually recognizable materials: "It suffices that the delusion of interpretation succeeds in linking the meaning of the different perceptions of images of diverse paintings hanging together on a wall, and nobody can further deny the real existence of these links. [...] By way of a clear paranoiac process, it becomes possible to receive a double image of perception: that is, the depiction of an object, that without the least physical or anatomical change is simultaneously the depiction of another wholly different object. [...] The double image of perception, (for example one of a horse which at the same time is a woman) can be extended and continues the paranoiac process; then the existence of another different obsession is enough to motivate the appearance of another third image of perception

81. Television interview from 1975
82. Television interview from 1975
83. Dalí: *Becoming the Man*, p. 257
84. Dalí: *The Secret Life...*, p. 63 f
85. Dalí: *The Secret Life...*, p. 304

Opposite page: *Sun Table*, 1936
Oil on panel. 60 x 46 cm
The Boymans-Van Beuningen Museum, Rotterdam

86. Salvador Dalí: *The Visible Woman*
[*La femme visible*, Paris 1930], quote
from: *Catalogue 1979*, p.276

Above: *Portrait of the Vicomtesse
Marie-Laure de Noailles,* 1932
Oil on panel. 27 x 33 cm
Private collection

(for example that of a lion), and so on, one after the other, until the final contention of one, limited by the number of images of perception, in relation to the degree of paranoic intellectual ability."[86]

Dalí's pictures are the imprint of his "paranoiac clairvoyance". Not unrarely does the process of identifying the secret hidden behind superficial appearances continue over many years. Two examples of this are the paintings, *Angelus* after Jean-François Millet, and the railway station at Perpignan.

Dalí had known Millet's painting since his early childhood: "Every time time I saw the painting of this farmer and his wife, both standing motionless opposite one another, I experienced an inexplicable sensation of disquiet. [...] In June 1932, it suddenly thrust itself into my mind with phenomenal force. [...] It became the source of manic images, not the energy of its spiritual or artistic value, but by way of its psychic significance, which comprised a

whole world of associations, and which suddenly appeared and became objective, a drama was revealed, far removed from the silence and pleasure which the subject was supposed to represent."[87] This "disquiet" was confirmed for Dalí, as he learnt that a "mad man" had slashed the painting in the Louvre.

Dalí attempts to uncover the secret of the *Angelus* by carrying out a picture-analysis: "The woman who stands there with folded hands like one of these postcard-heroines, who beseech the holy Catherine to give them 'a loving man', seems to embody the symbolic attitude of the exhibitionist eroticism of the tarrying virgin – the attitude before the act of aggression, which is similar to the praying-mantis before the cruel mating, which ends with the death of the male. The man stands hypnotized – and destroyed – by the mother. He seems to me to take on the attitude of the son rather than the father. One could say that the hat which he holds, and said in the language of Freud, signifies sexual excitement, in order to demonstrate the shameful expression of manhood."[88]

At the beginning of the sixties, Dalí learnt that Millet had originally painted a coffin containing their dead son between the farmer and the farmer's wife, later painting over the detail, because it appeared to him to be too melodramatic. Dalí asked the Louvre to make an x-ray of the picture, and it was actually possible to see the outlines of the coffin: "Now everything has been explained! My paranoiac-critical genius had guessed the essentials of the matter."[89]

87. Dalí: *Becoming the Man*, p. 170
88. Dalí: *Becoming the Man*, p. 171
89. Dalí: *Becoming the Man*, p. 173

Above: *The Railway Station
at Perpignan*, 1965
Oil on canvas. 295 x 406 cm
The Ludwig Museum, Cologne

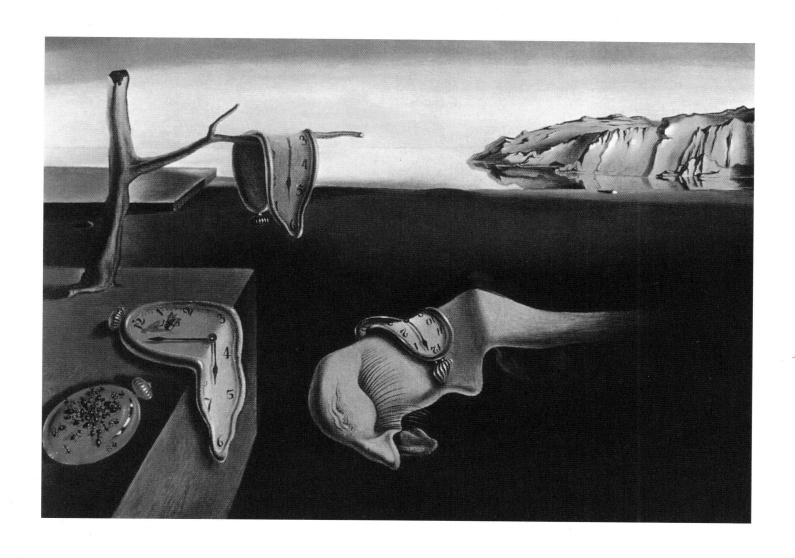

Opposite page: *The Maximum Speed of Raphaëls Madonna*, 1954
Oil on canvas. 81.2 x 66 cm
The Reina Sofía National Museum, Madrid

Above: *The Persistance of Memory*, 1931
Oil on canvas. 24 x 33 cm
Museum of Modern Art, New York

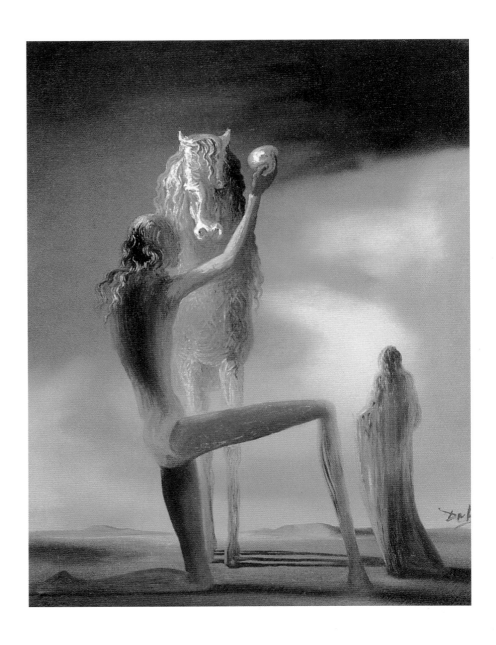

In a similar manner, Dalí found the railway station at Perpignan to be a magical place. After a summer in Cadaqués, during which he had worked on a painting for a very long time without any satisfactory results, he drove to Perpignan with Gala, to send this finished, but uncompleted work, by train. While Gala organized the transportation of the picture, he sat on a bench in the railway station and suddenly it became clear to him how he should have painted the picture.

Every time Dalí came back to Perpignan he had similar experiences. One day he took a taxi and let himself be driven around the railway station: "I arrived at the square at sunset, in all its glory. A light like the heat of many fires, yellow like the yolk of an egg and golden-red, penetrated through the whole building, sprang back through the roaring panes of glass, and flowed over all the facades round about, making the windows of the Hôtel de l'Europe explode in flame. As I lifted my eyes to this dazzling fire, I noticed that the electric cables above the square belonging to the streetcar described a full circle [...] This glass-roof in the sky penetrated by this imperial light had adorned itself with a crackling monarch's crown, and as I saw these cables, I sank into something like a trance accompanied by an erection."[90]

90. Dalí: *My Passions...*, p.148

Above: *The Knight of Death*, 1934
Oil on canvas. 65.5 x 50 cm
The G.E.D Nahmad Collection, Geneva

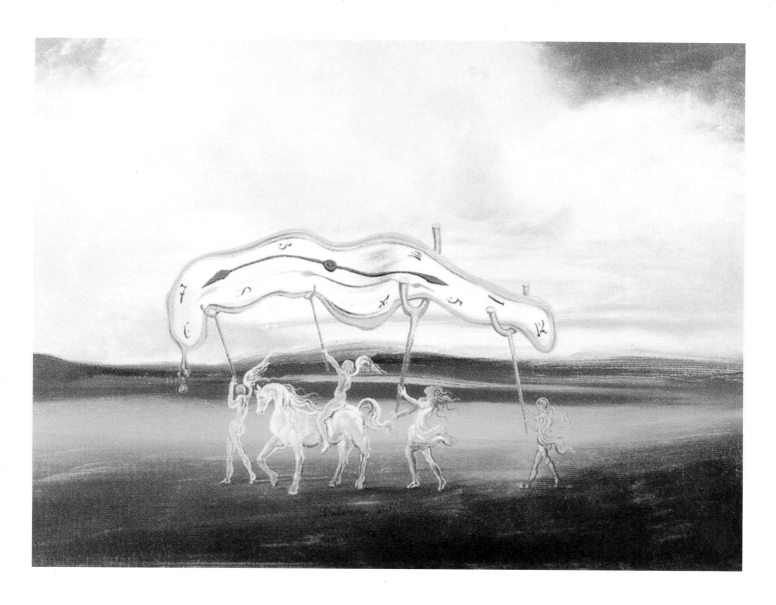

Dalí's opinion was that the railway station is an exact model of the universe, the cosmos. He began to measure out the railway station, and organized hundreds of photographs to try and find the hidden secret on the enlarged prints. He found the explanation for his inspiration in 1966, as he learned, "that the measurements of the earth, and of the meter, had been calculated and laid down in Perpignan. On a perfectly straight twelve kilometer long route stretching between Vernet and the entrance to the town of Salses, north of Perpignan, Méchain had laid down the principles of trigonometrical surveying in 1796, with the help of which the measurements for the meter had been decided. I comprehended the fundamental and metaphysical meaning of this investigation. A meter is not just the 40 millionth part of the Earth's meridian, it is also the formula for the specific weight of God, and this is the reason why this place appeared to me to be so outstanding. The railway station at Perpignan became transformed into a place of genuine holiness."[91]

Dalí quoted Millet's *Angelus* in many of his paintings. The farming couple also appeared portraying the universe in 1965 in his vision of the *Farm at Perpignan*.

Independent of other developments, the paranoic-critical method remained the basic principle in Dalí's work. The analysis however, did not always take place over a series of years. Often

91. Dalí: *Becoming the Man*, p. 174

Above: *Wounded Soft Watch*, 1974
Oil on canvas. 40 x 51 cm
Private collection

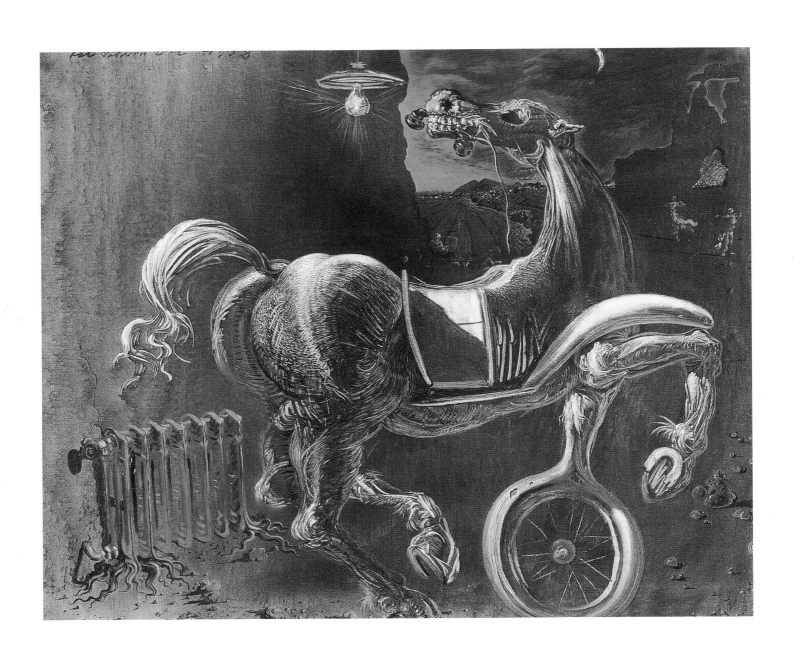

Above: *Debris of an Automobile Giving
Birth to a Blind Horse Biting a
Telephone*, 1938
Oil on canvas. 54 x 65 cm
Museum of Modern Art, New York

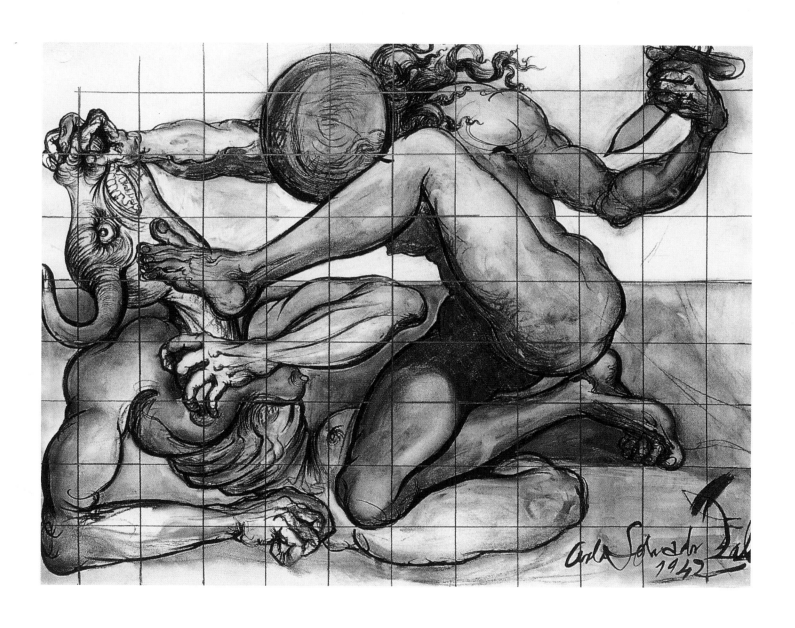

Above: *Fighting the Minotaure*, 1942
Pencil, Indian ink, watercolour and
gouache. 58.6 x 73.8 cm
The Gala-Salvador Dalí Foundation,
Figueras

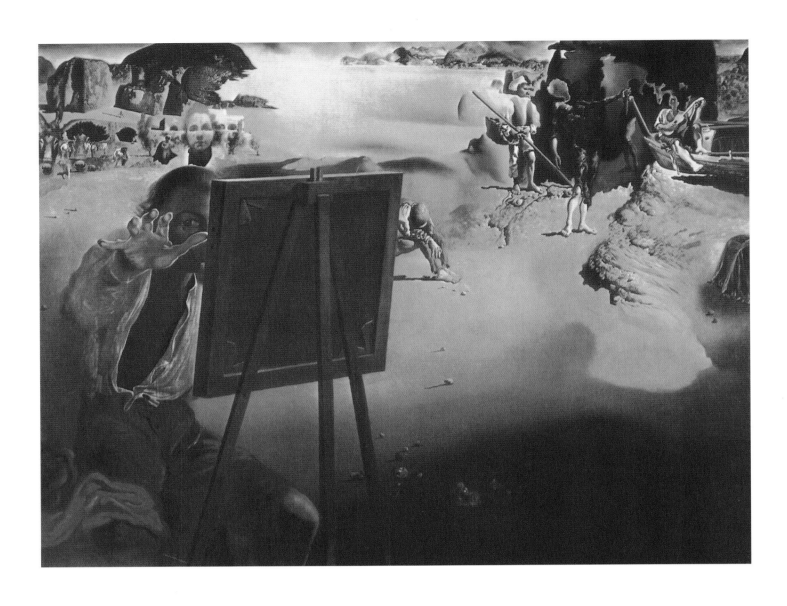

92. Dalí: *The Secret Life...*, p. 389 f

Above: *Impressions of Africa*, 1938
Oil on canvas. 91.5 x 117.5 cm
The Boymans-Van Beuningen Museum,
Rotterdam

discoveries in the form of spontaneous over-blending occured, as in the case of his renowned melting watches. Dalí discusses the genesis of the painting, *The Persistence of Memory*, in his autobiography: "It occured one evening as I felt tired and had a light headache, which is something that happens to me very rarely. We had wanted to go out to the cinema with a couple of friends but at the last moment I decided not to go [...]. Having concluded our dinner with a very strong Camembert and after the others had gone, I remained sitting quietly at the table for a long time considering the philosophical problem of 'Super-Softs' that the cheese had brought to my attention. I stood up, went into my atelier and turned on the light to take one last look at the picture I was presently working on, as was my habit. This picture depicts the landscape at Port Lligat; the cliffs lie in a transparent, melancholy dusk light and an olive-tree with severed branches devoid of leaves stands in the foreground. I knew that the atmosphere which I had been able to create with this landscape was the background for an idea that would serve to create a surprising picture but I didn't know in the slightest what it would be. I was just about to turn off the light when I suddenly 'saw' the answer. I saw two melting watches, one hanging pathetically over the branch of the olive-tree. Although my headache had become so strong that I was suffering, I readied my palette impatiently and got down to work."[92]

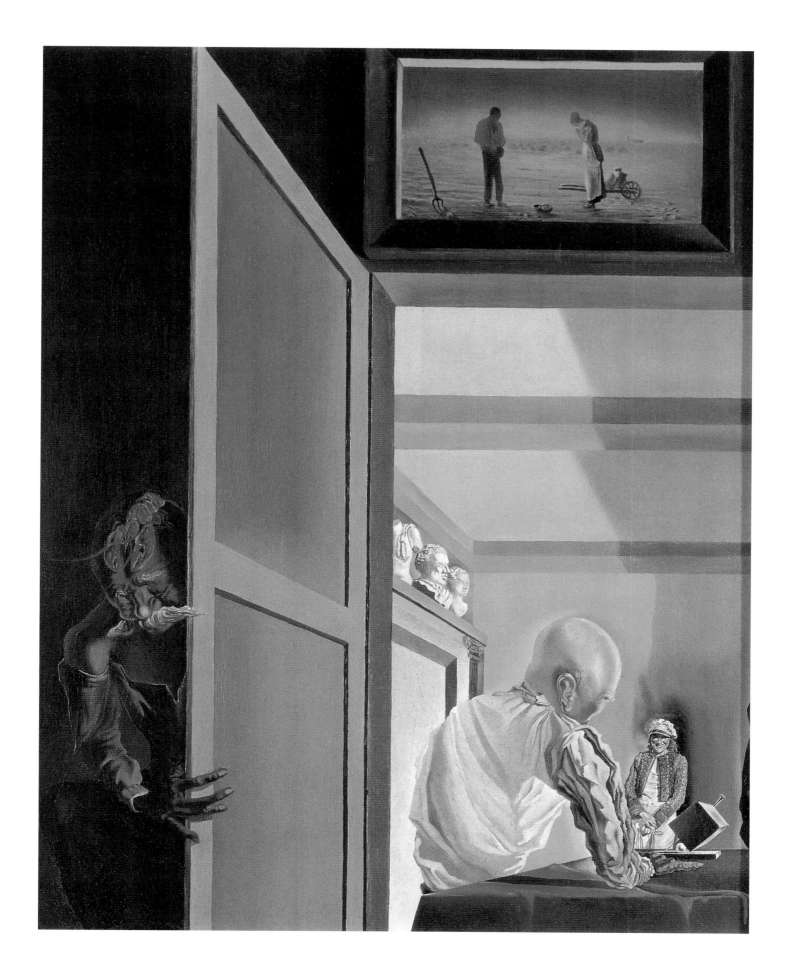

Above: *Gala and the Angelus of Millet Preceding the Imminent Arrival of the Conical Anamorphoses*, 1933
Oil on panel. 24 x 18.8 cm
The National Gallery of Canada, Ottawa

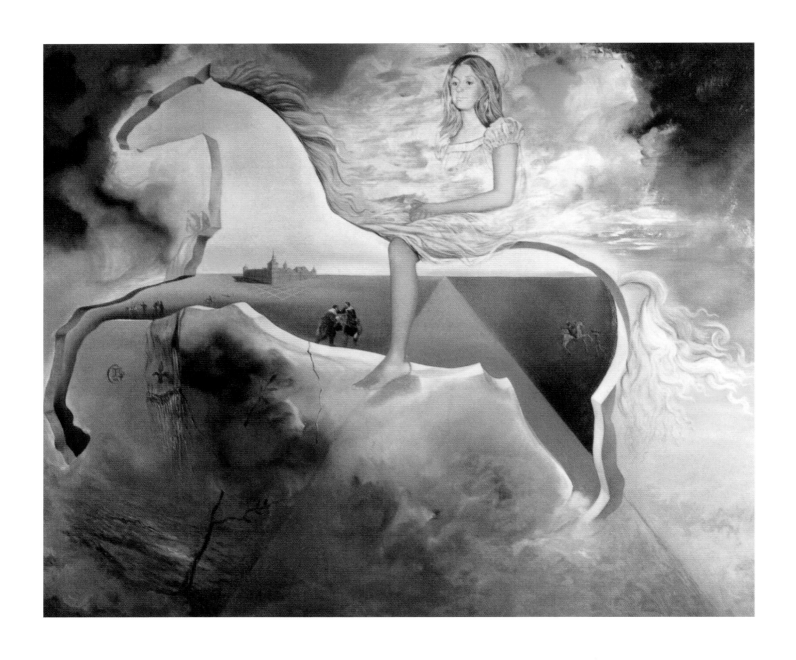

Above: *Equestrian Portrait of Carmen Bordiu-Franco*, 1974
Oil on canvas. 160 x 180 cm
Private collection

Opposite page: *Poetry of America, the Cosmic Athletes*, 1943
Oil on canvas. 116.8 x 78.7 cm
The Gala-Salvador Dalí Foundation, Figueras

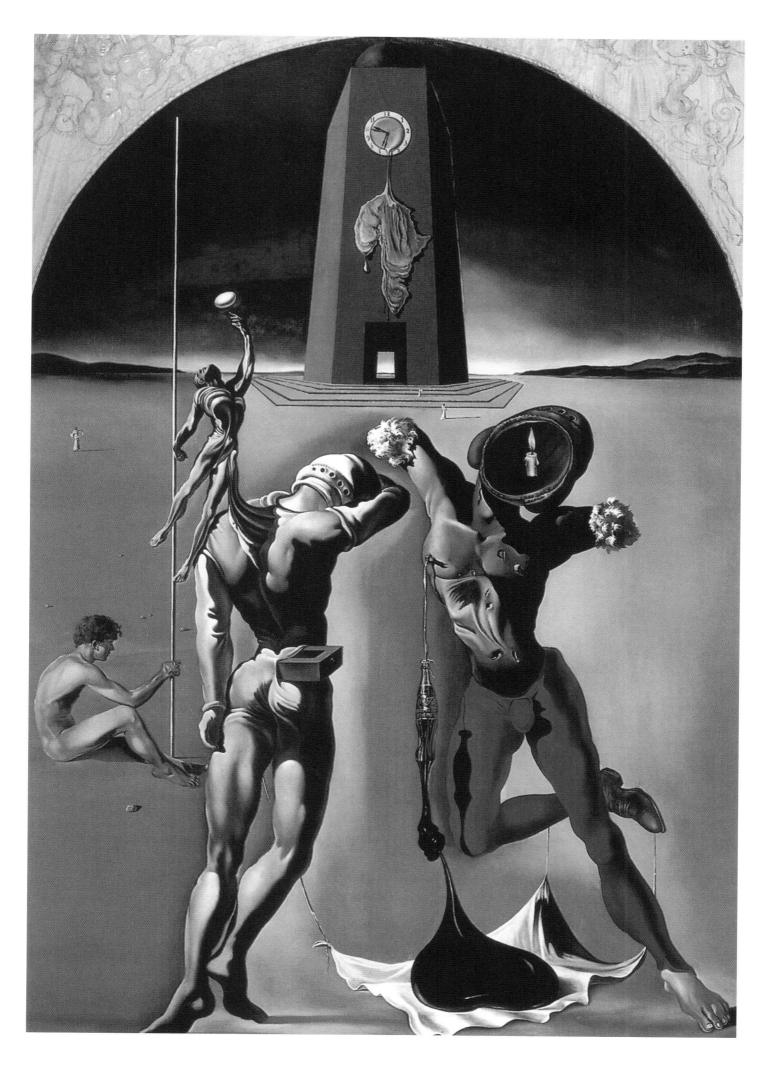

103

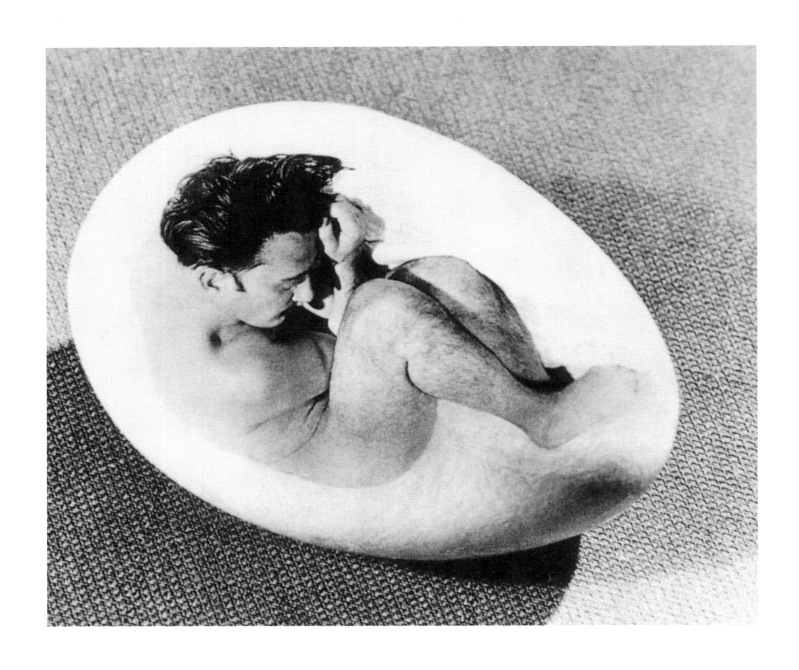

Above: *Dalí in the Egg*, 1942
Photography by Philippe Halsman

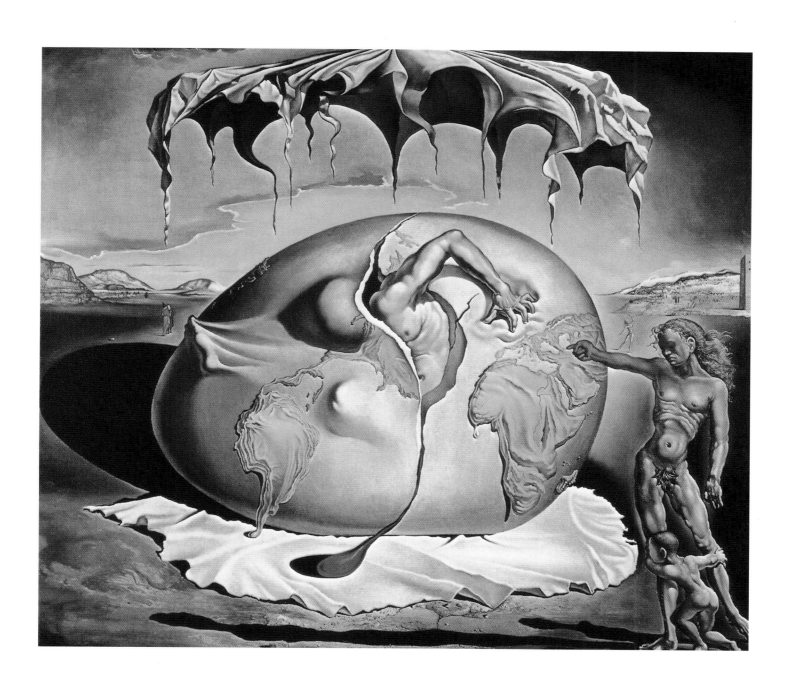

Above: *Geopolitical Child Watching the Birth of the New Man*, 1943
Oil on canvas. 45.5 x 50 cm
The Gala-Salvador Dalí Foundation, Figueras

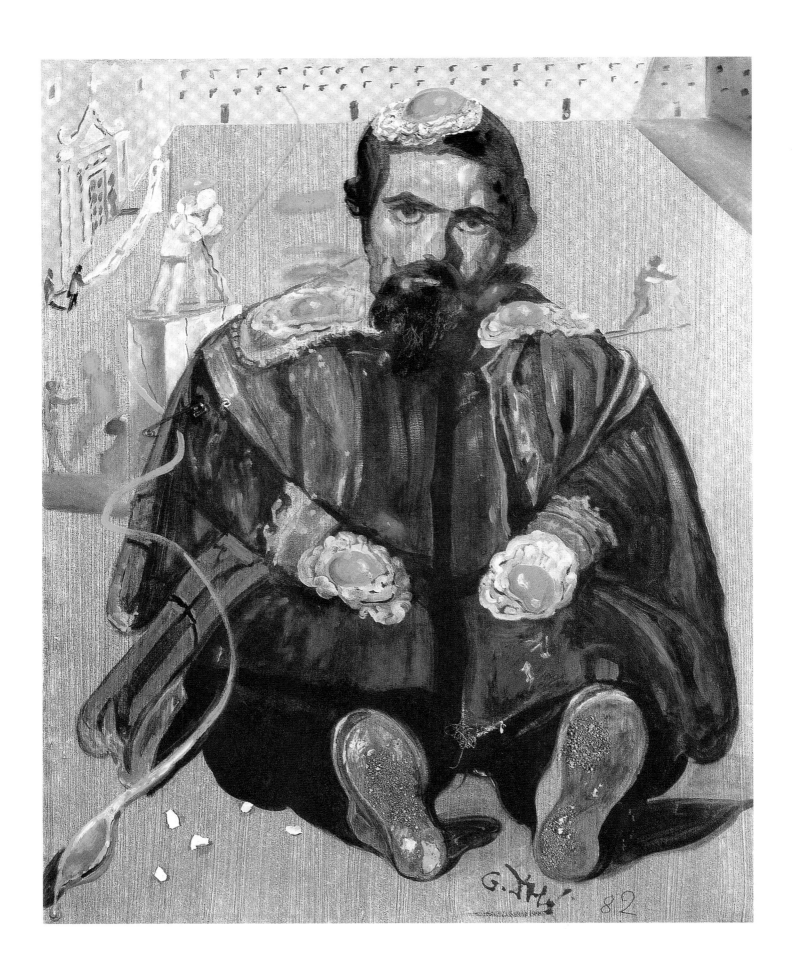

106

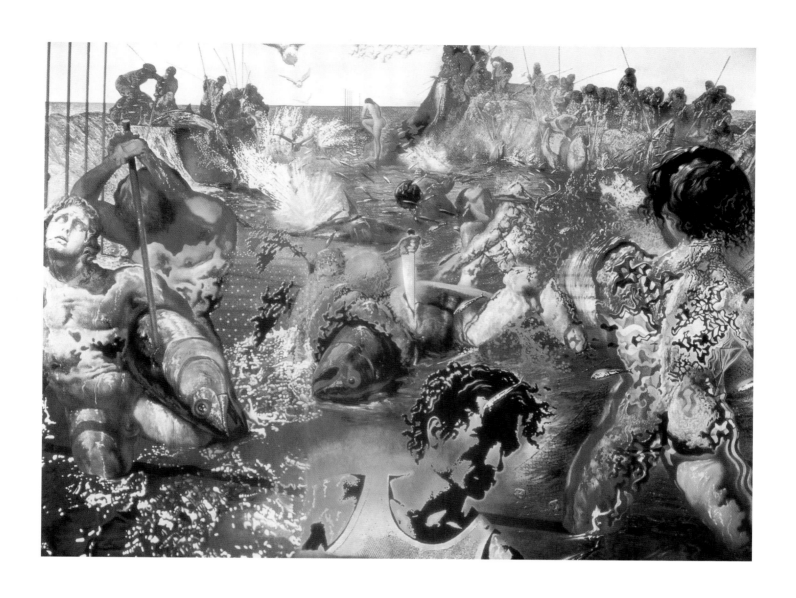

Opposite page: *Velásquez Dying behind the Window on the Left Side out of which a Spoon Projects*, 1982
Oil on canvas with collages. 75 x 59.5 cm
The Gala-Salvador Dalí Foundation, Figueras

Above: *Tuna Fishing*, c. 1966/1967
Oil on canvas. 304 x 404 cm
The Paul Ricard Foundation, Isle of Bendor

Between Worlds

First Successes in America

In November of 1934, Dalí and Gala travelled to the United States for the first time. Dalí's work had been known there since the end of the twenties. The painting, *Basket of Bread*, had been hanging in the Carnegie Museum of Art in Pittsburgh since 1926. Three further pieces, amongst them *The Persistence of Memory*, had been bought by the New York Museum of Modern Art after it had been exhibited in Julien Levy's gallery in January 1932. Levy, who was one of the first to introduce the European surrealists to the USA, exhibited Dalí's pictures in several other group-exhibitions, and in the winter of 1933, he devoted his first single exhibition to him.

Lack of money was not the sole reason why Dalí had put off a trip to the USA for so long: he was also afraid of the crossing. Reporting on his trip on the *Champlain* he tells of how he spent the whole journey practising abandoning the ship and drinking champagne.

On his arrival in New York, Dalí attempted to impress the reporters with some of his ideas. He let the ship's cook bake him a baguette, which he wrapped in newspaper and held in his hand the whole time during the interview. However the journalists did not respond to his gimmick: "All these reporters were extremely well informed about who I was. Not only that. They knew the most astounding details of my life. They asked me straight away if it is true that I had recently painted a portrait of my wife with a couple of fried chops on her shoulders. I replied, yes, but that they were not fried, but raw. Why raw? They wanted to know straight away. And I replied, because my wife is also raw. But why the chops together with your wife? And I replied, because I like my wife and I like chops and I saw no reason not to paint them together. These reporters were undoubtedly far better than their European counterparts. They had a fine feeling for 'nonsense', and moreover, one also got the impression that they were perfect masters of their job. They knew well in advance what would get them a good 'story'."[93]

Dalí's exhibition at the Levy gallery in 1934 was criticised by some newspapers as being a "fashion show" but for the public it was an unrivalled success. The new world offered Dalí unbridled possibilities for celebrating the sensational and eccentric. In December, he delivered a lecture in front of two-hundred visitors on the occasion of an exhibition of his work in Hartford (Connecticut) in which he defined himself: "The difference between me and a mad man is: I am not mad."[94]

93. Dalí: *The Secret Life...*, p. 405
94. *Catalogue 1989*, p. 485

Opposite page: *Mad Mad Mad Minerva*, 1968
Gouache and Indian ink with photo collages on paper. 61 x 48 cm
The Kalb Gallery, Vienna

95. Dalí: *The secret Life...*, p. 415

Above: *Portrait of Gala with Two Lamb Chops Balanced on her Shoulder*, 1933
Oil on olive panel. 6 x 8 cm
The Gala-Salvador Dalí Foundation, Figueras

Shortly before the Dalís returned to the old world in January 1935, Caresse Crosby organized a parting celebration at the elegant New York restaurant, Coq Rouge. This "dream-ball" has gone down in history as the first surrealist's ball. Dalí was impressed by the crazy ideas of the guests: "Society women appeared with their heads stuck in bird-cages and otherwise practically naked. [...] A man in a bloodied nightshirt wore a bedside table on his head, out of which a flock of humming-birds flew all in one moment. In the middle of the staircase a bathtub full of water had been hung, which threatened to fall down and empty its contents over the heads of the guests at any moment. And in the corner of the hall hung a butcher's hook with a whole, hollowed-out ox hanging from it, the gaping belly of which was held open with crutches, and stuffed full with half a dozen gramophones. Gala appeared at the ball as a 'discerning corpse'. On her head she carried a very life-like doll in the form of a child half devoured by ants, with its skull stuck between the pincers of a phosphorizing lobster."[95]

On their arrival in Paris, the Dalís were greeted with the news that they had caused a scandal in New York. The French daily newspaper *Petit Parisien* reported that Gala had worn a gory replica of the abducted Lindbergh baby on her head at the ball.

Dalí denied this: "The only one in New York who knew of this scandal was the French correspondent of the *Petit Parisien*, and he was not even present at the ball. However, in Paris, the news spread like wild-fire, and our arrival provoked a great deal of dismay."[96]

For Dalí, the atmosphere in the French capital felt oppressive: the surrealists were getting caught up in political conflict. He decided to escape with Gala to the isolation of Port Lligat. The former fishing cottage was slowly being transfomed into a home. Like a honeycomb, the Dalís were continually adding new rooms to their house.

The peace on the Catalan coast did not last for long. In Barcelona, the first bombs were exploding – an antecedent to the civil war. The Dalís decided to travel. Until 1940, they remained underway constantly. Twice in the winter of 1936/1937 and in January 1939 they traveled to the USA. In between times they lived in Italy and the south of France.

Dalí decided "decisively" that he was not a historical person.[97] The war also failed to alter his point of view. In pictures like *Soft Construction with Boiled Beans – Premonition of the Civil-War,* he showed his vision of the carnage. The political dimension of the state of affairs in his fatherland, however, did not interest him at all. He instead turned to studying the painting of the Renaissance and in Florence and Rome occupied himself with the architecture of Bramante and Palladio.

The Dalís only traveled to Paris "to call on higher company."[98] Aristocracy and money were a particularly attractive force for Dalí even if he did despise the majority of his rich acquaintances: "Most of the men in society lacked every expression of intelligence, but their wives wore jewels which were as hard as my heart, perfumed themselves extravagantly, and loved the music that I despised. I simply remained the naive, sly Catalan farmer, in whose body a king resided."[99]

In Dalí's opinion, the history of the time was not reflected in the conversations of the surrealists in the cafés of Montmarte, but at the Place Vendôme, in the heart of the fashion world. Dalí had befriended the fashion-designers Coco Chanel and Elsa Schiaparelli. In the designs of Schiaparelli, Dalí saw "new morphologies" which reflected the dissolution of society on the eve of the Second World War. The Italian-born woman, who opened her salon at the Place Vendôme in 1935, shook the fashion world with her "shocking" designs in stinging pink. She brought wide shoulders back into fashion and loved using cloth featuring optical effects such as human skeletons or tattoo-motifs.

Dalí drafted a perfume bottle in the form of a golden mussel for Schiaparelli as well as a shoe-hat and some clothing. These excursions into the world of design brought him into bad favour in the art world. André Breton formed the anagram "Avida Dollars" – "dollar hungry" – out of the letters of the name Salvador Dalí. Dalí took up the derisive characterization again later when in the mid-sixties the French publisher Albin Michel asked him to write an open letter to himself. In this letter, Dalí, the surrealist, addresses "Avidadollars".[100]

96. Dalí: *The Secret Life...*, p. 415
97. Dalí: *The Secret Life...*, p. 439
98. Dalí: *The Secret Life...*, p. 417
99. Dalí: *The Secret Life...*, p. 417
100. *Catalogue 1979*, p. 131

Above: *Soft Construction with Boiled Beans – Premonition of Civil War*, 1936
Oil on canvas. 100 x 99 cm
The Philadelphia Museum of Art, Philadelphia

Opposite page: *The Burning Giraffe*, 1936-1937
Oil on panel. 35 x 27 cm
Kunstmuseum Basel, Basle

101. Dalí: *The Secret Life...*, p. 423
102. Dalí: *The Secret Life...*, p. 424

Above: Hats designed for Elsa
Schiaparelli, 1936

Avida Dollars, 1954
Photo-Portrait by Philippe Halsman

Dalí was in the process of achieving his goal: becoming famous not just amongst a small circle of discerning artist-friends but to a much larger audience as well. On his second trip to New York in December 1936, *Time* magazine devoted the title page to him. It featured a portrait that Man Ray had taken of him. The day after the opening of the second single exhibition at the Levy gallery, all twenty-five paintings and twelve drawings were sold. Later Dalí described this visit to the USA as the "official beginning" of his fame: "I have never quite understood the speed with which I became so popular. Frequently people recognized me in the street and asked for my autograph."[101]

Dalí was showered with offers of work. For the New York luxury department store Bonwit-Teller on Fifth Avenue, he decorated a display window: "I used a jointed-doll, with a head made out of red roses and fingernails of ermine. On a table stood a telephone that turned into a lobster; and over the chair hung my famous, aphrodisiac jacket: a tuxedo, the back of which was covered with eighty-eight liqueur-glasses filled with green *crème de menthe* arranged in rows and columns next to one another, and with each single glass containing a straw and a dead fly."[102]

Dalí started a fashionable trend with this decoration: when he returned to New York two years later, he noticed that an array of display windows on the elegant shopping-street had been decorated *à la Dalí*. In order to demonstrate the difference between the real and the imitated surrealist decorations, he designed two further displays for Bonwit-Teller. This time, he used dusty old wax-dolls from the year 1900, which he had found in the attic at the department store. "The theme [...] was deliberately banal. One window symbolised the day, the other the night. In the 'day time' display, one of these dolls is climbing into a 'hairy' bathtub laid-out with astrakhan, and filled to the brim with water. [...] The 'night' was symbolized by a bed, the canopy of which consisted of the drowsy black head of a buffalo holding a bloody pigeon in its mouth; the feet of the bed were made out of buffalo hooves. The

black satin bed-sheet had burn-holes in it, through which one could see artificial coals burning. The pillow, on which the doll rested its dreamy head, was made completely out of these hot coals."[103]

As Bonwit-Teller changed this decoration a day later – the dolls were exchanged for others, the burning bed was removed – Dalí smashed-in the display window. He spent a night in prison. In the press, he was lauded for his open fight for the "independence of American art, which all too often is threatened by the inefficiency of industrial and commercially oriented middlemen."[104]

A short time later, Dalí was again confronted by the limits of artistic freedom. An American public company employed him to design a pavilion for the World Fair in New York. As his subject, Dalí chose the *Dream of Venus*. He drafted a 2.4 x 4.8 meter-large mural, with quotations from his most renowned pictures: melting watches, a burning giraffe, a drawer-woman. For the opening of the World Fair on May 21st, 1939, Dalí planned a surrealist "happening". In a tank filled with water, seventeen mermaids are supposed to act out several different absurd activities. One was to milk an underwater cow, another was to play an imaginary piano.

The preparations turned into a nightmare for Dalí: "For my girls, I had designed bathing suits according to the ideas of Leonardo da Vinci; instead they continually brought me mermaid-suits with rubber fishtails! I realized that soon everything was

103. Dalí: *The Secret Life...*, p. 458 f
104. Dalí: *The Secret Life...*, p. 465

Above: *Night and Day Clothes of the Body*, 1936
Gouache on paper. 30 x 40 cm
Private collection

going to turn into a fishy tale – that is, into a disaster!"[105] Dalí cut off the undesirable mermaid tails and altered the other costumes and decorations which failed to correspond to his wishes. "Resigned, they declared themselves ready to carry out everything that my royal desire decrees. However my battle was still not over; now the sabotage began. They did everything that I ordered, 'just about', but so badly and deceitfully, that the pavilion was doomed to become a lamentable caricature of my ideas and designs."[106]

Dalí realised that his name was merely being used as an advertising-gimmick for the pavilion, and that his art was clearly unwanted. When the organisers of the World Fair finally prohibited his displaying a reproduction of Botticelli's *Venus*, whose head had been replaced with a fish-mouth, Dalí's patience reached full tether. He wrote his *Declaration of Independence of Fantasy and the Right of Mankind to Madness.*

During his return trip to Europe in September, he mulled over the incidents again and reached the conclusion that his admiration for the "elementary and biologically secure force" of American democracy had suffered in no way: "On the contrary, because where one can converse with an open pair of scissors in the hand, enough healthy meat exists to slice and enough freedom for every form of hunger. Unfortunately the Europe that I encountered on my return had already been drained by masturbatory, sterile self-refinement."[107]

In Europe war had begun. In their search for a place to live, the Dalís combined the possibility of Nazi-invasion "with gastronomical potential".[108] They chose Arcachon near Bordeaux and moved into a large villa built in the colonial-style. Several guests also lodged there: Coco Chanel spent some weeks with them; Marcel Duchamp hurried down from Paris, because he feared the French capital would soon be bombed. In Arcachon, the war seemed a long way away.

In June however, the first bombs began to fall on Bordeaux. The Dalís decided to escape to the USA. While Gala drove directly to Lisbon to organise a ship's passage, Dalí took a detour via Figueras. He visited his father and sister, whom he had not seen for eleven years.

The civil war had also left scars on his family home – his sister had been tortured by the military intelligence and been driven into madness. A bomb had destroyed the balcony on the house. The tiled floor in the dining room had been blackened by fire. Nevertheless, Dalí found that in itself, "fundamentally", nothing had changed: the furniture stolen from the house during the unrest had, with time, been returned to its place. For Dalí, this was proof that the survival of things was much stronger than each revolution: "The process of 'being' seemed to obey the physical laws of the silent, traditional surfaces of the metaphysical seas of history – which, contradictory to the principles of Hegelian dialectic, recover their identity after each revolution."[109]

The visit to Figueras supported Dalí's belief that the war in Europe would not bring any change. In his opinion, the old world destroyed itself, not to give birth to something new, but instead to return to the roots of tradition. Dalí already sensed the coming

105 Dalí: *The Secret Life...*, p. 465
106 Dalí: *The Secret Life...*, p. 466
107 Dalí: *The Secret Life...*, p. 467
108 Dalí: *The Secret Life...*, p. 471
109 Dalí: *The Secret Life...*, p. 477

Opposite page: *Surrealist Poster*, 1934
Oil on chromolithographic advertising
poster with key. 69 x 46 cm
The Salvador Dalí Museum,
St Petersburg (FL)

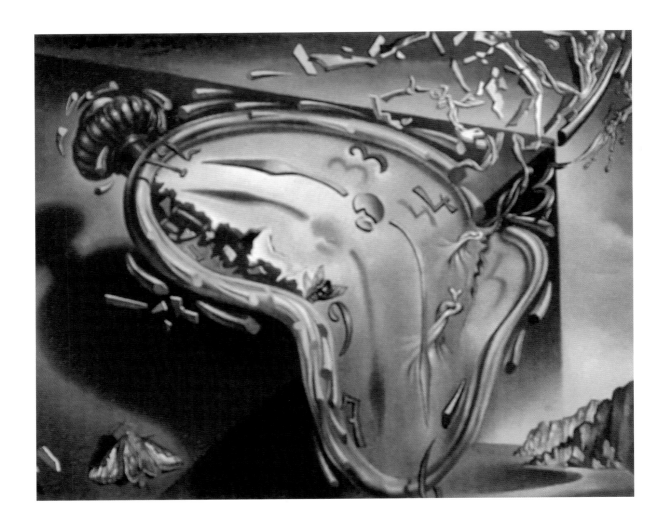

renaissance and began to work on a cosmogony, on a world design, created by Dalí, the divine.

He accepted his departure to the USA by reasoning that he needed a quiet place to prepare the genesis of his world-design: "I simply needed to remove myself from the blind and turbulent collective jostling of history, otherwise the classical, half-divine embryo of my originality would have been damaged, and considering the degrading circumstances, may have suffered a philosophical miscarriage on the sidewalk of the anecdote!"[110]

Arriving in the USA, Dalí wrote his autobiography. It was an act of shedding his skin – he stripped off his hitherto existing life: "My metamorphosis is tradition, because tradition means nothing more than shedding your skin, rediscovering a new, original skin, which is simply the ineluctable consequence of the biological form that went before. It is neither surgery nor mutilation, nor revolution – it is renaissance."[111]

110. Dalí: *The Secret Life...*, p. 482
111. Dalí: *The Secret Life...*, p. 485

Above: *Explosion*, 1954
Oil on canvas. 20.5 x 25.7 cm
Private collection

Above: *Geodesic Portrait of Gala*, 1936
Oil on panel. 21 x 27 cm
Yokohama Museum of Art, Yokohama

Above: *A Couple with their Heads Full of Clouds*, 1936
Oil on panel. 92.5 x 69.5 cm (man);
82.5 x 62.5 cm (woman)
The Boymans-Van Beuningen Museum,
Rotterdam

Opposite page: *Wind Palace*, 1972
Ceiling painting of the Old Teatro Museo

121

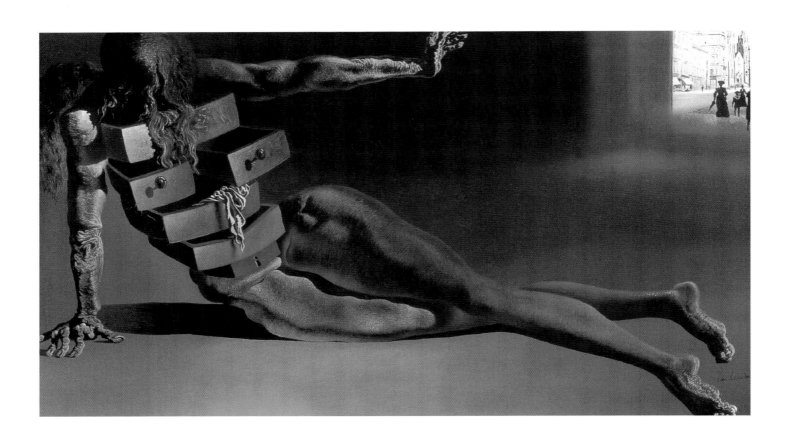

Opposite page: *The Anthropomorphic Cabinet*, 1936
Oil on panel. 25.4 x 44.2 cm
Kunstsammlung Nordrhein-Westfalen,
Düsseldorf

*Suburbs of a Paranoiac-Critical Town:
Afternoon on the Outskirts of European
History*, 1936
Oil on panel. 46 x 66 cm
The Boymans-Van Beuningen Museum,
Rotterdam

Above: *Napoleon's Nose, Transformed
into a Pregnant Woman, Walking his
Shadow with Melancholia amongst
Original Ruins*, 1945
Oil on canvas. 51 x 65.5 cm
The G.E.D Nahmad Collection, Geneva

Above: *Cover of Minotaure no. 8*, 1936
Ink, gouache and collage on cardboard
33 x 26.5 cm
Isidore Ducasse Fine Arts, New York

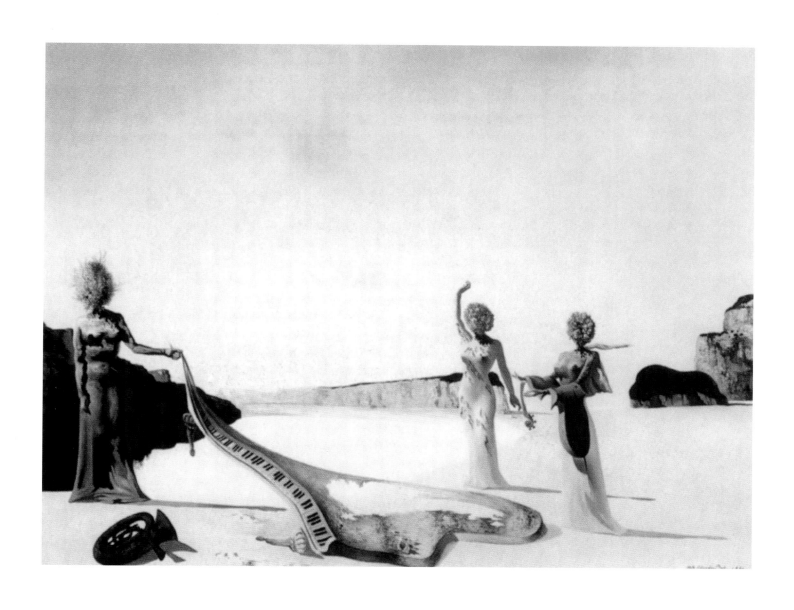

Above: *Three Young Surrealist Women Holding in their Arms the Skins of an Orchestra*, 1936
Oil on canvas. 54 x 65 cm
The Salvador Dalí Museum,
St Petersburg (FL)

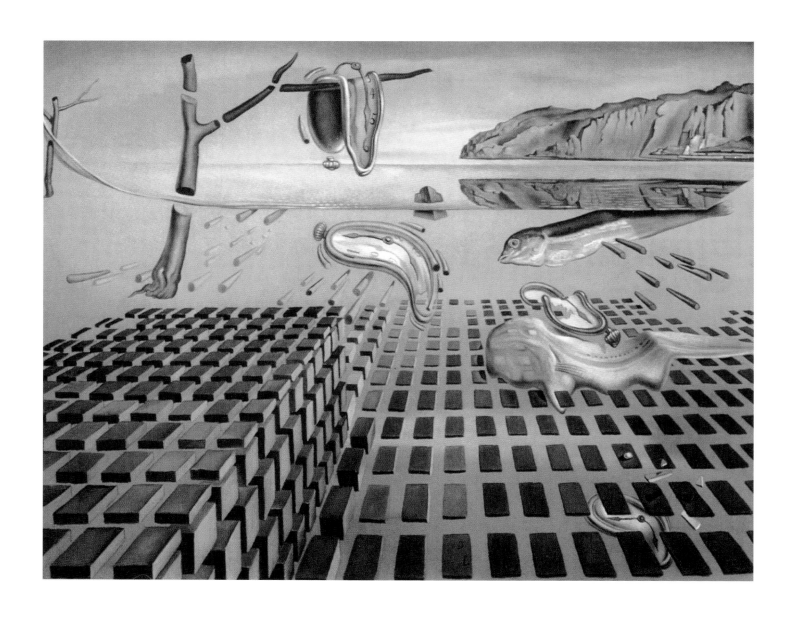

Above: *Desintregration of the Persistance of Memory*, 1952-1954
Oil on canvas. 25 x 33 cm
The Salvador Dalí Museum,
St Petersburg (FL)

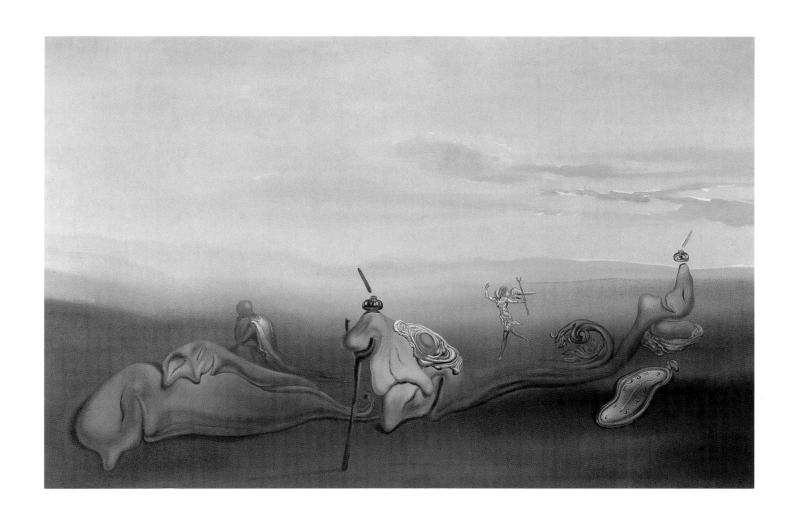

Above : *Soft Heads with Egg on a Plate without a Plate, Angels, and Soft Monsters in an Angelic Landscape*, 1977
Oil on canvas. 61 x 91.5 cm
Private Collection

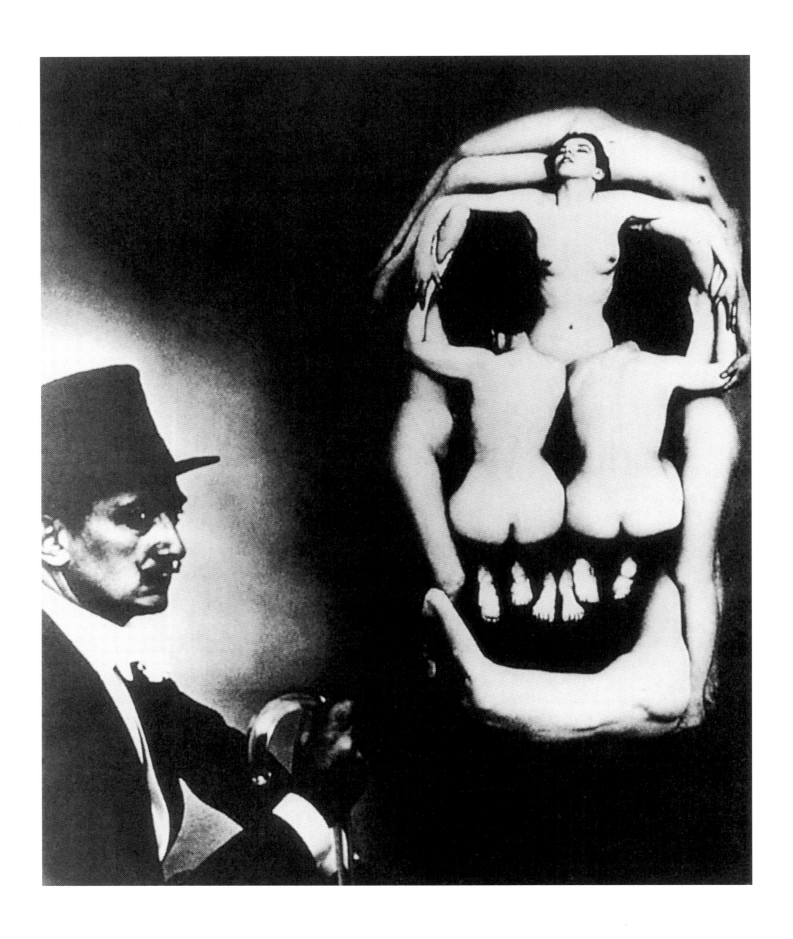

128

Break out into Tradition

The Renaissance of the Universal Genius as Marketing Expert

During his stay in Italy in 1937, Dalí had begun his studies of the Renaissance. In the painters of the 15th and 16th centuries, he found the meaning of death and eroticism, which he had already discovered in himself at an early age. Compared with the pictures of Raphael and Vermeer, his own work appeared meaningless: "What remained for one to discover that had not already been experienced with visual ultrasensitivity by Vermeer van Delft and which would surpass the gigantic metaphorical efforts of all the collected poets in objective poesy and perceived originality! Being classical means so much of 'everything' needs to exist and that everything needs be so perfectly ordered and hierarchically organized, that the innumerable details of the work nevertheless become more visible."[112]

Dalí saw himself as a universal genius in the sense of Leonardo da Vinci. He had always worked in a variety of different disciplines besides painting: he had studied philosophy and psychoanalysis, had written scripts, had designed furniture and clothing, had created scenery and costumes for drama and opera and had choreographed a ballet. At the end of 1939, he led the Metropolitan Opera in his first dramatic work titled, *Bacchantal*, based on motifs from Wagner's *Tristan and Isolde*. The break which Dalí decided upon at the beginning of his eight-year stay in the new world, was primarily based on the decision to transform the name that he had acquired into a lucrative market. Dalí also makes reference here to the Renaissance and Michelangelo, who had designed the uniforms of the Swiss Guard for the Vatican.

In 1941, the Dalís moved into a house at Pebble Beach not far from Los Angeles. Dalí made reference to his life under the Californian sun in 1941 in his *Soft Self-Portrait with Fried Bacon*: his face exists as a soft mass, merely given form by the presence of supporting crutches. The only distinctive Dalían trait is the curl of the eyebrows and the moustache, the tips of which are twisted upwards.

The beard became his trademark. A decisive role here was played by the photographer Philippe Halsman. One of the first photographs by Halsman taken of the artist at the beginning of the nineteen-forties, shows Dalí in tails, in front of a skull formed out of naked women's bodies, sporting a top hat and cane. In another picture, he is naked and doubled-up like a fetus. Halsmann also designed the dust-jacket for Dalí's autobiography which appeared in 1942 in English. None of the portraits he published in his 1954

112. Dalí: *The secret Life...*, p. 435

Opposite page: *Human Skull Consisting of Seven Naked Women's Bodies*
Photograph by Phlippe Halsman after a drawing by Dalí in 1951
The Ludwig Museum, Cologne

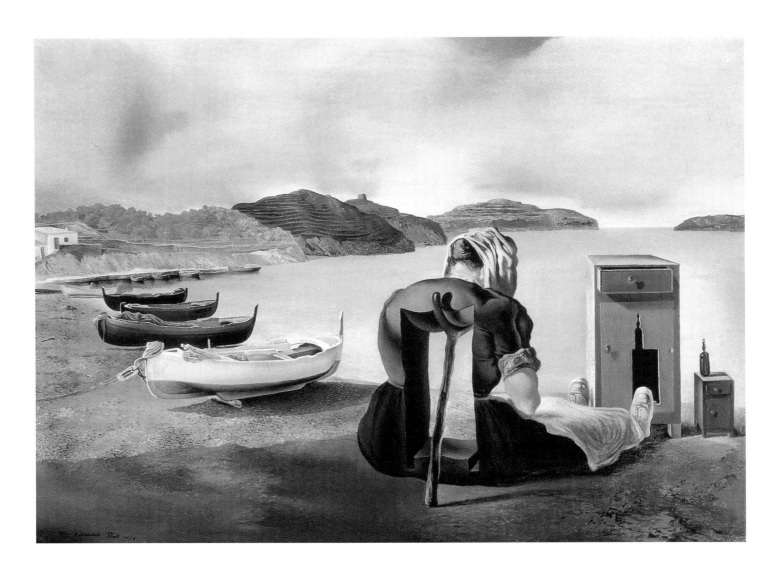

113. Television interview from 1975

Above: *The Weaning of Furniture-Nutrition*, 1934
Oil on panel. 18 x 24 cm
The Salvador Dalí Museum,
St Petersburg (FL)

Opposite page: *Soft Self-Portrait with Fried Bacon*, 1941
Oil on canvas. 61.3 x 50.8 cm
The Gala-Salvador Dalí Foundation,
Figueras

photo book, *Dalí's Moustache*, show Dalí in "natural" poses but always in manufactured ones, which for the most part were decided upon by the model himself.

Dalí stylized himself as an art object. In depicting himself, the painter was continually and thoroughly ironic: for one of the photos he transforms his moustache into a dollar-sign – an allusion to Breton's anagram "Avida Dollars". Dalí never denied his desire for wealth. He could never get enough of fame or money, as he stated in an interview in 1975.[113] And in the forties, both of these achieved untold proportions.

At the end of 1942, the New York Museum of Modern Art put on a retrospective of Dalí's work featuring fifty pictures and seventeen drawings. The exhibition subsequently went to eight other American cities. As part of the exhibition, pieces of jewelry that Dalí had created were exposed, and amongst them a version of *Persistence of Memory* in gold and gems.

In December 1942 Dalí met Eleanor and Reynolds Morse. Four months later the Morses bought their first "Dalí" for 1,200 dollars: *Daddy Longlegs of the Evening – Hope!* In the following

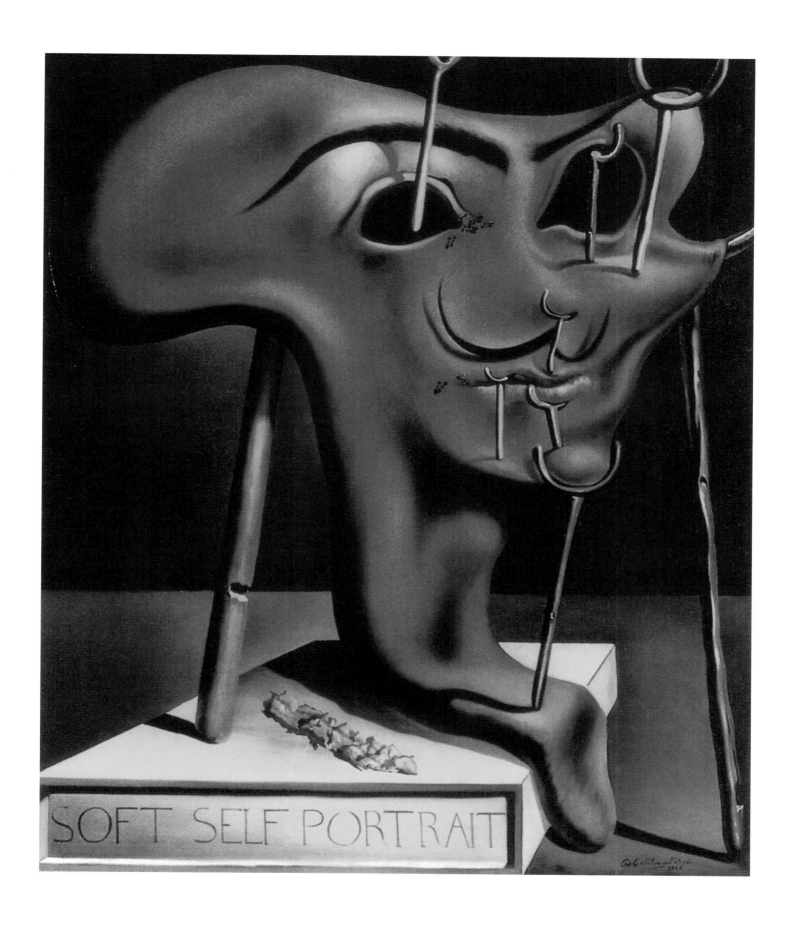

SOFT SELF PORTRAIT

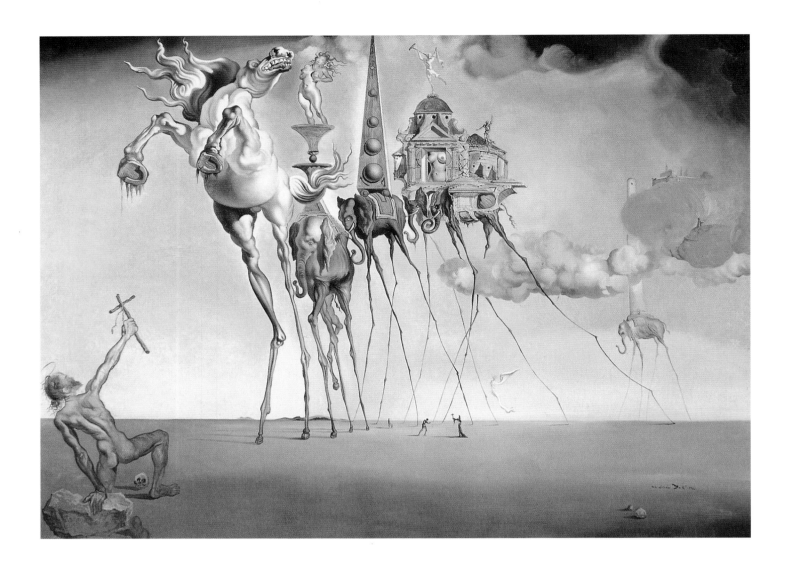

years the price for his works increased continually. The Morses, who were to become some of the most important collectors of Dalí's works, reported that Dalí always insisted on cash, and that they would soon require suitcases for the money-transportation. They acquired over four hundred of his works, and amongst these approximately ninety paintings. They built a museum in St Petersburg, Florida for their collection in 1982.

However, the most important source of income for Dalí was not his picture-sales, even though some single paintings did sell at up to 300,000 dollars. He earned much more from client contracts: he designed ties and ashtrays, created advertisements for perfums and nylon-stockings, designed the title page of the magazines *Vogue* and *Esquire*. In the house of the millionaire Helena Rubenstein he painted three large frescoes. He illustrated numerous books, amongst them Cervantes' *Don Quixote* and Shakespeare's *Macbeth*. With large editions' print cycles he opened up the market for middle and lower market art-collectors. Doctors and lawyers in particular bought his prints. In later years, Dalí signed thousands of blank sheets in advance and in doing so enabled the "sell-off" and misuse of his works. The number of more doubtful and phony Dalí prints became incalculable in the sixties and seventies.

Besides this, Dalí carried on his work in the theater. After the performance of his frequently reworked drama *Bacchantal* in

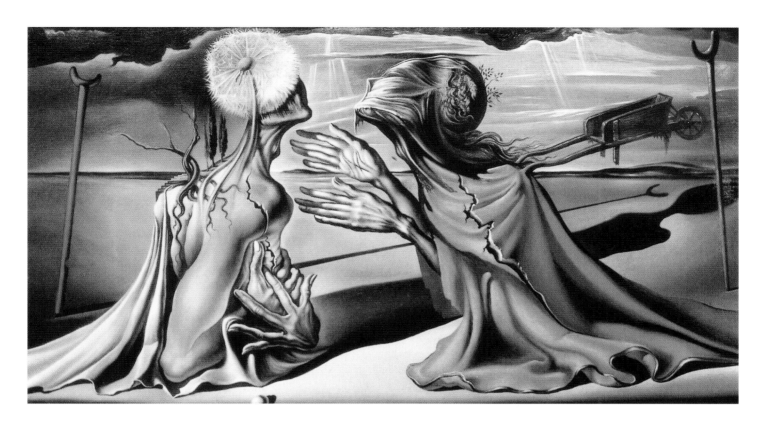

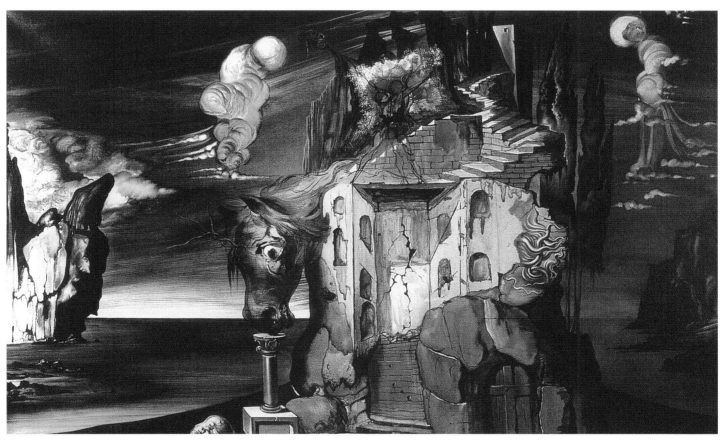

Above: Design for the set of the ballet
Tristan and Isolde, 1944
Oil on canvas. 26.7 x 48.3 cm
The Gala-Salvador Dalí Foundation, Figueras

Study for the backdrop of the ballet
Tristan Insane (Act II), 1944
Oil on canvas. 61 x 96.5 cm
The Gala-Salvador Dalí Foundation, Figueras

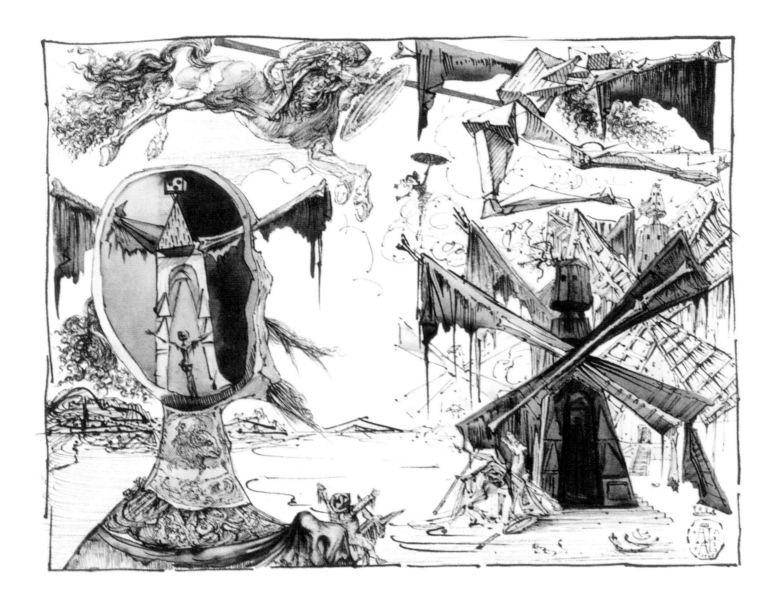

114. Cf.: *Catalogue 1989*, p. 283

Above: *Don Quixote and the Windmills,*
1945
Indian ink and watercolour on paper
28.5 x 32 cm
Gift of Dalí to the Spanish State

1939, he wrote the libretto for a ballet with motifs from the Ariadne myth. For the music, he chose the seventh symphony of Franz Schubert. Under the leadership of Leonide Massine, *Labyrinth* was premiered by the Ballets russes at the Metropolitan Opera on October 8th, 1941. The scenery consisted of a gigantic bust of a naked man with a lowered head. On the breast of the man gaped the entrance to the labyrinth. Dalí judged his work in 1945 as being too confused and improvised. The critics at the *New York Times* had not liked it and neither did he.[114]

The proximity to Hollywood enticed Dalí back to film again. As early as his second visit to the USA in 1936, Dalí had visited the dream factory. There he watched the Marx Brothers at work filming. He was a big fan of Harpo Marx and gave him a self-designed object – a harp made out of barbed wire and teaspoons. Together, they both wrote a scene for a film, although this was never to be produced.

In 1945, the director Alfred Hitchcock brought Dalí into the studio to create the dream-sequence for his psychoanalytically inspired film *Spellbound*. The film's producer, David O. Selznick, saw a perfect opportunity for promotion in using a renowned painter, as Hitchcock later related. Hitchcock had envisaged dream

Opposite page: *The Lacemaker (Copy of the painting by Vermeer van Delft),* 1945
Oil on canvas. 24 x 21 cm
Gift of Dalí to the Spanish State

Above: Paranoiac-Critical Painting of Vermeer's "Lacemaker", 1955
Oil on canvas on panel. 27.1 x 22.1 cm
The Solomon R. Guggenheim Museum, New York

115. *Catalogue 1979*, p. 348
116. *Catalogue 1979*, p. 355

Above: *Don Quixote*, 1956-1957
Colour lithograph. 41 x 32.5 cm
The Boston Museum of Fine Arts, Boston

Opposite page: One of 13 illustrations
for Shakespeare's *Macbeth*. Edition pub-
lished by Doubleday, New York, 1946
Pen and Indian ink on paper. 28 x 19 cm
The Orangerie-Reinz Gallery, Cologne

sequences of particular visual sharpness for his film: "Up until this
point, the dream-pictures in films had always consisted of a halo
surrounded by a whirlpool of puposefully effervescent clouds with
people moving back and forth in a mixture of stage-snow and mist.
This was the unquestioned norm and I was determined to do the
opposite. I chose Dalí [...] because of his ability to paint with hal-
lucinogenic accuracy, which expressed the exact opposite of these
evaporations and steamings."[115]

 Not all of Dalí's ideas were used during the filming, howev-
er. For example, the studio refused to hang fifteen pianos from the
ceiling. And so Dalí refrained from using the corresponding
sequence and created a new setting. Among other things, the
dream-sequence is set in a nightclub, where the curtains are paint-
ed with large eyes being cut by a man holding a large pair of scis-
sors – suggestive of the entrance-scene in *An Andalusian Dog*.

 As a medium, Dalí considered film to be a "secondary
form".[116] However, he did become more and more attracted to the

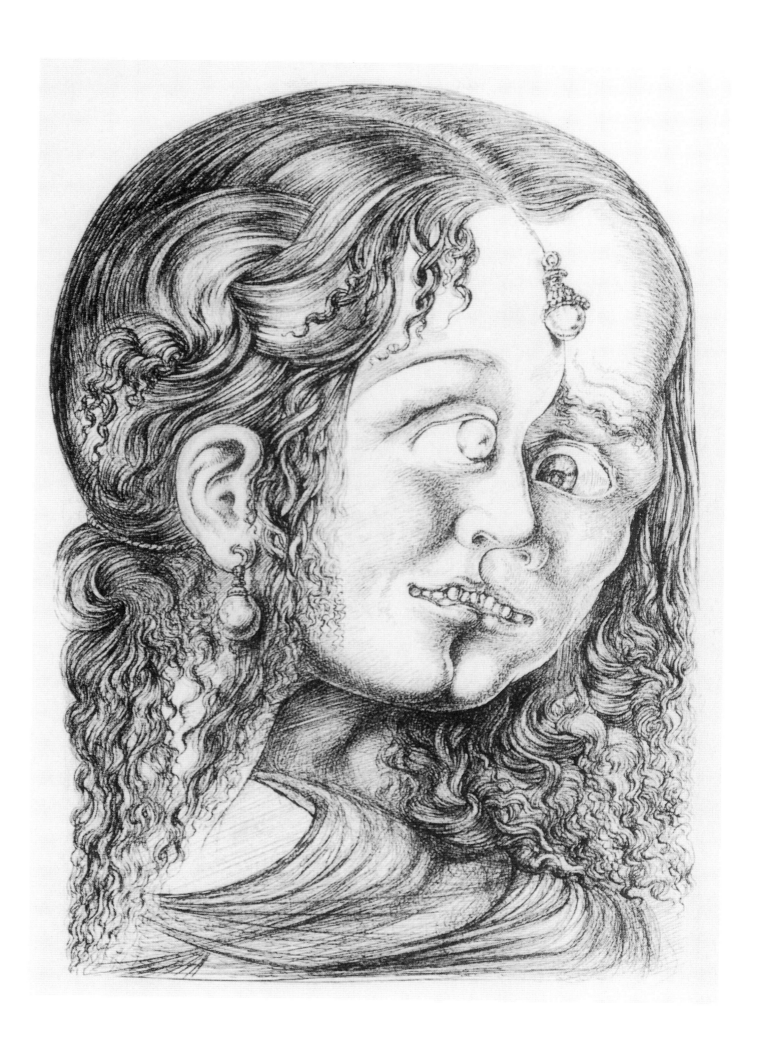

137

technical possibilities: through film, he could bring his paranoic-critical view of things directly to the viewer by over-blending two different positions or settings. A few months after the successful cooperation with Hitchcock, Walt Disney courted the artist: Dalí was supposed to create a six-minute sequence for an animation film with the title *Fantasia*. Together with the graphic artist John Hench he developed the screenplay. But then Disney dropped him from the project.

In 1950, Dalí worked on another film. He created the dream-sequence for Vincente Minelli's comedy *The Bride's Father*.

As a result of these many activities, the painter faded more and more into the background. Dalí's turning to classicism carried itself over onto the screen only marginally. Since his arrival in the USA, Dalí did not come any further with his world-design, which proved to be a difficult birth. However, the dropping of the first atomic bomb over Hiroshima gave way to the first contractions: "The explosion of the atomic bomb on August 6th, 1945, jarred me seismically. From this point onwards, the atom became the first object of my considerations. Many landscapes that I painted at this time express the enormous fear I felt on being notified of this

explosion. I applied my paranoic-critical method to explore this world. I wanted to comprehend the latent powers and the laws of the things, in order to dominate them, and I had the brilliant notion that I was the guardian of an uncommon weapon which would enable the advance to the nucleus of reality: mysticism, that is, the deep intuitive knowledge of that which is the immediate communication with the whole, the absolute vision of the mercy of the truth, the mercy of God."[117]

Religion and science became new topics for Dalían painting. In 1946, he painted his first piece of work with a religious motive: *The Temptation of Saint Anthony*. In Dalí's version, Antonius is threatened by a rearing horse and spindle-legged elephants. In 1948, Dalí converted to the Roman Catholic church. In the same year he returned once more to Europe.

117. Dalí: *Becoming the Man*, p. 243

Above: *The Eye – Design for "Spellbound"*, 1945
Oil on panel. Dimensions unknown
Private collection

Above: *Raphaelesque Head Exploded*,
1951
Oil on canvas. 43 x 33 cm
The National Gallery of Scotland,
Edinburgh

Opposite page: *Dematerialisation of
the Nose of Nero*, 1947
Oil on canvas. 76.2 x 45.8 cm
The Gala-Salvador Dalí Foundation,
Figueras

Above: *Meditation on the Harp*,
1932-1934
Oil on canvas. 67 x 47 cm
The Salvador Dalí Museum,
St Petersburg (FL)

Above: *Melancholy, Atomic, Uranic Idyll*,
1945
Oil on canvas. 65 x 85 cm
The Reina Sofia National Museum,
Madrid

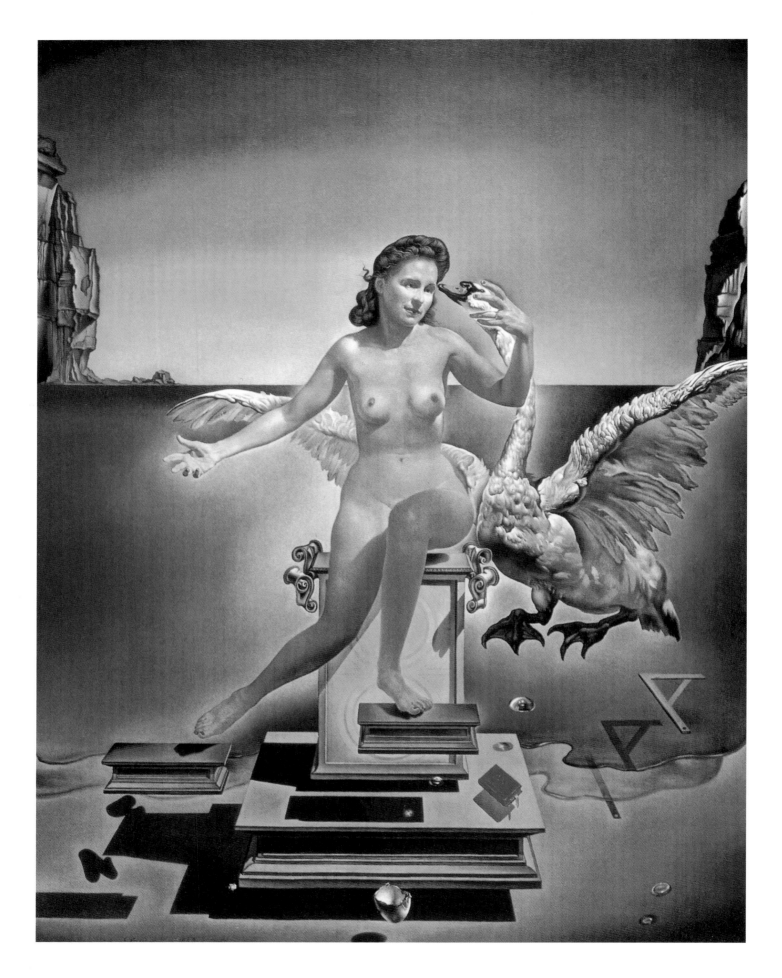

Above: *Leda Atomica*, 1949
Oil on canvas. 61.1 x 45.6 cm
The Gala-Salvador Dalí Foundation,
Figueras

144

Above: *Hallucinogenic Toreador,*
c. 1968-1970
Oil on canvas. 398.8 x 299.7 cm
The Salvador Dalí Museum, St Petersburg (FL)

145

Metamorphosis to Divine

The Time of Honour and Riches

"Bienvenida a Salvador Dalí": *Destino* magazine greeted the famous son with this cry as he returned to his fatherland. In 1948, Dalí and Gala moved back into their house in Port Lligat. There, in the place that had retained such special meaning for him since his childhood days, Dalí underwent his metamorphosis to sainthood, to the divine: "On the beach of Port Lligat I realized the Catalonian sun [...] to be the thing that had caused the explosion of the atom of the absolute in me. [...] I understood I was destined to become the saviour of modern painting. Everything became clear and obvious: the form is a reaction of matter under the inquisitorial force of all sides of hard space. Freedom is the shapeless. Beauty is the last spasm of a strict inquisitorial process. [...] And I threw myself into the strictest, most architectonic, most pythagoraic and most exhausting mystic dreaming. I became a saint."[118]

Dalí decided to resurrect the spirit of Leonardo: "the methodical interpretation of all metaphysics, the complete philosophy and the whole of science in unison with the foundation of Catholic tradition [...] through the discipline of the paranoic-critical method".[119] He wanted to find a "pictorial solution for the Quantum Theory: quantumified realism."[120]

After Dalí had raised himself to sainthood, he declared Gala Madonna: with glorified countenance she became the "mother of God" in his paintings. In 1949, he painted the first version of the *Madonna of Port Lligat*. As a model for the painting he used Piero della Francesca's *Madonna with Child* from the 15th century. Dalí attempted to demonstrate the dissolution of gravity in this picture. The madonna is divided into single body parts, which although unconnected are held in balance and in their correct anatomical positions. The Christ-child floats in the open belly, which is also perforated. The surrounding architectural elements are also mere fragments, which, raised above the earth, create the form of a bow. Everything on the picture seems to be arranged around an invisible centre. In order to achieve this effect, Dalí took the advice of a mathematician.

At a private audience with Pope Pius VII in November 1949, Dalí presented the first version of his madonna. The Pope – as the painter reported, admired the picture greatly.[121] Having reached the pinnacle of his fame, the doors of the mighty now began to open for the Catalonian farmer[122]. And he entered with joy. In 1956, he allowed himself to be received by General Franco, who, eight years later, awards him the "Cross of Isabel". Critics accused him of

118. Dalí: *Becoming the Man*, p. 243 f
119. Dalí: *The Secret Life...*, p. 474
120. Dalí: *Becoming the Man*, p. 244
121. Cf.: Dalí: *Becoming the Man*, p. 245
122. Dalí: *The Secret Life...*, p. 417

Opposite page: *The Madonna of Port Lligat*, 1950
Oil on canvas. 144 x 96 cm
Private collection, Tokyo

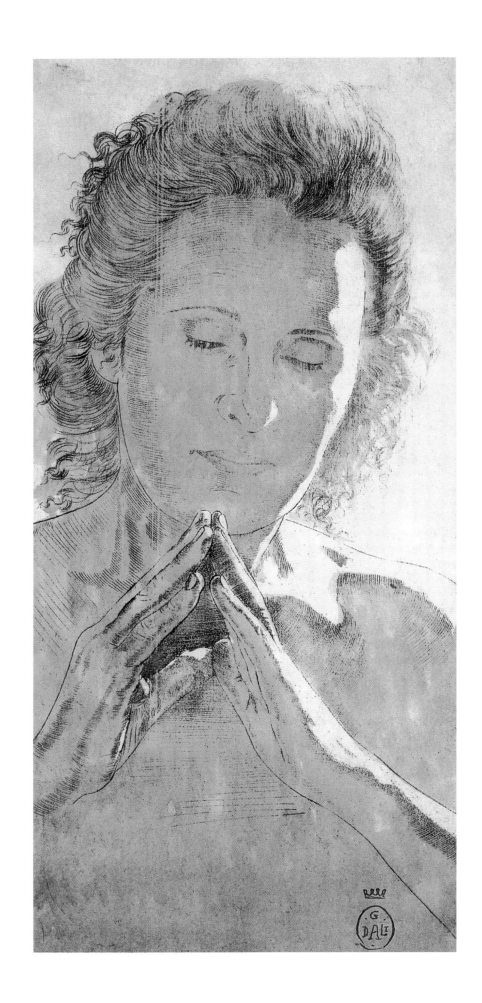

Opposite: Study for the head of *The Madonna of Port Lligat*, 1949
Oil on canvas. 49 x 31 cm
The Salvador Dalí Museum,
St Petersburg

Opposite page: Study for the head of *The Madonna of Port Lligat*, 1949
Oil on canvas. 48.9 x 37.5 cm
Marquette University, Haggerty Museum of Art, Milwaukee (MI)

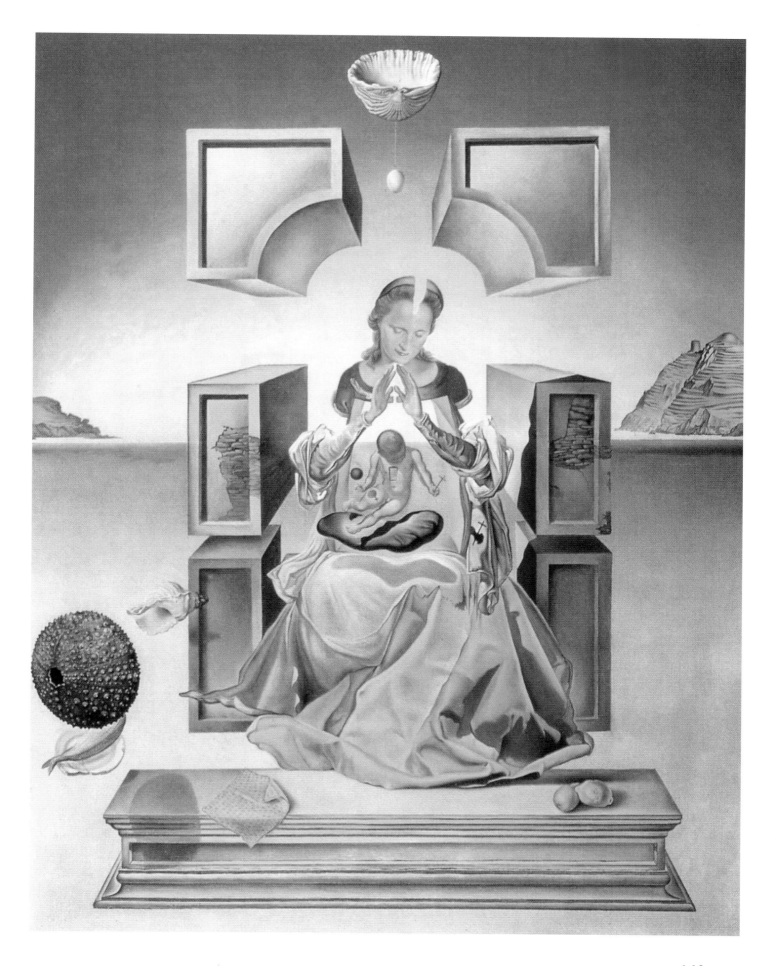

149

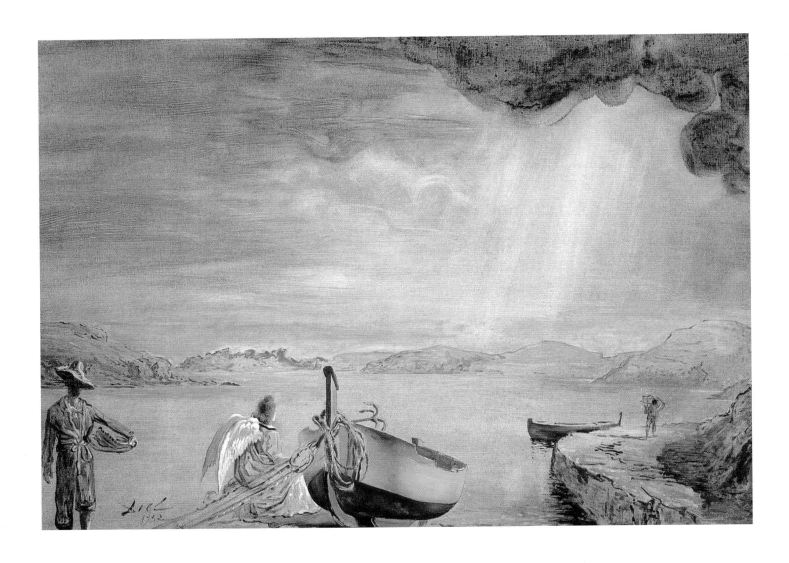

allowing himself to be honoured by the murderer of his friends, but he rejected this with the answer: "If I have accepted the Catholic 'Cross of Isabel' from the hands of Franco, it is only because nobody in Soviet-Russia has seen fit to award me the Lenin-Prize. And I would also accept an honour if Mao Tse-tung awarded it to me."[123]

Dalí stylized his non-political stand to the point of provocation. He accepted that a group of artists protested against Dalí's participation in an international surrealist exhibition in New York in 1960: each headline increased his popularity and that was good for business. Television, which he described as the "medium of degradation and feeble-mindedness of the masses", was a means for Dalí to become even better known: "I use it gladly; just to make sure that even more people run after Dalí so that my pictures become even more expensive."[124]

Spectacular appearances were still more media-effective than provocative declarations, however. On September 3rd, 1951, Dalí and Gala appeared as seven-metre tall giants at a ball in Venice. The costumes were created by the young Parisian fashion-designer Christian Dior. In 1955, Dalí transferred his atelier for some days to the rhinoceros enclosure at the zoo in Vincennes, a suburb of Paris, in order to work on his paranoic-critical version of the *Bobbin-Lace Maker* of Vermeer. He promoted his books with staged signature sessions. In 1962, in the Parisian bookstore La

123. Bosquet: *Discussions...*, p. 4
124. Television interview from 1975

Above: *The Angel of Port Lligat*, 1952
Oil on canvas. 58.4 x 78.3 cm
The Salvador Dalí Museum,
St Petersburg (FL)

Opposite page: *The Discovery of America by Christopher Columbus (The Dream of Christopher Columbus)*, 1958-1959
Oil on canvas. 410 x 284 cm
The Salvador Dalí Museum,
St Petersburg (FL)

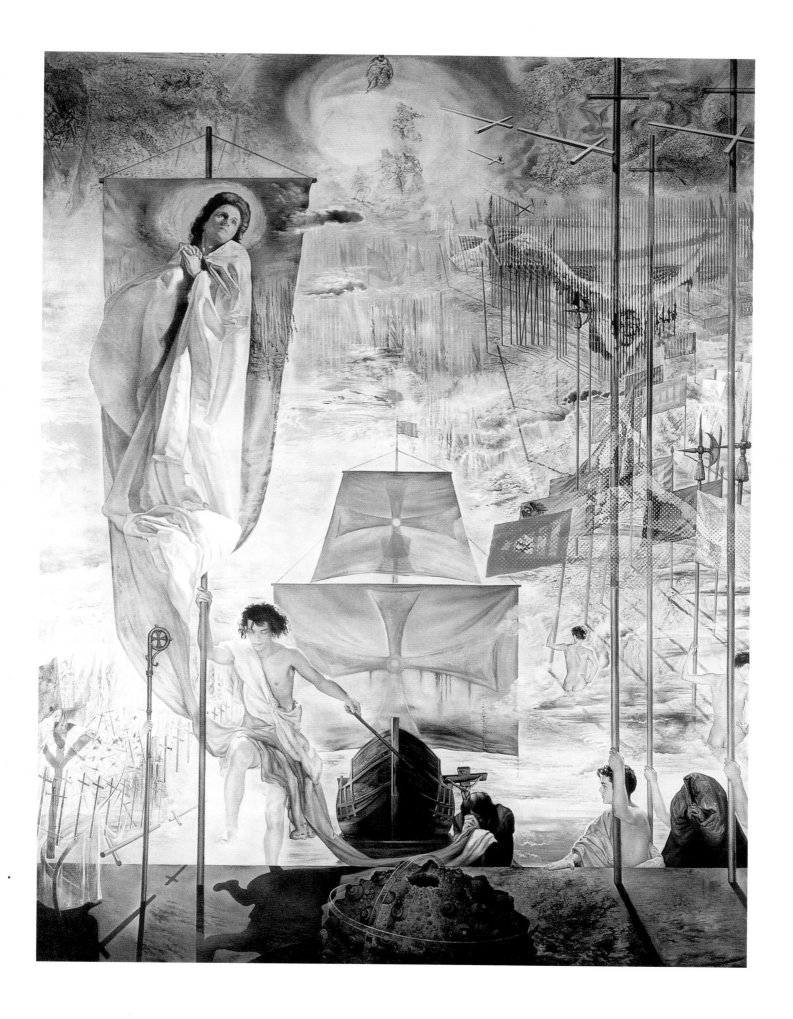

151

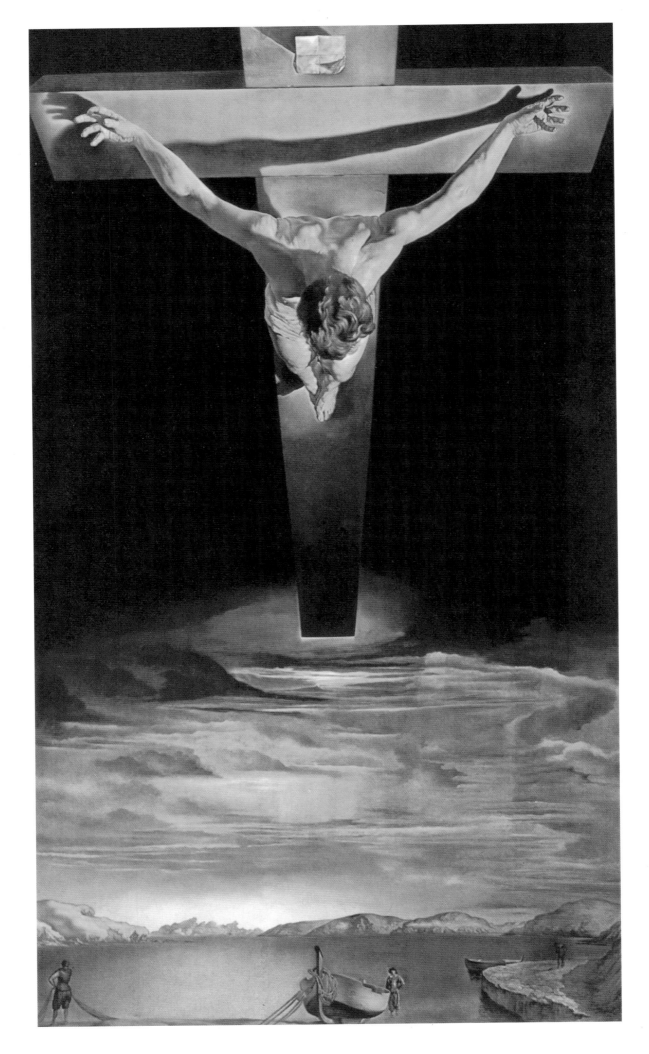

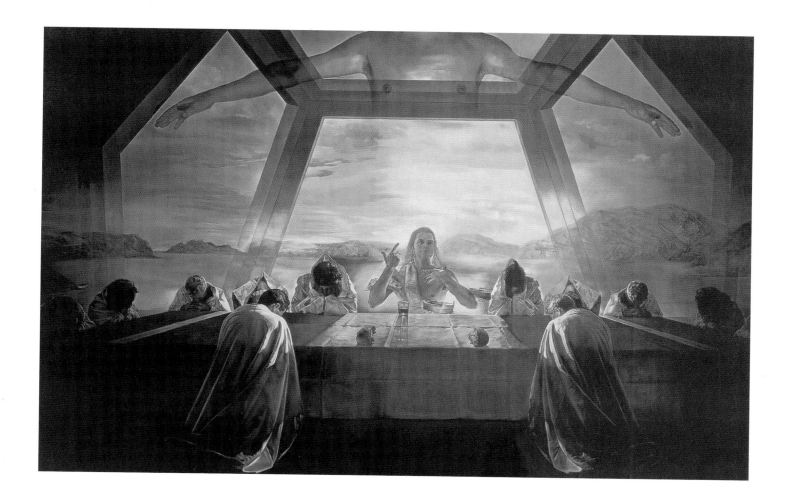

Hune, he allowed himself to be hooked up to a cardiograph that measured his heart-beat, while he wrote dedications in Robert Descharnes' book, *Dalí de Gala*.

In the eyes of the art-critics Dalí did not just lose credibility because of his promotion in the media. Since his change towards classicism and Catholicism, his paintings had been more negatively assessed. In 1951, he painted a picture of the crucified Christ from the perspective of a bird according to a drawing that John of the Cross, a mystic of the 16th century, had made during a trance. When the Glasgow Art Gallery bought the *Christ of Saint-John of-the-Cross* in 1952 for 8,200 pounds, the public responded with thorough indignation. A visitor to the gallery slashed the picture with a knife.

Despite this criticism, almost all the major museums in the world bought Dalí's works in the fifties. *The Last Supper* has been hanging at the National Gallery in Washington as part of the permanent collection since 1959, although the experts consider this painting to be one of Dalí's weakest.

At the beginning of the sixties, Dalí began with plans for a museum in his home town of Figueras. His choice of building was a town theatre, a classical building from the 19th century, and one which was very badly damaged during the civil war. First of all, Dalí planned to take over the ruins in their damaged state and use them as an exhibition place. In view of the missing roof, however, this proved to be too difficult. Together with the architect Emilio Pérez Piñero, Dalí drafted a dome: "A principle related in particular measure to the monarchy, life and the liturgy."[125]

125. Gómez de la Serna: *Dalí...*, p.193

Opposite page: *Christ of Saint John the Cross*, 1951
Oil on canvas. 205 x 166
The Glasgow Art Gallery, Glasgow

Above: *The Last Supper*, 1955
Oil on canvas. 167 x 268 cm
The National Gallery of Art, Chester Dale Collection, Washington (DC)

On September 28th, 1974, the seventy-year-old Dalí opened his "Teatro-Museo": it is not just an exhibition place, but also a holy one where the Dalí, the divine, pays homage to himself. He dedicates the dome to Spain's sovereigns – to which the governing dictator Franco also belonged.

Dalí called his museum an example of the "Pompierism", that he attracted as the "endstation of the contemporary taste in art".[126] He created a face out of one room, with a lip-sofa, a nose-wardrobe and hair-curtains. The eyes were marked with two pictures. For this design, Dalí fell back on an idea from the thirties. At this time he had created a room out of a photograph of the face of the actress Mae West.

For Dalí, the time for being honoured began: in 1978, the Spanish royal couple, Juan Carlos and Sofia, visited the "Teatro-Museo". In the same year he was accepted by the French Académie des Beaux-Arts in Paris as an honorary-member. The Georges-Pompidou Centre in Paris devoted an extensive retrospective to him in 1979, with over 250 paintings, which was subsequently shown at the Tate Gallery in London. In 1982, the painter was raised to a peerage by King Juan Carlos. And with this, the dream of Dalí's childhood was in one way fulfilled.

Fame and wealth marked the last twenty years of Dalí's life. From 1970 onwards, his yearly net income was estimated at half a million dollars. For the administration of his "empire", Dalí employed a small court which almost constantly surrounded him. While in interviews, Dalí always claimed he could never have too much of being in the public eye but Gala wished for a place of peace. In the thirties, the house at Port Lligat had been their refuge. Since the sixties, at the very latest, the tiny fishing village became populated by Dalí's illustrous circle of supporters. Popstars such as Amanda Lear belonged to the "divine one's" more narrow circle of companions.

In 1967, Dalí bought the half-ruined Chateau Pubol for Gala, which they renovated and furnished to their own taste. Here was a place to which Gala retreated more and more frequently. The management of Dalí's general affairs, which had been her task earlier, had been taken over in 1962 by John Peter Moore. Moore, a former officer, was replaced in 1976 by Enrique Sabater. Sabater quickly succeeded in becoming a multi-millionaire at Dalí's expense.

With increasing age, Gala began to worry more and more about her looks. She underwent cosmetic surgery in New York on her face, and travelled to Switzerland for fresh-cell therapy. Dalí on other hand was not afraid of age but was certainly afraid of death. He believed emphatically in his immortality. Since the sixties he had been studying various winter-sleep and freezing theories.

At the beginning of the eighties, Dalí became ill with Parkinson's Disease. He let himself be treated in Paris, and someone spread the rumor that Gala wanted to separate from him. Furthermore, the psychiatrist Dr. Roumeguère, who had treated Dalí over many years, accused Gala in a newspaper article of tyrannizing and hurting her husband.[127]

126. Gómez de la Serna: *Dalí...*, p. 194
127. Secrest: *Salvador...*, p. 315

Opposite page: *Mae West's Face which May Be Used as a Surrealist Appartment*, 1934-1935
Gouache on newspaper. 31 x 17 cm
The Art Institute of Chicago, Chicago

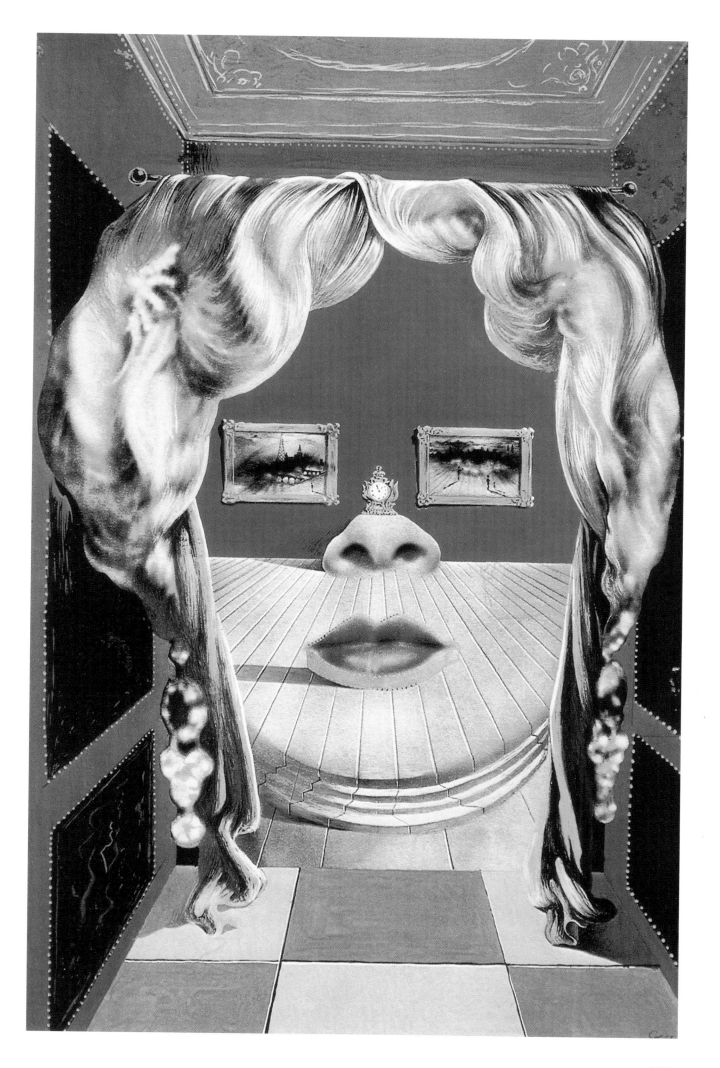

155

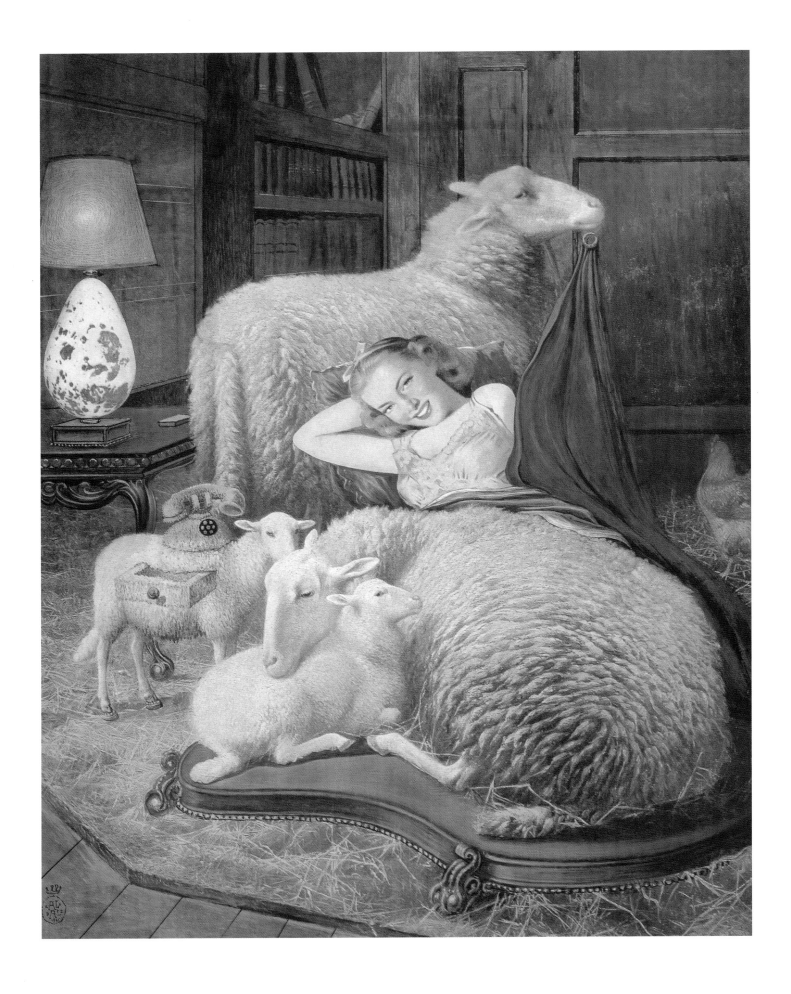

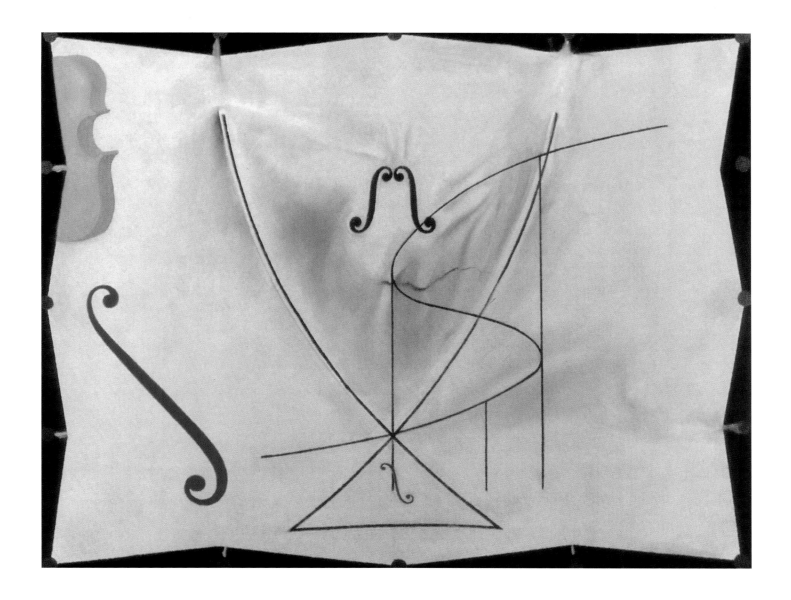

On June 10th, 1982, Gala died of an infection of the ureter. According to her wish, she was laid to rest at Chateau Pubol. After the burial, Dalí remained at the chateau, where he lived a secluded life and carried on working despite his illness. Here, in 1983, he painted his last picture: *The Swallow's Tail* – a cloth featuring geometrical signs, which Dalí borrowed from the formulas of the French mathematician René Thom. The upwardly curving ends of the swallow's tail are reminiscent of Dalí's moustache.

A few months after the completion of the painting a fire broke out at the chateau, the cause of which has never been identified. Dalí survived the fire badly injured. After his convalescence, he returned to his birthplace and lived beside his "Teatro-Museo" until his death on 23rd January, 1989. He was laid to rest there under the dome. He bequeathed his estate – over two-hundred and fifty paintings and two thousand drawings – to the Spanish state in his last will and testament.

Opposite page: *Design for the interior decoration of a stable-library*, 1942
Chrome overpainted with gouache and Indian Ink. 51 x 45 cm
The Gala-Salvador Dalí Foundation, Figueras

Above: *The Swallow's Tail (series on catastrophes)*, 1983
Oil on canvas. 73 x 92.2 cm
The Gala-Salvador Dalí Foundation, Figueras

List of paintings and photographs reproduced

1644